D1489263

Preservation Microfilming

A Guide for
Librarians and Archivists

Edited by Nancy E. Gwinn

for the Association of Research Libraries
and Northeast Document Conservation Center

American Library Association

Chicago and London

Produced with the cooperation of the Northeast Document Conservation Center, Andrew Raymond, Project Director, with contributions from: Wesley L. Boomgaarden, Sherry Byrne, Pamela W. Darling, Carolyn Harris, Jeffrey Heynen, Patricia A. McClung, Peter Scott, and Ann Swartzell.

Cover designed by Ray Machura

Text designed by Ray Machura

Composed by Point West Typesetting, Inc.
 in Times Roman and Bodoni on a
 Quadex/Compugraphic 5000 typesetting system

Printed on 50-pound Glatfelter, a
 pH-neutral stock, and bound in
 10-point Carolina cover stock
 by Edwards Brothers, Inc.

Library of Congress Cataloging-in-Publication Data

Preservation microfilming.

 Includes bibliographies and index.
 1. Micrographics—Library applications.
2. Microfilms—Library applications. 3. Library materials—Reproduction. 4. Archival materials—Reproduction. 5. Books on microfilm. 6. Documents on microfilm. I. Gwinn, Nancy E. II. Association of Research Libraries.
Z681.3.M53P73 1987 025.7 87-10020
ISBN 0-8389-0481-5

Copyright © 1987 by the American Library Association and the Association of Research Libraries. All rights reserved except those which may be granted by Sections 107 and 108 of the Copyright Revision Act of 1976.

Printed in the United States of America.

Contents

Figures

Tables

Preface

It happened again. When I finished my keynote address at the 1986 Preservation Microfilming Institute at the Library of Congress, a staff member from a local university appeared at my elbow during a coffee break. "When will that manual be finished?" she asked. She explained that her institution had received a grant for cataloging a collection and preserving it on microfilm and that she had been asked to plan the project. "We've never done it before," she said, "and I don't know where to start. It's *so* complicated!"

She was the very person the advisors to the Association of Research Libraries (ARL) had in mind when they suggested that preparation of a manual on preservation microfilming should be a top priority. ARL wrote a proposal and obtained funding from the Andrew W. Mellon Foundation. They found a cosponsor in the Northeast Document Conservation Center (NEDCC) and asked Andrew Raymond, at that time NEDCC's Director of Photoduplication Services, to be the project director, with Jeffrey Heynen, ARL's program officer for preservation, as co-director. Raymond secured additional funding from the National Historical Publications and Records Commission to include information related to microfilming of archives. After much consultation, he chose the people to begin writing the individual chapters. He asked me to be the general editor, and bravely we set our first deadline.

Preparation of this guide over the past two years has been a challenge for all participants. As the chapter drafts arrived, it became clear that each author had much to say about preservation microfilming, and their comments spilled over from their assigned topics into many related subjects. What has emerged is not a book of readings, where each author covers a distinctive topic in a unique style. Rather, information migrated among chapters; it was revised, reshaped, and rewritten; additional material was sought and inserted; and finally the manuscript was reorganized into what we hope is an integrated description of the process of preservation microfilming. The guide now contains contributions from many sources: practitioners, administrators, organizers, coordinators. All are joined to provide you, whether you are new to the subject or an old hand, with instruction and guidance into a fundamental component of the expanding field of preservation.

The principal contributors provided initial chapter drafts, which formed the basic structure of the book. They are:

Introduction	Pamela W. Darling Preservation Consultant
An Overview of Administrative Decisions	Carolyn Harris Preservation Officer Columbia University Libraries
Selection of Materials for Microfilming	Wesley L. Boomgaarden Preservation Officer Ohio State University Libraries
Production Planning and Preparation of Materials	Ann Swartzell Associate Librarian (Preservation) New York State Library
Microfilming Practices and Standards	Peter Scott Head, Microreproduction Laboratory Massachusetts Institute of Technology
Preservation Microfilming and Bibliographic Control	Jeffrey Heynen Program Officer Association of Research Libraries
Cost Controls	Patricia A. McClung Associate Director for Program Coordination Research Libraries Group, Inc.
An Afterword	Andrew Raymond Preservation Consultant

A very special word of thanks goes to these experts. But another must be given to Sherry Byrne, Preservation Officer, University of Chicago Libraries, who contributed information about costs and the process of contracting for preservation microfilming, prepared the sample contract, provided the target examples, and augmented several of the technical chapters under a very tight deadline. A hat also goes off to Helga Borck, Special Projects Librarian, New York Public Library, who put together the bibliographical references and verified footnotes.

The Introduction sets the stage for the rest of the manual by providing a historical context and examining the environment in which local microfilming programs operate. The first chapter, An Overview of Administrative Decisions, is an extended abstract of the entire manual and presents a bird's-eye view of all the facets of preservation microfilming. The chapter may also be used as a checklist against which to measure programs in progress.

Each of the remaining chapters explores a phase of preservation microfilming in depth. Selection of Materials for Microfilming discusses how to go about deciding what to film and whether an item can be filmed success-

fully. It also points out the place of microfilming in a comprehensive preservation program with its variety of options. Production Planning and Preparation of Materials reviews the steps toward organizing the work of moving volumes and documents from an institution's shelves to the camera and back again. Microfilming Practices and Standards explains in detail what is required to ensure the quality and permanence of microform products. It makes plain most technical issues for the nontechnician and guides the reader among the existing body of published standards and specifications. Preservation Microfilming and Bibliographic Control emphasizes the importance of cataloging preservation microforms and of sharing that information—and the need to develop institutional support for this endeavor. In Cost Controls, how to estimate costs and what elements to consider in planning a budget for preservation microfilming are covered. Finally, the Afterword points out the need for further research concerning preservation microfilming and for constant review of methods and procedures.

The *appendixes* are among the most valuable parts of the manual. Here you will find the exact citations to published standards and specifications and information on how to obtain them, a sample contract for microfilming services to use as a basis for designing your own, a glossary of terms used throughout the manual, and a listing of institutions and organizations with expertise to offer when you need more advice. The Index complements the Contents. Certain topics, such as contracting for services or quality control, reappear throughout the manual, approached from a variety of viewpoints. The Index draws these discussions together so that you will not miss any relevant information.

You can approach this book in many ways: as an overview of the whole process of preservation microfilming, as a detailed—but not exhaustive—guide to each step of the operation, as a reference book to other documents or programs to meet your specific needs, as a fact book, as a checklist, as a place to find sample forms or photos—in short, as a helper to keep right behind your desk. Read it through, then go back as needed for specific facts and referrals. You won't find in detail every procedure that you will require—many of them must mesh with local priorities and conditions—but the critical issues are all covered. We hope the book will end up being well-thumbed.

There is one area where this guide cannot help—the decision as to which of your collections should be filmed. Some institutions are part of regional or national consortia, which are tackling this issue in cooperative ways and within which an institution must fit its own plans. Some collections have national prominence but no local constituency; others are of high value locally but are duplicated many times over. In the end, it is a matter of policy, which each institution must develop based on its unique environment and relationships with others. As long as the investigation into existing programs is thorough and duplication of effort avoided, possible choices are wide-ranging. There is much work to be done.

Preservation microfilming programs depend on an understanding of voluntary micrographics standards, which are developed and maintained in the United States by the American National Standards Institute (ANSI), the As-

sociation for Information and Image Management (AIIM), and other allied organizations. In referring to these standards throughout the manual, we use the organization acronym(s) plus a number (e.g., ANSI/AIIM MS23-1983). The year cited is the most recent revision at the time the manual was written, but the latest edition should always be consulted. Appendix 1 lists all relevant standards with their full titles, current as of this writing. Copies can be obtained from the appropriate organization, the address of which appears in Appendix 4.

Other organizations, especially the Library of Congress, the Research Libraries Group, the National Historical Publications and Records Commission, and the Society of American Archivists, also have issued specifications and guidelines. These too are cited in full in Appendix 1, with appropriate addresses in Appendix 4. The number of citations throughout the book to these standards and specifications emphasizes how important it is for all staff involved in preservation microfilming projects to become thoroughly familiar with them.

NANCY E. GWINN
July 15, 1987

Acknowledgments

In addition to the reviews of chapter drafts by the author team, the guide benefited tremendously from the work of a dedicated group of other reviewers, who read the entire manuscript from beginning to end and who provided numerous worthy suggestions that were incorporated into the draft. These reviewers were:

Myron B. Chace
Head, Special Services Section
Library of Congress
 Photoduplication Service

Madeleine Bagwell Perez
Medical Center Archivist
Bowman Gray School of Medicine
Wake Forest University

Veronica Cunningham
Director, Photoduplication Services
Northeast Document Conservation
 Center

Tamara Swora
Assistant Preservation
 Microfilming Officer
Library of Congress

Heinz Dettling
Technical Director
University Microfilms International

George L. Vogt
Director, Records Program
National Historical Publications
 and Records Commission

John D. Kendall
Head, Special Collections and Rare
 Books
University of Massachusetts at
 Amherst Library

Gay Walker
Head, Preservation Department
Yale University Library

In addition, the draft was circulated to all members of the ARL Committee on Preservation of Research Library Materials. These persons, primarily directors of major research libraries, took their role seriously and organized reviews of the manuscript by appropriate staff within their institutions. The committee members were:

Harold W. Billings
Director, General Libraries
University of Texas at Austin

John Laucus
Director
Boston University Library

Deanna B. Marcum
Vice President
Council on Library Resources, Inc.

Kenneth G. Peterson
Dean of Library Affairs
Southern Illinois University
 Library

John B. Smith
Director of Libraries and Dean
State University of New York at
 Stony Brook

Peter Sparks
Director, Preservation Office
Library of Congress

William J. Studer
Director
Ohio State University Libraries

David C. Weber, chair
Director
Stanford University Libraries

Another vote of thanks goes to Karen Garlick, conservator, and Merrily Smith, National Preservation Program specialist, both at the Library of Congress, who spotted inconsistencies in those sections that describe the conservation options of a comprehensive preservation program and helped us correct our terminology. Eileen Usovicz, Columbia University Libraries, improved our understanding in several technical areas of microform production. All of the persons so far mentioned have helped to make this text as authoritative as possible.

The text is only one portion of the guide, however. Its utility in the end will also rely on the helpfulness of the sample forms, the clarity of the tables, the ease of use of the flow charts and target sequences, the logic of the worksheets, and the relevance of the photographs. Many helped to prepare them. Mary Ann Ferrarese, assistant chief of the Library of Congress Photoduplication Service, organized the majority of the photographs, with additional contributions from Veronica Cunningham, Northeast Document Conservation Service, and National Underground Storage, Inc. Marilyn Courtot made certain our standards citations were up-to-date and gave permission for us to use several illustrations from standards publications produced by the Association for Information and Image Management. Her counterpart at the Research Libraries Group, Inc., Jennifer Hartzell, extended the same courtesy. CACI, Inc., a graphics design firm located in Fairfax, Virginia, produced the target sequences, which were prepared by Sherry Byrne based on actual targets used for microforms produced by Columbia University Libraries. We hope that all of these friends will accept our gratitude for their contributions that add illumination and luster to the text.

As I began on a personal note, let me now end on one. First, to Nicola Daval, who managed the production of the manuscript and negotiations with the publisher for the Association of Research Libraries, and especially to Margaret McConnell, who keyed and rekeyed and rekeyed again the numerous drafts and revisions, I offer unbounded appreciation. With them,

cordiality and a willingness to meet and work with my schedule were always the order of the day. But without the intelligence and dedication brought to the management and oversight of the preparation of this guide by Andrew Raymond and Jeffrey Heynen, it would not have happened. Not only did they offer advice and critique various drafts, but they also wrote portions of the book. Andy selected contributors, managed the budget, and turned an understanding ear to my many attempts to sort out the technical questions and contradictions that inevitably arose. Jeffrey allowed me to absorb his time on numerous evenings and week-ends, providing sound advice and much moral support.

PRESERVATION MICROFILMING was a group effort from start to finish. I am pleased that it had such a happy result.

N.E.G.

Introduction

This is a book about the why's and how's of capturing information on microfilm, information which otherwise may be lost along with the deteriorating paper on which it is recorded. Chances are that if you fit into any of the following categories, this book will benefit you.

Who Should Read This Book?

Perhaps you are a librarian assigned to "doing something" about the crumbling Dewey collection in the old stacks, wondering if microfilming is a plausible "something," and, if so, how you might go about it. Perhaps the Preservation Committee on which you serve has been asked by your institution's director to make a recommendation about joining your consortium's planning for a cooperative microfilming project. Perhaps the library is about to take over the university's microfilming department, giving you the opportunity to complete the salvage of an important collection of old periodicals, a project begun years ago by a small micropublisher who went out of business. Perhaps you own a commercial microfilming service bureau and want to expand your market to libraries or archives interested in preserving their older collections.

You may be an archivist sure to be buried by one more year of incoming material unless you find a way to miniaturize some of the collection, or a manuscript curator in need of study copies to take the stress of constant use off priceless documents. Perhaps you have the go-ahead to write a microfilming grant proposal, or to survey a collection to determine whether it should be filmed. Your institution may have been allocated camera time as part of membership in a new regional preservation center, or a donor keen on technology may have offered to buy a microfilm camera.

Maybe you are about to start a new cataloging job that involves working out the bibliographic control procedures for a preservation filming project, or, as selection officer, you have to make preservation decisions about books and serials in your field. Perhaps you are the preservation officer and the time has come to establish a microfilming component in your program. Or

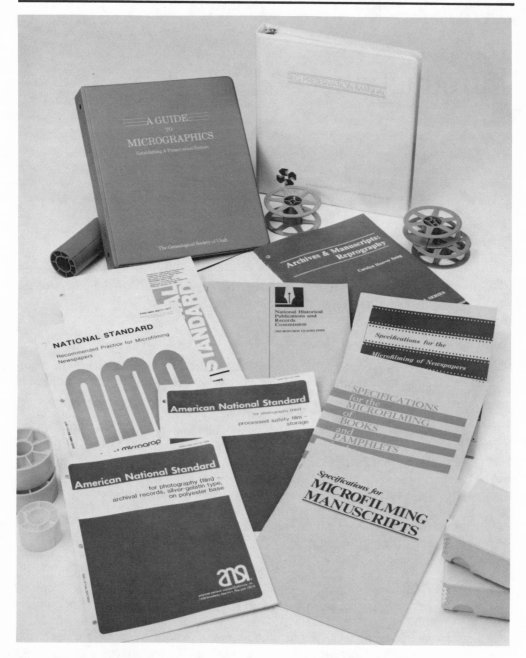

Just a few of the multiple standards and guidelines that pertain to preservation microfilming. Source: Library of Congress

you are a student, hoping for a career in preservation but daunted by the how-complex-it-is tone of the few articles you have seen about microfilming.

You may even be the experienced manager of a well-established preservation microfilming program, generally satisfied with the procedures you have

developed but interested in comparing them with those in other places and always on the lookout for ways to improve quality and efficiency while controlling costs.

This book is not a one-stop, learn-everything encyclopedia on preservation microfilming, but it is a good place to begin. It includes in-depth considerations of the various procedural and technical aspects—selection, preparation, filming, inspection, bibliographic control, and reporting—set in the essential context of administrative planning and the calculating of costs. It can also serve as a sort of manual to the manuals, pointing beyond itself to the various published standards, procedural guidelines, specifications, and instructional handbooks which deal with subsets of the whole.

Why Yet Another Volume on the Subject?

There is, indeed, such an array of existing resources that one might reasonably ask, why another one? The proposal that secured part of the funding for the preparation of this manual addressed that question as follows:

> Except at a very few institutions, preservation microfilming is not a well-established, permanent activity. Experienced personnel are rarely available to organize and staff the operation, and procedures and policies must be developed "from scratch." Existing standards and specifications are highly technical and difficult for administrators and inexperienced staff to locate and interpret. Apart from general conservation guides and the proceedings of preservation conferences, the only available guides are tailored to a specific internal operation...or project.... The former are often too idiosyncratic to adapt successfully, while the latter are not comprehensive enough to cover all necessary elements of a local operation.[1]

This manual is not intended as a substitute or replacement for those other sources of technical information. Instead, it sets out to provide an administrative context, a conceptual, intellectual framework within which specific decisions about the details of individual programs can be made. It contains answers to a number of commonly asked questions; even more important, it includes many questions that must be addressed to each particular situation if intelligent decisions are to be reached. Of special value, both for comparison and for planning purposes, is newly assembled information—formulas and cost data—drawn from recent experience in large-scale cooperative filming projects.

There is no such thing as a prepackaged preservation microfilming program, in a book or in any other form. But informed common sense, together with application of appropriate technical resources, can enable any library or archival institution to take advantage of microfilming as a tool for preserving endangered materials.

Why Only Now? Hasn't Microfilm Been Around for Ages?

The fact that this book could be written now—and not until now—and that it is the product of a group effort rather than of an individual author, sug-

1. *Proposal to Prepare a Guide to Preservation Microfilming*, submitted to the Andrew W. Mellon Foundation by the Association of Research Libraries, August 1983, p. 1.

gests the growing importance of the preservation field in recent years, and particularly of microfilming as a preservation tool.

Experimental miniaturization of textual information on photographic film began in the middle of the nineteenth century. By the time the 35mm planetary camera was perfected for microfilming use by Recordak in 1935, its possibilities for compact, permanent storage of information contained in bulky and impermanent newspapers were recognized. The Harvard and Yale university libraries, the New York Public Library, and the Library of Congress all began filming newspapers, and then other materials, in the thirties.

In the next three decades, a few other libraries and archival repositories followed that lead, but during that period most of the developments in microfilming as a technology took place in the commercial sector. Business applications (bank checks, sales records, and parts inventories, for example) offered rewards and profits for microfilm service bureaus, as they came to be called. Most libraries became familiar with microforms through the pioneering activities of University Microfilms and the numerous micropublishers who followed its lead.

Technical standards for the several laboratory procedures involved in manufacturing of film, camera work, and film processing were developed, primarily by those in the industry. Concurrently, working groups within the American Library Association and the Library of Congress identified the particular requirements for handling published and documentary materials in the library or archives setting and prepared guidelines and specifications for filming such materials.

Reprographic experts working in scattered library and archival institutions contributed significantly to all these developments. But their activities, for the most part, had to be conducted on the fringes of their institutions' programs and organizational structures. (Most film laboratories are in basements to this day!) It was only as the scope and urgency of the problem of paper deterioration began to be recognized in the 1960s and 1970s that the professional community, through its leaders in major libraries, associations, and organizations, began to exploit systematically the tremendous potential of microfilming as a preservation tool.

The key word here is *systematically*, both in the sense of being systematic—logical, consistent, coherent—in planning and carrying out an extended sequence of technical operations, and in the sense of recognizing those operations as elements within an overall institutional system, each one integrated with, dependent upon, and contributing to the whole.

In the past two decades, a small but growing number of libraries and archives have begun to give sustained professional attention to the creation of programs to meet their preservation needs. Those needs, in large collections particularly, were and remain on such a vast scale that individualized physical treatment could be effective only for a small proportion of endangered materials. Thus a system including several program elements or strategies had to be developed: environmental control to retard future deterioration; improved processing, shelving, and handling techniques to minimize mechanical damage; physical treatment for appropriate materials; and the preservation of information in some other medium, when salvaging the original was either impossible or economically unjustifiable.

It must be said that the growth of microfilming programs and their integration with other approaches to preservation have been a slow, sometimes tortuous process. Mastering the intricacies of the actual filming process was only the first step. A brief review of some other historical developments will illuminate the context within which preservation microfilming is carried out today.

Enter the Micropublishers

One important facet of this development has been the relationship between libraries and commercial micropublishers. In the 1960s, when educational institutions were booming, many new academic library collections were created and older ones were rapidly expanding. The market for hard-copy reprints and microform editions of standard works in numerous fields was strong. Many publishers—some established and reputable, some not—stepped in to serve that market. All relied on the existing holdings of libraries for the originals from which they produced the reprint or microform copies, and they struck a variety of deals with libraries to compensate them for such use.

For awhile it appeared that "there was gold in them thar stacks." Because the agreements generally included not only some financial compensation but also copies of the reprint or microform, the publishers—particularly the micropublishers—were welcomed as allies in the preservation battle.

With their large-scale filming facilities, marketing expertise, flexibility in assigning staff to special projects, and capital to initiate programs pending sales income to recover costs, micropublishers could dedicate resources to preservation filming much more efficiently than most libraries. Consequently, there was a period when they were seen as "the answer" to the problem of inadequate filming capacity within libraries, and even as a source—through fees or royalties—of funds for other preservation activities.

Unfortunately, many such alliances broke down after a time because, beyond the basic titles in a field, the preservation priorities of the library seldom matched the results of commercial market surveys. Opportunities for mutually beneficial contract arrangements still exist for some very specialized collections. But commercial micropublishers must sell a number of copies of each title to stay in business—only a fraction of the press run required for hard-copy publications, to be sure, but often more than can realistically be projected for the bulk of brittle volumes making up research collections today. What has evolved, then is a de facto division of labor between the micropublishing and library communities, the former attending primarily to major (and particularly current) serials, newspapers, and the more popular monographs.

Wrestling with the Issues

In addition to the selection issue—that is, what items were to be preserved on microfilm—the relationship between libraries and micropublishers was also influenced, and occasionally strained, by concern for the technical

standards that affect the physical quality of the film, and for the bibliographic practices governing the identification of and access to the microform.

...like Film Quality

In the technical area, a major issue has been that of the archival qualities of the film base on which information is recorded. To summarize briefly a complex matter: silver-gelatin film, if manufactured, processed, and stored in accordance with well-tested national standards, is a medium of great permanence, or chemical stability.[2] Images recorded on such silver film will therefore last much longer, probably centuries longer, than the same information recorded on acidic paper. Silver film is not particularly durable, however. It scratches easily and it is relatively expensive. Several nonsilver films are considerably more durable for copies used frequently than silver film, but not as permanent, their images subject to fading from prolonged exposure to heat and/or light.

Since it is generally faster and cheaper to produce microforms using nonsilver film (either diazo, which is processed with ammonia, or vesicular, in which the image is set by heat), the usual marketplace rules applied: commercial firms began issuing microforms on nonsilver film. Representatives of the library and archival community became concerned about the longevity of such products, and a lengthy debate ensued.[3]

In time, a working consensus emerged: the demonstrable permanence of silver-gelatin film made its expense justifiable for the master copy (normally the camera negative) from which duplicates, or "service copies," could be made as needed for sale or use. These duplicates might be on either silver or nonsilver film, with the more durable latter type even preferred for titles expected to receive very heavy use. This illustrates the fact that new technical developments must continue to be monitored, both for their effect on costs and for their preservation implications.

...or Bibliographic Control

Bibliographic issues that have affected both libraries and micropublishers fall into two related categories: first, the way in which the original was presented and identified on the film itself; and second, the way in which standard cataloging information about the new microform was provided for

2. It has been customary for librarians and archivists to refer to the archival film used for preservation microfilming as "silver halide." However, the latest industry standards now uniformly refer to this film as "silver gelatin," and that is the term used in this manual. See the Glossary for full definitions.

3. The issue was mightily confused when one particular type of vesicular film, Kalvar Type 16, which was used for segments of the *New York Times* in the early 1970s, proved to emit hydrogen chloride under certain storage conditions, which combined with atmospheric moisture to form hydrochloric acid, causing considerable damage to film boxes and cabinets (though not, apparently, to the film itself). That type of film was quickly withdrawn, but the episode strained relations between the library and micropublishing communities and gave all nonsilver film a very bad name.

users and for the library community at large. The first required careful collation of the original before filming to ensure completion and correct sequence, and the creation and use of an array of "targets"—titles, guides, and notes included on and within the microform itself. Time-consuming as such preparation is, it is acknowledged as essential if the microform is to be easily used and readily recognized as a faithful copy of the original. The Library of Congress led the way in establishing specifications for this work, with other libraries and micropublishers building on that foundation.

The related bibliographic issue, crucial in regard to microforms of published material, was even more problematical than deciding how to identify the microforms themselves. To avoid the cost of unnecessary duplicate filming of materials held in more than one place, information about what had been filmed needed to be disseminated. From annotated catalog cards submitted to the *National Register of Microform Masters* (a union catalog compiled manually at the Library of Congress and published in book form from 1965 through 1983) to queuing dates (intent-to-film notes added to an online bibliographic record in the computerized Research Libraries Information Network), the efforts to meet this need have been long, complicated, and expensive.

The goal is simple enough: we need a nationwide (even worldwide) system which will enable anyone about to decide what to do with a deteriorating item to determine whether another copy of that same item has already been reproduced in accordance with preservation standards. Reaching agreement on the essential data and implementing procedures to achieve that goal have not been simple tasks, especially since microforms were rarely given full cataloging when they first began to be added to library and archival collections, and only a few institutions accord them that treatment even now.

The revolution in bibliographic control signalled by the adoption of a new cataloging code in 1978, the adaptation of procedures involved in automating the cataloging function, and the gradual exploration of new opportunities offered by automated bibliographic databases caused significant delays in resolving the question of distributing data about preservation microfilming. But a dramatic increase in filming activity, coupled with persistence in educating the library community about the need, is leading steadily to the building of an accurate and widely accessible union list of preservation microforms.

Cooperation Is at the Heart of the Matter

Not surprisingly, cooperation among numerous parties has been essential, and a roll call of key participants in this effort will identify organizations that have played crucial parts in almost every aspect of preservation. The Association of Research Libraries has initiated and coordinated a series of projects aimed at improving bibliographic control of microforms. Leadership and support, both moral and financial, have been consistently provided by the Council on Library Resources. Preservation administrators, catalogers, and microform specialists from libraries and micropublishing firms have worked through appropriate units of the American Library Association to identify needs and problems and hammer out solutions.

The Library of Congress, as the largest noncommercial producer of preservation microfilm and the chief creator and distributor of bibliographic data, has guided the development of both laboratory and cataloging standards. It and the New York Public Library, one of the other largest volume producers of microforms, have been leaders in cooperative filming projects for many years. The Research Libraries Group (RLG) and its members (with financial support from the National Endowment for the Humanities and the Andrew W. Mellon Foundation) have made significant contributions to the translation of technical standards and bibliographic ideals into working programs on the local level.

Cooperation in preservation microfilming is steadily extending beyond the ex post facto sharing of bibliographic data to include the use of common procedures, specifications, and even facilities for preparation and filming, and, in some cases, a coordinated approach to the selection of items to be filmed. A few examples will illustrate the range of possibilities.

For almost three decades, the American Theological Library Association (ATLA) Board of Microtext has used a revolving account and the facilities of both the University of Chicago Library Photoduplication Department and commercial microfilming services to produce microfilm of deteriorating theological serials identified by ATLA members, with sales of duplicates to other members helping to recover the filming costs. In a dramatic expansion of that effort in 1984, dozens of members pledged substantial annual sums to support the filming of commonly held religious monographs published between 1860 and 1905 to replace the brittle volumes.

The Cooperative Preservation Microfilming Project of the Research Libraries Group, which began in 1983, uses a selection strategy which combines the principle of targeting high-priority areas with the expedience of dividing up the task. Thus, focusing on U.S. publications and Americana that appeared between 1870 and 1920, participants concentrate on subject areas matching their particular collection strengths. As an indication of their breadth of coverage (and to emphasize the importance of seeking this type of information), here is a list of subject areas: American poetry; American literature, philology, and language; American regional farm journals; travel accounts, trial literature, and railroad history; philosophy and religion, cultural anthropology, law, and medicine; history of physical sciences; general history, economics, sociology, political science, technology; dime novels; and American history. In late 1986, RLG added a segment focused on East Asian materials (monographs, serials, newspapers) published in China or in Chinese in the period 1880 to 1949.

In 1984, the American Philological Association pioneered yet another multitiered cooperative approach: scholar-specialists in classical studies have been assigning priorities to the most important works within their subject fields published between 1850 and 1918. The works are sought first within the collections of the Columbia University Libraries, whose Preservation Department arranges for preparation and filming using both in-house cameras and commercial microfilming services. Bibliographic records are added to the Research Libraries Information Network.

In July 1984, the State of New York passed legislation authorizing sub-

stantial funds to support preservation of library materials within the state. In fiscal year 1985, the amount appropriated was $1.2 million, but in 1986, this was increased to $2 million, with $350,000 earmarked for cooperative programs among New York State's eleven major research libraries. Nearly all of the proposed cooperative projects involved preservation microfilming of a broad range of brittle research materials. The program is administered by the New York State Library.

What about Optical Disk?

Establishing a preservation microfilming program, with or without such cooperative frameworks, represents a major investment in a technology which some would regard as a temporary stage between the printing press and the computer. Another medium for reformatting, whose potential was being investigated as this manual was being prepared, is the laser-written optical disk in both analog and digital form. The analog form appears suitable for compact storage of pictorial information and sound recordings, while the digital form can "read," store, and reproduce text with great accuracy.

A multiyear optical disk pilot project at the Library of Congress has been investigating the technical, bibliographic, economic, and copyright issues involved in converting materials to this "high-tech" storage and retrieval system. The National Library of Medicine and the National Air and Space Museum of the Smithsonian Institution have mounted smaller research efforts, and the National Archives is planning one. Technical feasibility of the disk for the storage of textual information has been amply demonstrated. However, much remains to be discovered about adequate indexing and access structures, the mechanics of building and using a large "library" of materials on disk, the impact of this technology on current patterns of publishing and information distribution, operational costs, and the permanence of the medium.

Fortunately, the selection and preparation procedures for reformatting are essentially the same whether the storage medium is microfilm or optical disk. At the Library of Congress, staff in the Preservation Microfilming Office prepare materials both for filming and for the disk project. It is possible that materials first captured on high-quality microform can later be transferred to disk. Therefore, the library and archival community can continue to expand preservation microfilming activities without fear that the disk technology, should it prove economically feasible, will render these efforts obsolete. In fact, if institutions have in place well-tested and smoothly operating procedures for selecting and preparing materials for conversion, they will be prepared to take advantage of whatever storage medium provides the best result.

As of this writing, microfilming remains the most reliable method of format conversion for paper-based records and is likely to continue as the most economical for storage of less heavily used materials in the foreseeable future. Consequently, preservation microfilming has become firmly established as an essential component of a comprehensive preservation program. It is part of "the system," not just by fiat but through the dedicated efforts

of a young generation of preservation administrators who have discovered or invented ways to integrate the technical capabilities of the microfilming laboratory with their institutions' existing procedures for selection, processing, bibliographic control, and storage.

Preservation itself is an increasingly multifaceted specialty, each aspect involving its own technical and procedural expertise while at the same time depending upon coordination with all others. As an emerging discipline it has been noteworthy from the start in its emphasis on the necessity for cooperation, the absolute need for coordinating developments both within local institutions and among institutions with comparable collections and needs.

This characteristic is amply demonstrated in the present volume, both in the varied backgrounds and specialties of its contributors and in its numerous references to cooperative projects, joint program developments, and the sharing of information about what is being done. You will discover solid information and thoughtful advice about the several aspects of preservation microfilming and their relationship to other facets of library or archives operations. There are different ways to think about these issues, different ways to approach the creation of solutions to a variety of problems—ways that are not contradictory, but rather valid, necessary, and mutually constructive. Complex problems are seldom met with simple solutions.

If It's That Complicated, Is It Worth It?

It is often much more difficult and lengthy to describe *how* to do something than it is to do it. Try writing instructions on how to shift gears in a standard transmission car for someone who has never driven, for example; or think about the manual that comes with a washing machine or stereo system.

Learning any new set of skills requires time, patience, and attention, and it is certainly easier to master them if one has a human teacher to demonstrate, guide, and correct. I would not like to ride with someone who learned to drive solely from a book, and I would be uneasy consigning irreplaceable documents to a preservation microfilming operation set up solely on the basis of information in this or any other book. But I use the car manual to show me how to drive my new car, and refer to it when a dashboard light goes on that I cannot interpret, or to tell me where to place the jack when my tire goes flat. And I would use this manual in the same way: to set the stage, to find references to other informants, and to guide me if something goes wrong.

This manual attempts for the first time to codify and present the variety of technical, procedural, and administrative issues that have been found by experience to be essential to the establishment of a successful preservation microfilming program—a program which must select things intelligently, prepare them physically so they can be copied, produce legible long-lasting film, and make its existence known so that the intended beneficiaries of all that effort, the patrons of libraries and archives now and in generations to come, can actually find and use the material.

Those who first conceived of this manual hoped that it "would have a significant impact on the quality and efficiency of current filming work and

would facilitate the establishment of new filming programs."[4] That more—much more—filming must be done soon if we are not to lose large portions of our intellectual heritage is certain. It is clear that, as the endangered materials documenting that heritage are distributed among libraries and archives throughout the country (indeed, the world), so the efforts to preserve them must be distributed.

No single institutional or governmental program could begin to handle everything, but individual institutions need not reinvent the wheel. Adapting procedures developed by others is much faster and safer. In the case of published materials, work done in one place need not be duplicated in another. Pooling efforts by sharing filming facilities, dividing responsibility for filming commonly held materials, and collaborating on improvement and refinement of procedures will make the inevitably "too-few" dollars stretch to encompass more of the task.

Getting into this business, then, is not for those who prefer to work in isolation or eschew professional meetings and reading. The Association of Research Libraries, the National Preservation Program Office of the Library of Congress, the Preservation Microfilming Committee, and other preservation sections and groups within the American Library Association, the Society of American Archivists, as well as a growing list of consortia, networks, and regional programs are active both in planning and supporting new preservation microfilming developments and in sharing information with their respective constituencies. Make sure your office is on the appropriate mailing lists, because after you finish reading this book, you will want to know what's happened since it went to press.

4. Shirley Echelman, letter to James Morris, August 5, 1983.

1

An Overview of Administrative Decisions

The attics and basements of many libraries and archives are treasure troves of unused furniture and forgotten equipment. Were you to sleuth in those quarters today, you might come across a planetary 35mm microfilm camera, the purpose of which is long forgotten. Most likely it was used to film newspapers as part of a cooperative activity, or to film rare, noncirculating materials for use by offsite patrons. The last staff member who knew how the camera worked probably retired years ago. Now that your institution has become aware of the large number of deteriorating volumes on its shelves, or that the space taken up by archival records is running out, interest in the camera has revived. If it only could be made productive again, perhaps it could solve all your institution's preservation problems. How do you find out?

Consulting a local microfilming service, you learn that the camera, admittedly an important tool in preservation microfilming, is only a small part of a complex procedure to transfer the contents of books and documents to film. Immediately, questions arise: Which materials are to be filmed first? Have these volumes or documents already been preserved on film? How does one identify the materials on the film? How should they be prepared for filming? Should they be preserved on film or fiche? The consultant mentions standards, specifications, and quality control. What standards should be followed and how? What about access to the film? Should the paper copy be preserved? How do you decide? You will have to answer all these questions and more, if a filming program is to be successful. This manual is designed to give guidance to the librarian or archivist in the planning and implementing of a preservation microfilming program, whether it is local or part of a national or regional cooperative project.

Purposes and Definitions

The primary purpose of preservation microfilming is to provide replacements for materials written or printed on paper of poor quality, most likely that has already become brittle, so that the contents will continue to be avail-

able to the scholarly and research community in the future. But microfilming is also a way of increasing access to library and archival materials by providing film copies for offsite users. It can also reduce the space required to house large archival or serial collections and protect valuable, fragile, or unique books, journals, and documents from unnecessary handling.

Preservation microfilming is the process of recording in facsimile on photographic film, reduced so as to require optical assistance to be read, the intellectual content (the written or printed matter and illustrations) of archival and library materials, following the standards and specifications necessary to provide optimal bibliographic and technical quality. These specifications include preparation of materials prior to filming, processing of the microfilm, and storage.

Almost any item found in a library or archives may be reproduced on microfilm, but generally they are those printed on paper: for example, books, serials, newspapers, photographs, and historical records. Some nonpaper materials, such as lantern slides and photographic negatives, are also appropriate for microfilm. Libraries and archives have somewhat different preservation problems. Printed materials in libraries are usually not unique, but one of a set of identical, or mostly identical, items which are often found in many libraries. They have complex bibliographic histories. They are issued, reissued, edited, reprinted, or republished with minor or major changes. Archival repositories, on the other hand, are holders of unique materials, often large complex collections that have to be internally organized for use and made available to patrons at distant locations. At the same time, many libraries do house archival materials, and some archival repositories own books. The two types of repositories may have differing needs for filming programs, but the basic filming procedures are the same. Materials must be prepared, filmed according to standards, stored, and provided with a means of access.

Current practice for preservation microfilming is to photograph materials on 16 or 35 millimeter roll film, or on 105 millimeter microfiche, or on microfilm inserted into microfiche jackets. All film is black and white, since there is no accepted standard for color at present. Assuming the original document has black letters on a light background, the image is created on negative polarity (white letters on black background) silver-gelatin film. (It is also possible to film a negative-appearing document, which will result in a positive-appearing master.) This camera master (the original camera film, also known as the *preservation master negative* or first-generation film) is duplicated once to create a negative polarity *printing master* (also second-generation film or duplicate negative) on silver-gelatin film, which is used to make positive (black letters on white background) duplicate copies for the institution's clientele. These *service copies* (also known as use, or distribution, copies) may be on silver, diazo, or vesicular film.

As a cost-saving measure, some institutions postpone production of a printing master until a request is received for a copy of the film, especially if the material being filmed is particularly esoteric or unlikely to be in heavy demand. The preservation master negative is stored offsite under proper se-

curity and environmental conditions; the printing master is used to produce duplicates on demand, and the service copy is available for scholarly use. By sending records of titles filmed to the Library of Congress for inclusion in the National Union Catalog and entering them into one of the large computerized shared cataloging databases, both institutions and researchers nationwide are informed that a book or set of papers has been filmed, and that copies of that film are available through purchase or interlibrary loan.

The Deterioration of Paper

Library and archival repositories house the historical and intellectual record of human progress, both the original sources for scholarship and the production of past scholarly work. The primary purpose of housing these materials is to preserve their contents—the text and illustrations—and to make them available to current and future scholars. For a subset of those materials, their aesthetic and physical attributes equal or surpass their intellectual contents in value. The great majority of that record is either written or printed on paper, which, as an organic substance, deteriorates over time. Some papers made before the mid-nineteenth century deteriorate more slowly than modern paper. Early hand paper-making techniques and the use of alkaline materials contributed to the longevity of paper; contemporary acidic components and high-speed machine techniques set the stage for rapid deterioration. The industrial revolution of the nineteenth century provided the machines, and the spread of literacy the impetus, for inexpensive mass-produced paper which, in its acid content, bears the seed of its own destruction.

Library and archival repositories have also had a role in the deterioration of paper. Paper deteriorates much more quickly when housed under poor environmental conditions. All too often, libraries and archives have provided environments that are too hot, too dry, too wet, or too changeable; they harbor high ultraviolet light levels and are polluted with sulphur dioxide, ozone, and other chemicals, as well as dust, smoke, and other particulate substances. These problems, at least partially correctable for the future, cannot now be rectified for the past.

The bulk of the collections of most libraries and archives was written or printed after 1850. Materials from earlier periods may be well-protected in rare book collections, but the later ones are often accessible in open stacks. Therefore, the number of items, combined with the generally poor paper and environmental conditions, have made the problem of preserving the historical and intellectual record one of crisis proportions. In some large research libraries, surveys show that over one-third of the collections are printed on paper that has become so brittle as to be unusable.[1]

1. Sarah Buchanan and Sandra Coleman, *Deterioration Survey of the Stanford University Libraries Green Library Stack Collection* (Stanford, Calif.: Stanford University Libraries, 1979) and Gay Walker et al., "The Yale Survey: A Large-Scale Study of Book Deterioration in the Yale University Library," *College and Research Libraries* 46:111–32 (1985).

This problem has not gone unnoticed, especially among scholarly publishers, thanks to recent efforts to highlight the issue on the part of the Council on Library Resources, Inc., government agencies such as the National Historical Publications and Records Commission, and academic librarians. A number of paper manufacturers now produce alkaline papers, and there is growing evidence that publishers and printers are attempting to follow the new standard, *Permanence of Paper for Printed Library Materials*, published in 1985 by the American National Standards Institute.[2] While these efforts may help to mitigate the problem for the future, much of the paper used for printing today will deteriorate in less than fifty years.

Physical Treatment vs. Microform Replacement

Reasonably inexpensive physical treatments do not yet exist to restore brittle paper to its original suppleness and strength. Nor are such treatments likely to appear soon. All current techniques involve handling materials a leaf at a time, whether a book or manuscript, and thus are time-consuming and labor-intensive. Therefore, physical treatment is usually reserved for rare or unique materials with artifactual value—for example, those that exemplify specific types of printing.

Deacidification will improve some paper slightly and arrest further acidic deterioration, but this process will not strengthen most papers. The mass deacidification techniques under development by the Library of Congress and in use at the Public Archives of Canada will delay greatly future acid deterioration of books and journals that contain paper that is still flexible. If it is not necessary to retain a volume in its original form, another option is available. Some libraries create a "preservation photocopy" of items that receive heavy local use. A preservation photocopy is a photocopy made with acid-free paper on a machine that produces a thermoplastic image by heat and pressure fusing through electrostatic charges. The pages are then bound, using acid-free materials.[3]

Restoring a volume to its original form, deacidification, and preservation photocopying will ensure that many titles will remain available to future readers for a much longer time. These techniques have a great benefit for local users by keeping hard copies of books on library shelves. But the institution that also employs preservation microfilming will be able to provide inexpensive, usable duplicates to many other institutions and users and thereby assist in alleviating the problem that affects all. If the bulk of materials in our collections are to remain available for the future, microfilming is currently our best preservation solution.

For archives, the choices are more narrow. If a document is not to be

2. *American National Standard for Information Sciences—Permanence of Paper for Printed Library Materials,* ANSI Z39.48-1984 (New York: American National Standards Institute, 1985).

3. Guidelines for preservation photocopying and a discussion of appropriate equipment may be found in Gay Walker, "Preserving the Intellectual Content of Deteriorated Library Materials," in *The Preservation Challenge: A Guide to Conserving Library Materials* by Carolyn Clark Morrow (White Plains, N.Y.: Knowledge Industry, 1983), pp. 103–105.

treated and retained in its original form, preservation microfilming may be the only way to create a substitute that will retain its legal significance—that is, that will stand up in court.

Microform Characteristics

Microforms have many functions within a library or archives.[4] For example, they are used extensively to save space in library stack areas, replacing the paper copy of extensive, little-used newspaper and journal files. Both libraries and archives also provide microform to researchers for the most rare and fragile items, thus providing security and preservation by reducing handling of the original paper copy. Microforms produced by commercial micropublishers, libraries, and other nonprofit organizations provide remote access to large collections, as well as to unique or rare materials. Many research libraries produce microfilm instead of loaning some items to offsite users, and most larger archives do this routinely. Libraries also provide access to their own collections through microfiche or computer output microfilm (COM) copies of card catalogs and use microforms to provide security for card files and for other routine records management purposes.

Microforms have been used extensively as a means of building retrospective collections. Many volumes long out of print are available in microformat. Micropublishers are able to bring together large collections of materials located in many repositories. Universal access to unique documents housed in historical and personal archives is now possible through microform. Often, business records are routinely kept only in microform, and many archives house cabinets full of rolls of film or drawers of microfiche that are themselves primary source documents.

Silver-gelatin microfilm is a medium with several advantages. It can be more durable than most of the paper on which library materials are printed or written. If produced properly, handled carefully, stored under ideal conditions, and inspected regularly, the preservation master negative should last many years. If it begins to deteriorate for any reason, which can be caught early through regular inspection, the negative can be duplicated to produce a printing master, and therefore has an unlimited life span. Working copies for library users may be on silver-gelatin film, but there is a growing preference for less costly diazo or vesicular films, which are more resistant to scratching (see Chapter 4 for discussion of the properties of these films). Many librarians feel, however, that any microform added to their permanent collections should itself be of archival quality, and only silver-gelatin film stock meets this criterion.

Microfilm stores information in up to 90 percent less space than is required for the corresponding paper copy, and it can be reproduced easily and inexpensively on demand.[5] The 35mm width of most microfilm allows

4. William Saffady, *Micrographics*, 2nd ed. (Littleton, Colo.: Libraries Unlimited, Inc., 1985), pp. 1–20.

5. Pamela W. Darling, "Developing a Preservation Microfilming Program," *Library Journal* 99:2803–9 (1974).

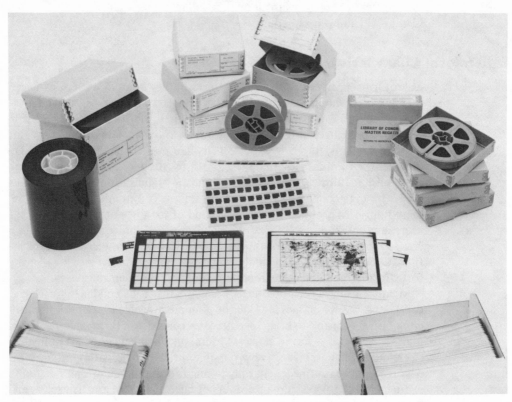

Microforms used in preservation microfilming programs appear in many forms. Starting at upper left and proceeding clockwise: 105mm roll microfilm on core for storage (used to produce microfiche); 35mm roll microfilm service copies (note acid-free string ties); 16mm roll microfilm master negative; single-exposure microfiche for cartographic materials; standard 98-frame 105mm microfiche; jacketed microfilm (in center). At the bottom are microfiche boxes; they and all other boxes are made from acid-free materials. Source: Library of Congress

for a relatively large image at a low reduction ratio (the number of times the microform image is reduced from the original) and can thus accommodate the full range of library materials.[6]

Either roll film or microfiche may be used successfully for preservation microfilming. However, 35mm roll film has predominated in archival and library applications. Institutions have much experience with roll film, and its production is very nearly completely standardized. The lower reduction ratios (often $12 \times -14 \times$), and correspondingly larger images, that can be used on 35mm roll film make it especially attractive to the institution that plans to discard the original volume or document. Roll film also affords more security against loss, especially for serials and multivolume works, since films are not prone to misfiling. Roll film is more subject to wear and tear on a film reader than is microfiche, however.

6. Saffady, *Micrographics,* p. 26.

Microfiche master negatives of archival quality can be produced and stored securely, just like roll film. Because of user preference, there is increasing interest in this format. However, microfiche production is in a transitional state. Microfiche generally employs higher reduction ratios, and although a 24× reduction ratio is commonly found, there is still a great variety of ratios employed by different filming agents, generally based on economic reasons rather than on the optimum in image quality. New kinds of cameras at deescalating prices are slowly coming on the market, and increased experimentation is adding to the body of experience available. It still seems that microfiche are more expensive than roll film for most institutions and laboratories to produce, since for the most part it requires more expensive equipment and additional labor costs to plan and lay out. But microfiche readers are easier to operate and usually less expensive than roll film readers and reader/printers. The eye-legible titles allow for quick retrieval of individual works. In general, microfiche seem more "friendly."

Aside from production considerations, the end use of the microform can influence the choice of format. Microfiche can be used successfully to reproduce pamphlets and monographs that will be heavily used; roll film is more appropriate for serials, manuscripts, multivolume works, and low-use items. Reference books may more properly be transferred to fiche because it provides easier access to brief information.[7]

No matter which types of microforms are chosen, they are not a perfect replacement medium. They cannot reproduce the intellectual and historical information embedded in the physical characteristics of the volume: the watermark and chain lines, sewing techniques, binding materials, seals or other three-dimensional aspects of the work, the printing impression, or colored illustrations and maps. Microforms are not as flexible and easily used as a book. The optical equipment available to read and duplicate microforms in most libraries is often not the state of the art, not well-maintained, and difficult to use. Trained staff members may be unavailable to give assistance. The films and fiche may be of poor quality or scratched from overuse and therefore difficult to read. There is user resistance because microforms usually do not circulate and can only be used when the library is open. Microforms can neither reproduce color permanently nor reproduce the detail of halftone photographic illustrations unless special films are used. Microforms do not allow annotation in the margins, and it is almost impossible to compare several items at one time.

Despite these drawbacks, microform is the most appropriate medium for many of the materials held in libraries and archives that must be preserved. It is a long-lived, accepted technology, and its handling, cataloging, and storage are routine in most libraries and larger archives. The use of microforms in business for records management has made them familiar to most

7. See Francis Spreitzer, ed., *Microforms in Libraries* (Chicago: American Library Association, 1985), pp. 1–2, and Roger S. Bagnall and Carolyn L. Harris, "Involving Scholars in Preservation Decisions: The Case of the Classicists," *Journal of Academic Librarianship* 13: 140–46 (July 1987), for further discussion of advantages and disadvantages of microfiche and film. See *Microform Guidelines* (Washington, D.C.: National Historical Publications and Records Commission, 1986), p. 12, for a discussion of this choice relevant to archival materials.

people, and user resistance has declined. Preservation is perhaps the ideal function for microforms in libraries because the items preserved are usually low-use items; they may only be used once over many years, or only by patrons needing access at a distance. Scholars who have tried to use books or documents so brittle that the leaves break when they are turned, and who understand the concept of artifactual value, usually find microforms an acceptable substitute.

Microfilming within a Preservation Program

Even with all their good qualities, microforms are not appropriate for certain materials, and the microfilming process itself can cause severe damage if the items to be filmed are especially fragile. Microfilming is only one option and must be used in the context of a complete preservation program appropriate to the local collection.

The preservation program should include prospective preservation as well as retrospective repair. Prospective preservation, or preventing the future deterioration of materials as much as is possible, includes providing a proper environment, sensitive care and handling procedures, training and education for staff and users in preservation attitudes, and disaster preparedness and recovery. To obtain the proper environment requires attention to temperature, relative humidity, light levels, air purity, and storage techniques. Retrospective preservation focuses on the physical treatment of materials on paper that is still flexible and may include paper repair and rebinding, polyester encapsulation for brittle materials inappropriate for microfilming, and professional conservator services for valuable and rare items, in addition to the replacement of brittle materials by microfilm or other means (see Chapter 2 for preservation treatment options).[8]

Program Planning

Implementing a preservation microfilming program is not a decision to be taken lightly. Microfilming is a technical photographic field, and the prefilming and postfilming processes are complex. Nor should the decision to implement a program be made in isolation, without the knowledge of preservation microfilming projects and priorities undertaken by other libraries, archives, and commercial micropublishers. Microfilming is one function where avoiding duplication has an immediate cost benefit. It is much less expensive to purchase a copy of a film than to produce an original. If institutions with filming programs take care not to duplicate efforts either among themselves or with responsible commercial vendors, preservation dollars can be stretched much further.

The first step in making a decision is usually to survey a collection to determine whether microfilming is necessary to preserve brittle or poor-paper

8. See Morrow, *The Preservation Challenge* for a description of a complete preservation program.

materials that may otherwise be lost, or to provide security, use, or remote access duplicates.[9] A survey should include reviews of the condition of the collection and of the current availability of replacements for the deteriorated books found. An analysis of preservation microfilming projects is necessary to prevent duplicate work. This is not an easy task; the information is not available in one convenient place. Micropublishers issue separate catalogs of available collections or titles. The *National Register of Microform Masters,* the *National Union Catalog: Books,* and *Guide to Microforms in Print* also list individual titles. Library and micrographics journals carry news items on grants awarded and new projects. Finally, specialists in a specific subject field will often know of projects completed or under way. (See Chapter 2 for details of the search process and Chapters 2 and 5 for a discussion of the relevant bibliographic tools and problems of bibliographic control.)

Suppose that most of the deteriorated volumes or documents in your collection are obsolete and may be withdrawn, or that replacements, on paper or film, are available for most titles, or you discover major preservation projects are already under way in the chosen subject field. It may be wiser to consider whether your institution could contribute its materials to another project and simply purchase film copies as needed, rather than go to the expense of setting up a local microfilming program.

For example, many libraries have collections of nineteenth-century American language and literature, much of which may be brittle. Because this is a subject which has had a significant amount of attention for preservation, an examination would reveal that most of the major titles have either been reprinted, are available from commercial micropublishers,[10] or have been filmed by institutions participating in the Research Libraries Group's cooperative preservation microfilming project. Filming the same titles covered by these sources would be a waste of money if good microform copies can be purchased. However, your institution might have a strong collection of regional nineteenth-century American literature, which would not have been included in these other projects and would add depth and richness to the aggregate resources available nationwide.

Planning for a preservation microfilming program is a critical part of the process. Grant funding in recent years has supported a variety of projects, not all of which have been successful. A project will not contribute to the growing national preservation effort if film has been created that does not meet standards for permanence, or if the scholarly community has not been provided adequate or accurate bibliographic information about what has been filmed. If you are informed about the microfilming process, and the

9. See Pamela W. Darling, *Preservation Planning Program* (Washington, D.C.: Association of Research Libraries, Office of Management Studies, 1982) for a planning and survey methodology.

10. Research Publications, Inc., a commercial micropublisher, based the first three parts of its microform collection, *American Fiction, 1774–1910,* on the following works: Lyle Henry Wright, *American Fiction, 1774–1850,* 2nd rev. ed. (San Marino, Calif.: Huntington Library, 1969); *American Fiction, 1851–1875* (San Marino, Calif.: Huntington Library, 1965); and *American Fiction, 1876–1900* (San Marino, Calif.: Huntington Library, 1966).

proper planning is done, the project will serve the purpose for which it was intended.

First, analyze the financial and organizational resources currently available within your institution and determine what should be added. These resources include funding for in-house equipment or outside contracts, to renovate work space, and to fulfill staffing and managerial requirements. Then consider the ongoing maintenance and supply costs. This manual will guide you in generating the information from which to estimate costs. Apart from funding, you must foster a commitment to the program throughout the institution, because other departments must be willing to take on the extra functions that result from a microfilming program.

Participation in cooperative or regional programs requires two levels of planning. First, each local institution must assess its own needs and requirements, as outlined in this manual. Second, the cooperative participants must decide how the program will be administered, whether a single set of specifications will be followed by all participants, how it will be funded, and which institutions will film which materials. Often the last question serves as the stimulus for the cooperative program in the first place. Institutions may decide to cooperate because each has significant holdings in one subject, or in different subjects within a geographic area or network.

Contracting for Services

If most of your needs may be met by a single microfilming project, to be accomplished within a definite time period, you should seriously consider contracting for services outside the institution. The services of a regional preservation center, a commercial micropublishing firm, or a microfilm service bureau would be especially advantageous for a small library or for a specific project. But institutions planning to set up in-house, long-term programs can also increase their resources by using outside filming agents guided by clearly defined contracts. Your first step in contracting for services is to determine what your institution is able and willing to handle internally.

The most frequent use of contracts within a preservation microfilming program is for the filming process itself. But depending on the filming agent and the circumstances of the project, contracts can be used for any or all of the following:

preparation of materials for filming

filming, film processing, technical inspection

testing the film for residual chemicals

storage of master negatives and/or printing masters

dissemination of the completed microforms through sales or other means.

It is generally not wise to contract for the selection of materials to be filmed, since selection is based on intellectual content and use considerations as well as physical characteristics of the candidate volumes. In many cases, the institution must take on the responsibility for preparation of the materials as

well. In all cases, the institution is responsible for establishing the standards that guide the filming agent's work, monitoring the agent's performance, and carrying out the final quality check of the finished product.

Program Design

If your analysis of the materials, the resources, and the organizational commitment shows that preservation microfilming is needed and feasible, the next step is program design. This manual will provide the information needed to design either a long-term program or a specific project. Although the materials in libraries and archival repositories may be different and the size of the project will suggest certain options, the organizational considerations are much the same.

Integrating the elements of a preservation microfilming program into the other functions of the institution is critical to its success. The collection development officers, bibliographers, and curators should be responsible for the decision of what is filmed. They must both understand the subject of the materials and be able to determine their physical condition with the help of specific criteria or a preservation administrator. The materials may be identified as individual items or as a collection, for example, a known and acknowledged strength in a subject. Brittle materials may be identified as they return from circulation by the circulation staff, or as part of an inventory or survey. Archival preparation and processing staff may be responsible, in addition to other duties, for indexing collections to be filmed. The cataloging staff will be responsible for much of the record keeping and for providing local and national bibliographic access to the collection. Public services staff may also identify materials in need of treatment and provide access for users to materials preserved in microform. Representatives of all staff involved with these functions must participate in the planning process. They must understand the need for preservation microfilming and be prepared to meet the increased demands that will be generated to process and service materials.

Each institution will have its own mechanisms to coordinate the planning for a program. You might find it useful to bring together staff from across the institution as a group for education and training if needed, and to present the issues and problems clearly. Program design elements will include establishing criteria for filming, assigning work flow and forms, and writing position descriptions. While you may develop these elements, the wider group must consider the implications for each function. By involving all interested parties in the planning process, you will build an effective institutional commitment to the program.

If your institution has a reprographic laboratory or photographic services department, integrating preservation microfilming into its other functions is a logical course. The reprographic laboratory may already microfilm items on demand for offsite users, as well as prepare photocopies and photographs. These operations are functionally similar in many ways to preservation microfilming, and it makes sense to administer them together. A reprographic laboratory involves different kinds of administrative issues, however, including pricing, handling orders and invoices, maintaining

equipment for functions other than preservation microfilming, and public service responsibilities.[11]

The following is a description of the administrative decisions necessary to planning and implementing each step of the process of preservation microfilming. Detailed descriptions of each step and its prescribed components are covered in the individual chapters of this manual.

Managing a Preservation Microfilming Program

Before looking at each element of the program, consider its overall management. A professional staff member (curator, librarian, or archivist) should manage the program. The staff member should have some familiarity with preservation techniques, microfilming technology, and library or archival procedures, and demonstrate good managerial skills. Ideally, a trained preservation administrator should be hired to plan and implement the program, but if that is not possible, an internal staff member can be given the responsibility. A willingness to learn, a flexible personality, and an ability to understand and work with all levels of staff and all functions within the institution are characteristics required of the successful program manager.

There are two functional aspects to the preservation microfilming process—the technical and the nontechnical. The nontechnical involves the pre- and postfilming procedures. These are primarily preservation activities: coordination of functions, materials preparation, and bibliographic control. The technical covers the camera work, developing and duplicating the film, and quality control.

Any program that includes an in-house microfilming laboratory should hire a technically trained person to supervise it. This person should be familiar with microfilming and photographic techniques and have both mechanical abilities and supervisory skills. Even if the program consists of only one camera and camera operator, the operator should be able to understand photographic processes and make minor repairs to the camera. Experienced laboratory managers willing to work for nonprofessional salaries are scarce. A photographer, with the ability and willingness to learn, would be a good choice if an experienced manager is not available. The laboratory manager should understand and implement the standards and specifications for archival quality filming and have an understanding of the need for the highest quality product. Staff from commercial microfilm vendors may be available and competent to do the job, but often will have to be trained in what it takes to film documents according to archival specifications.

The pre- and postfilming aspects of the process should be coordinated by a librarian or archivist familiar with preservation techniques and issues, as well as bibliographic control. This person should have supervisory skills,

11. Two publications cover reprographic services: Carolyn H. Sung, *Archives and Manuscripts: Reprography* (Chicago: Society of American Archivists, 1982) and Charles LaHood and Robert Sullivan, *Reprographic Services in Libraries: Organization and Administration,* LTP Publication no. 19 (Chicago: American Library Association, 1975).

since much of the routine work can be done by support staff, student assistants, or volunteers. The work of a preservation microfilming program ranges from the routine of pushing the button to take the picture, bibliographic searching, and collating materials to see if any parts are missing, to the highly sophisticated coordination of several departmental functions or the development and monitoring of external contracts.

There are four distinct elements of the microfilming program: (1) selection and identification of materials; (2) preparation; (3) filming; (4) access and bibliographic control. You may think of the first two as prefilming processes, while the last—providing access and bibliographic control—is a postfilming process. Although each element is distinct, they are interrelated. Decisions made in each area affect the others.

Selection and Identification

The most important aspect of the preservation microfilming program is the identification and selection of the materials to be preserved. No matter how well the process is implemented, if materials that should be preserved are lost, or unimportant or inappropriate materials preserved, nothing has been accomplished. This is a difficult decision. The directions of future scholarship are hard to predict, which makes it almost impossible to consign any item held in our collections to the dust bin. One way of approaching the process is to raise a series of questions.

1. *What materials are important for preservation?*

 The curators, archivists, subject specialists, and other collection development and management staff are the appropriate persons to decide what should be preserved and in what order. These staff members should understand the strengths and importance of various collections, both as collections and in their individual components. Systematic identification and selection for preservation should be integrated into the management of an archival or library collection.

 As detailed in Chapter 2, criteria for selection include current use by scholars and importance to future scholarship. Materials can be identified item by item or as a collection. In a collection, each item may not by itself be valuable to preserve, but the collection as a whole may represent the breadth of thought or the publishing record of a specific subject or a time period.

2. *What materials are most in danger of loss?*

 There are many items in library and archives collections that will need systematic preservation over the next few years; it is only appropriate that those in the most deteriorated condition be preserved first.

3. *Is microfilming the most appropriate technique?*

 The curators and collection development staff should understand all of the preservation options available. It often is the responsibility of the preservation officer or microfilming project manager to make the options clear. Chapter 2 includes a description of the options and the materials for which they are most appropriate.

4. *Have the materials already been preserved?*

Before you make a decision to microfilm a volume in a library program, it is important to know that a suitable replacement for it does not already exist. The volume may have been reprinted in paper copy, published in microform by a micropublisher, or filmed by another library. Because of user resistance to microforms, libraries usually consider paper replacement first. Another edition, a reprint, a facsimile, or a preservation photocopy of the title is usually preferable and often less expensive to acquire or produce than it is to film. The paper replacement will itself deteriorate over time, but the original item may be deferred as a potential candidate for filming.

If the preservation option of choice is microfilming, it must be ascertained that the volume is not already available in microform. This requires a search of bibliographic tools, both printed and online databases. Because a significant amount of filming and micropublishing has been accomplished, this search is required to prevent duplicate filming. If the exact edition of a title is found to have been filmed by a reputable source through this search, it can be considered preserved. If the item is important to meet local needs, a copy of the microform can be purchased. Only when no acceptable replacement exists should an item be considered for preservation microfilming. The searching process is described in Chapter 2.

5. *How will the procedures to select and identify materials be organized within the institution?*

The identification and selection processes in a preservation microfilming project are usually absorbed by existing professional staff. The existing staff has the necessary expertise to make the informed decisions and must allocate the additional time to do so. They may determine the priorities among collections, or review materials on an item-by-item basis.

The searching process may be assigned to support staff. Usually one searcher and preparer can support the full-time operation of one camera. Costs can be controlled by limiting the tools searched, especially if you find after some experience that your category of materials is not covered by certain catalogs. Unique collections may be filmed without searching. Space must be considered: after materials are selected they must be housed while awaiting preparation and filming. As described in Chapter 2, forms will have to be designed, and records kept.

6. *Is the material protected under the copyright law?*

Another important consideration in selection is the copyright issue. You should make every effort to observe the copyright law. Determine before filming whether the title is still under copyright. Materials in the public domain can be filmed even if they have been reprinted by another publisher. However, the original, not the reprint, should be filmed. If the materials are still under copyright, an attempt should be made to contact the copyright holder if you plan to create more than the one copy allowed for preservation or for scholarly use. This is especially true if you plan to package a set of titles for sale as a collection.

Archival and manuscript materials create special copyright problems. If permission to film cannot be obtained from the copyright holder, or even if the permission is obtained, it is often best to provide access to the film only onsite, or through controlled access that prevents further copying or duplicating of the film.

For either published or nonpublished materials, a copyright statement indicating the users' responsibilities for observing the copyright law should be included on the film of books, journals, or documents that are likely to be protected under the law. See Chapter 2 for more details on the copyright issue.

Preparation of Materials

After identification and selection, the materials must be prepared for filming. Many of the decisions made in the identification and selection process affect the preparation of volumes. For example, materials are treated quite differently if they are to be withdrawn after filming than if they are to be retained. Preparation of materials is a production-oriented task. The work flow must be carefully coordinated to meet the needs and expectations of the filming agent. The responsibilities of both the preparations staff and the filming agent must be spelled out and understood by each if the process is to proceed smoothly and to result in a high-quality film. Chapter 3 describes the process of planning production, the relationships between preparation of materials and the filming process, and the tasks involved in preparing volumes and documents to "go under the camera."

The major steps and issues in each of the elements of preparation are as follows:

1. Collation

 Collation is the process of examining materials to determine if they are complete and in order.

 a. *Are the materials complete?*

 Most materials require a page-by-page collation to determine if all sections of the item are present. This is important in serials or books that are in such poor physical condition that the leaves are breaking away from the text block.

 b. *If not, is this the best copy available?*

 To ensure that the best and most complete copy is filmed, most program administrators will complete a copy by requesting photocopies of missing pages, or will borrow another more complete copy from another institution to film it. Of course, the permission of the owning institution should be secured first. In many cases no other copy will exist, and the incomplete copy will be the best available. In archives, the materials are normally unique and therefore the only copies. However, an archives may want to complete a microform project by requesting that another archives film a complementary collection, such as the other half of a correspondence, for example.

 c. *Are the materials in order?*

A preparations clerk must page carefully through a brittle volume to uncover any flaws. Source: Library of Congress

Again, the materials should be in correct order for filming. This may require removing the binding of a volume and rearranging the pages or special notification in the film to indicate where pages can be found, if they are deliberately placed out of order.

2. Physical preparation

The materials must be prepared in a way that will make possible the highest quality filming.

a. *Will the materials be retained after filming?*

If the materials have artifactual value, they will be retained after filming. Retention after filming dictates that the microfilming agent must understand the need for care of the materials and be able to film bound volumes in a book cradle.

b. *If not, how should the materials be disbound?*

Disbinding materials before filming results in optimal quality film, since most cameras are set up to film separate sheets, no shadow will appear on the film from an inner margin, and gutter distortion is avoided. The text block may be cut away from its binding and the spine cut off by a mechanical device known as a guillotine. This has to be done with great care to prevent cutting either into the text in the inner margin or into material folded into the book.

c. *What parts of the collection should be filmed, and are all the materials free of paper clips and other objects that will disrupt filming?*

Archival collections are often filled with paper clips, staples, and other objects, although these items can also be found in library materials. Often, the physical preparation is the most time-consuming part of the microfilming process in archives; the filmer should not have to stop and remove extraneous items from the materials. Decisions are required on such issues as: should the archival folders also be filmed? Should blank pages be filmed? Should pages be numbered to be sure they are in proper order and can be matched to an indexing tool? Should book bindings and end sheets be filmed?

d. *Does the material require repair?*

Material selected for filming may require repair on further examination. If the volume is to be discarded, efficient minor repairs can be made without resorting to archival techniques. If the item is to be retained, or if the repairs are extensive or difficult, a reevaluation of the item is required.

3. Target Preparation

Targets must be prepared to identify the materials on the film. Targets are sheets of information filmed along with the item to identify the materials on the film, to identify any features of the original that may be confusing to a user, to identify the filming agent, the date filmed, and the project under which the materials are being filmed, to inform the user where materials are on the film, to provide record control numbers, and to provide technical information necessary to determine the quality of the film. Some targets should be eye legible, that is, readable without optical equipment. The filming agent must understand the routine requirements and be instructed in any special features for a specific item. This process is further discussed in Chapter 3.

a. *Have appropriate targets been prepared?*

Does the bibliographic record match the material to be filmed (for example, the *exact* edition)?

Are all routine targets prepared and ready for insertion?

Do the targets account for anomalies in the materials?

Are the proper control numbers assigned?

b. *Will the filming agent use the proper bibliographic targets at the beginning and end of each reel and also the appropriate technical targets?*

c. *Does the agent understand where to insert special targets indicating anomalies of the text?*

Preparation of materials for microfilming must be carefully thought out and implemented for each filming project and item. The processes are often routine, but they are so important that staff should be well-trained and closely supervised. If the materials are improperly identified, they could be

Eye-legible targets can be created in many ways. Left, a computerized photo typesetter; right, one type of hand-lettering system (others produce larger letters for film exposed at higher reduction). Sources: left, Library of Congress; right, Northeast Document Conservation Center

lost for all practical purposes; inattentive preparation routines could damage fragile volumes.

The costs of preparation may be minimal if students, volunteers, and other support staff are used for this step. Costs can be controlled by not collating certain kinds of materials; in this case, the filming agent should be instructed on what to do if missing pages are discovered. One alternative is to leave a blank space on the film so that copies of the pages can be retrieved after the fact, filmed, and spliced into place. Another is to insert a target stating that missing material may be found at the end of the reel, if located at a later time. Creating standard photocopied target sequences for most volumes will also cut costs. There are various techniques for creating targets, from a simple drafting table and Leroy lettering system to a computer-driven printing machine or microcomputer.[12]

Filming

Filming is the actual process of recording on film the targets and documents to be preserved. It involves the photographic processes of camera work, film developing, and duplicating. Preservation microfilming is exacting work and should be performed following the standards necessary to produce the highest quality film possible. Quality control is an important part of the filming process. Chapter 4 discusses the standards and practices that undergird the production of archival-quality microforms.

1. *What agent should do the filming?*

12. See Chapter 3, footnote 3.

Microfilm is inspected on a microfilm reader to ensure bibliographic integrity and readability. Source: Library of Congress

A major decision for the administrators of a microfilming project is what filming agent to use. The filming agent may be a section of a preservation department, as it is in a few large research libraries, a photoduplication unit of the library or archives or of its parent body, or a microform vendor. The vendor may be a microfilm service bureau, a commercial micropublisher, or a nonprofit preservation center.

An in-house facility that is currently in operation and has the capacity to expand into preservation filming is an obvious choice for a filming agent. The in-house facility staff must be both *willing* to meet the standards (as set out in Chapter 4) and *capable* of their achievement. If no internal filming operation exists, creating one is an option. Setting up a facility involves a considerable expense in space, equipment, technical staff, and overhead. Supplies and their storage, plumbing and electrical renovations, maintenance of equipment, and energy requirements should be considered. However, an in-house facility may provide more control of quality and assurance that standards and specifications are met. There is also a higher level of involvement between the filming staff and those performing pre- and

postfilming procedures. Rare, unique, and valuable materials will not have to be transported outside of the repository if an in-house facility exists.

For special preservation microfilming projects, or for long-term programs in either a small repository with few resources or space or a larger institution that does not have the desire to set up an in-house facility, the decision to use an outside filming agent is appropriate. In fact, almost any institution that is beginning its first microfilming operation will most likely accomplish more, more quickly, if a satisfactory vendor can be found. See Appendix 2 for a sample contract.

2. *What standards and specifications should be followed?*

National standards produced by such organizations as the American National Standards Institute and the Association for Information and Image Management provide the basis for preservation microfilming projects, but they do not cover all aspects of a program. They must be adapted to the needs of the specific project and additional guidelines developed. Fortunately, there are model specifications to consider; these are discussed in Chapters 3 and 4.

3. *How many film copies are required?*

The number of copies needed depends on whether you are planning to microfilm materials that are in heavy demand or are rescuing materials that are unlikely to receive frequent use. At a minimum, the preservation master negative and a service copy should be made at the time the film is created, but a printing master will also be required when you receive requests for copies.

4. *Has optimal quality film been produced? What is the role of the filming agent, and of the archives or library, in quality control?*

Quality control involves both technical and bibliographic considerations. The filming agent should perform appropriate technical tests and inspection routines. But the repository should also expect to monitor the filming agent's work by inspecting films as they return. Chapters 3 and 4 provide details of the repository's role in inspection.

5. *Where will the completed film, both master negatives and service copies, be stored? How will they be housed?*

Few libraries or archives have film vaults that meet archival storage requirements. New construction may not be possible. Offsite storage of master negatives in a leased commercial facility that meets archival standards is an option chosen by a number of institutions. Attention must be paid to the quality of reels, film boxes, envelopes, and cabinets to ensure the longevity of microforms.

Access and Bibliographic Control

Access both to the film itself and to the information that a title has been preserved is crucial to an effective program. If scholars cannot determine that the item exists, their work may be impaired; if other preservation microfilming programs are not able to identify what has already been preserved, re-

sources may be wasted in duplicate effort. Access has two factors: internal local access and external national access. Chapter 5 details the routines required to assure that microforms, once created, are not lost.

1. *How will local access be provided?*

 Internal access is a function of local organization. In most cases a service copy of the microfilm will be provided for local use and the existing catalog records either updated or converted into an online system. Often a catalog of records for master negatives that have been produced is kept in a separate file for internal control. In archives, inventory records should be revised to show that film is available.

 The catalog departments or processing units will have the expertise and tools to provide the proper bibliographic records for the film. Institutional priorities may have to be set also, so that the film does not end up in a local arrearage, but gets processed routinely with other materials. This requires good interrelations between institutional units.

2. *How will off-site access be provided?*

 One of the purposes of preservation microfilming is to provide inexpensive copies of the items to scholars. A mechanism for duplicating film on a scholar's demand, either in-house or through a filming vendor, should be established.

 Access to the information that an item has been filmed must be accomplished through reporting to a national database. The record must be forwarded to the Library of Congress for publication in the *National Union Catalog,* itself available only on microfiche.[13] If your institution uses a national shared cataloging database, such as OCLC, the Online Computer Library Center, or RLIN, the Research Libraries Information Network of the Research Libraries Group, the record should also be entered there.

 Cataloging conventions have been written for microforms in the *Anglo-American Cataloguing Rules,* as interpreted by the Library of Congress.[14] Libraries and archives must decide on the degree to which they will revise existing catalog records to meet these conventions. Most often a record for a published item will already exist in the local catalog, although the record may not meet current standards. Some institutions simply transfer the information in that record into a na-

13. From 1965 to 1983, the Library of Congress published records for master negatives produced by nonprofit and commercial vendors in the *National Register of Microform Masters,* an annual book catalog with cumulations for certain periods. Since 1984, records for microforms of monographs appear in the *National Union Catalog: Books,* published by the Library of Congress in microfiche. As of this writing, the library has not begun routinely to publish records for microforms of serials, although it plans for them to appear in its publication *New Serials Titles,* which will probably be renamed. However, institutions and commercial vendors are still encouraged to send reports of titles filmed, addressed to the *National Register of Microform Masters,* Library of Congress, Washington, DC 20540.

14. See Chapter 5 for details.

tional database, adding the proper coding in the relevant USMARC communications format (e.g., Books, Serials, Maps, etc.) along with the appropriate microform information. This may meet certain minimal requirements, but in the long run it is the least acceptable practice for retrospective conversion of records. The local decision should normally be to improve, or upgrade, at least the heading of the record to meet current standards. Decisions on bibliographic standards have cost implications for the local institution. If the paper copy of the filmed item is retained, a record for that copy may also need to be contributed to a national database, if it does not already exist. In archives, this would almost always be the case, of course.

Each of the foregoing elements of the preservation microfilming process is essential to its success. The selection must be informed, the materials prepared properly and filmed to standards, and access provided, both locally and nationally. The processes are complex and labor-intensive, but easily accomplished in an archives or library environment.

Record Keeping and Statistics

Records and statistics are useful to track progress and monitor activity in preservation microfilming programs. There is no standardization as to which statistics to keep or in what form. But at a minimum, statistics should include the number of titles or documents filmed, the number of volumes filmed, and the number of exposures produced, either annually or in a specific project. It may also be useful to know the number of reels produced and the number of feet of duplicate film produced. Production work may also be counted, such as the number of titles searched, collated, and prepared, in order to increase production and control preparation time.

When volumes or documents enter the preservation microfilming stream, they are removed from active use. You must keep records to locate items that may be requested before filming is completed and to ensure against loss. The amount of record keeping depends on the complexities and size of the operation.

At a minimum, the volumes or documents to be filmed must be controlled: materials are usually logged into the process; a system is set up for identification of materials while in the filming laboratory or in the hands of a vendor; the materials are logged out after completion. Other record-keeping devices may include:

recommendation, review, and searching forms
circulation records (i.e., titles are charged out to the preservation unit)
a distinct catalog of completed films
quality control forms.

Other forms and instruction sheets will depend on whether filming is performed in-house or outside the institution.

Assistance in Setting Up a Microfilming Program

If the subject of preservation microfilming is new to you or your institution, you may take comfort in knowing that assistance is available in planning and implementing a program. The Library of Congress has published several manuals on preparation, which are cited in Chapters 3 and 4. Regional centers such as the Northeast Document Conservation Center will provide training in preparation and advice for filming programs. Members of the Research Libraries Group's Cooperative Preservation Microfilming Program either have in-house filming programs or have successfully contracted for filming services outside. The preservation staff in those institutions, including the University of California at Berkeley, the University of Michigan, the University of Minnesota, Stanford University, Brown University, Columbia University, New York Public Library, and Yale University, have written standards and specifications published in the *RLG Preservation Manual* and are willing to share their hard-earned experience.[15] Microform policy and procedures manuals are available from several institutions.[16] A useful first step in setting up your program would be a visit to an institution, analogous to your own, which has a microfilming program.

Costs and Funding

As indicated, preservation microfilming is a process with definite cost. Recent cost studies show the cost per monograph filmed varying from $25 to $75. Although there are significant cost variables depending on such things as size of the item being filmed and local labor costs, for estimating purposes a price per volume of $50 is not far off the mark. The process is worth the costs, however, when the alternative is the probable loss of a significant portion of our historical heritage. Specific costs for each step of the process, as well as the costs of meeting the quality specifications and standards, are discussed in Chapter 6.

When compared to the costs of keeping unusable materials on a repository's shelves, or of the space for storage of little-used materials, microfilming seems less expensive. This is also true when comparing microfilming to other preservation treatments. Mylar encapsulation is estimated to cost about $1.00 per $8^{1}/_{2}$" × 11" page, which would result in a per-volume cost of over $300. Conservator services are expensive, in line with their skills and training. Complete restoration of a badly deteriorated volume will also cost hundreds of dollars. The cost of microfilming is usually less than fifty cents per page.

Funding for preservation microfilming may not easily be carved from

15. *RLG Preservation Manual,* 2nd ed. (Stanford, Calif.: Research Libraries Group, 1986).

16. See, for example, the University of Georgia Libraries Microfilming Policy (unpublished, 1985), and Yale University Libraries' "Guidelines for the Handling of Microforms," *Microform Review* 9:11–20 (Winter 1980); 72–85 (Spring 1980).

within an existing institutional budget. But a continuous, effective program should be supported with internal operating funds. Some libraries are reallocating acquisition funds for the purpose. Although private donors have not traditionally given to microfilming programs, this is a resource that could be tapped. A personal or corporate donor may be willing to provide funds to ensure that a certain collection or item is preserved.

Start-up costs or special projects are often funded externally. Grant funding has been available through governmental and private agencies for preservation microfilming on a local or cooperative basis. Funding agents have been educated to require that projects follow archival standards, ensure nationwide bibliographic access, and avoid duplication of effort. The National Endowment for the Humanities (NEH) in 1985 announced a major preservation program office, with preservation on microfilm a high priority for funding. U.S. Department of Education funds, through Title II-C of the Higher Education Act, have also been used extensively for microfilming. Both NEH and the National Historical Publications and Records Commission have funded microfilming projects for archival and manuscript collections.

Conclusion

To assure continued access to the books, journals, pamphlets, and documents in libraries and archives, they must be preserved. Preservation microfilming is an appropriate preservation technique for many of those materials for a variety of reasons: (1) they are written or printed on poor, often brittle, paper, which can no longer be used; (2) they are too fragile for other reasons to be used in the original; (3) they are used so infrequently that the space they require is too costly; (4) offsite patrons need access to them and they would be damaged if transported; and (5) they are rare or valuable and filming will improve security while reducing handling. Preservation microfilming is an appropriate choice to preserve items of little artifactual value because it is a medium that is well understood in archives and libraries, long lasting, and space saving. However, as you will see from this manual, the process is complex, involving much more than the camera work. All four aspects of the preservation microfilming program must be carefully investigated: the selection and identification, the preparation, the filming, and the access to and bibliographic control of the completed film. Preservation microfilming is not accomplished unless all four of these elements are present. The prefilming and postfilming processes are just as important as the filming itself, and often more time-consuming.

To conclude, the administrative principles for a successful preservation microfilming program are as follows:

1. Materials important to scholarship are selected for preservation by staff with appropriate judgment.
2. Microfilming is found to be the proper preservation technique for those materials.
3. The materials have not already been preserved and copies made available elsewhere.

4. The materials are properly prepared for filming, properly identified on the film, and as complete as possible.
5. The filming, processing, and duplicating meet appropriate national standards.
6. The film is checked to ensure completeness and legibility.
7. The preservation master negative is stored under proper security and environmental conditions.
8. Access, both physical access to the film itself and access to the bibliographic record, is provided to the scholarly community.

The Interim Report of the Council on Library Resources' Committee on Preservation and Access strongly recommends that we "move in concert" to develop preservation microfilming programs based on local priorities and, ultimately, on national priorities.[17] Using the principles and guidelines outlined here will ensure that preservation microfilming is performed optimally to preserve materials for the future.

List of Suggested Readings

Ashby, Peter, and Robert Campbell. *Microform Publishing*. London: Butterworths, 1979.

Child, Margaret. "The Future of Cooperative Preservation Microfilming." *Library Resources and Technical Services* 29:94–101 (Jan./Mar. 1985).

Darling, Pamela W. "Developing a Preservation Microfilming Program." *Library Journal* 99:2803–9 (Nov. 1, 1974).

———, and Wesley Boomgaarden, comps. *Preservation Planning Program: Resource Notebook*. Washington, D.C.: Association of Research Libraries, Office of Management Studies, 1987.

Glossary of Micrographics. Rev. ed. Silver Spring, Md.: National Micrographics Assn., 1980.

Goerler, Raimund E. "Archival Microfilming: A Select Bibliography." *Ohio Archivist* 14:8 (Fall 1983).

Gwinn, Nancy E. "The Rise and Fall and Rise of Cooperative Projects." *Library Resources and Technical Services* 29:80–86 (Jan./Mar. 1985).

International Micrographics Sourcebook. New Rochelle, N.Y.: Microfilm Publishing, Inc. Biennial.

LaHood, Charles G., Jr., and Robert C. Sullivan. *Reprographic Services in Libraries: Organization and Administration*. LTP Publication no. 19. Chicago: American Library Association, 1975.

Lynden, Frederick C. "Replacement of Hard Copy by Microforms." *Microform Review* 4:15–24 (Jan. 1975).

Morrow, Carolyn Clark. *The Preservation Challenge: A Guide to Conserving Library Materials*. White Plains, N.Y.: Knowledge Industry, 1983.

Nitecki, Joseph Z., ed. *Directory of Library Reprographic Services*. 8th ed. Westport, Conn.: Meckler Publishers, 1982.

Preservation of Historical Records. Washington, D.C.: National Academy Press, 1986.

RLG Preservation Manual. 2nd ed. Stanford, Calif.: Research Libraries Group, 1986.

Saffady, William. *Micrographics*. 2nd ed. Littleton, Colo.: Libraries Unlimited, 1985.

Sung, Carolyn H. *Archives and Manuscripts: Reprography*. Chicago: Society of American Archivists, 1982.

Warner, Robert M. "Preserving the Records of America: The Role of Micrographics in the National Archives." *Journal of Imaging Technology* 10:137–39 (Aug. 1984).

17. Council on Library Resources, Committee on Preservation and Access, *Interim Report* (Washington, D.C.: CLR. 1985), p. 2.

2

Selection of Materials for Microfilming

Preservation microfilming must be but one option out of a full range of possibilities available to the archivist and librarian in a balanced, coordinated program of preservation management. A preservation program must include an identification, screening, and selection process to choose the most appropriate method of preservation for a given item within the context of an institution's stated preservation goals. Since most institutions have limited financial resources to devote to preservation, this selection process often becomes as much a decision of what must be *neglected,* as it is of which items can be *preserved*, whatever the means or form. Certain grant-funded programs may require microfilming as the first choice, but local demands may make it necessary to also retain the original or purchase a hard-copy replacement. In short, selection of items for preservation in a research collection is a most important and difficult task.

The collections found in libraries and archives are similar in many ways, and preservation managers will find problems of determining suitable approaches comparable. Both, for example, acquire, house, service, and preserve large quantities of paper-based materials that are deteriorating at a rapid rate with age and use. Both house paper-based materials of varied formats (bound volumes, maps, charts, scrapbooks, pamphlets, manuscripts, etc.). And both would like to retain items of artifactual value in their original format and preserve the intellectual content of other materials through microfilming or other copying methods. But there are also major differences.

Look at how their respective collections are acquired, processed, described, and classified, and you will see that the method and intent of archival repositories are different from those of libraries. Think, for example, of how researchers gain access to the collections. In libraries, researchers most often use catalogs to find single items in the collection, while in archives, finding aids or indexes point to boxes, files, or folders containing groups of documents. Archival and manuscript collections consist of predominantly flat-paper, single-sheet materials, while the majority of items in the library are bound volumes. The statutory governance of the retention of public rec-

ords and sometimes other archival materials and the legal implications of control of access to unpublished manuscript collections may differ significantly from policies affecting library collections. Finally, archives are made up of mostly unique items, while library collections consist of publications issued in multiple copies. These differences are significant and suggest that libraries and archives will need to employ quite different curatorial approaches to preservation management in general and to selection for preservation microfilming in particular.

Preservation Options

Generally speaking, the most crucial decision to be made regarding an individual item is this: Must this book (or map, letter, scrapbook, document, etc.) be preserved and retained in its original form?

The "yes," "no," or "maybe" answer to this question will give you the necessary guidance for the review of the menu of preservation/conservation options currently available. Only if you are aware of the full range of preservation options can you make wise decisions about which items are suitable for preservation microfilming. Here is a brief comment on the advantages and disadvantages of each. Some are obviously more relevant to library collections than to those in archives.

1. Options to repair or restore items in order to retain the original format
 a. Minor repairs: repairing book bindings, mending tears in flat paper materials, etc.
 Positive aspects: original format retained; usually low unit cost, depending upon condition.
 Drawbacks: not suitable for materials that have sustained significant loss of paper strength and are, therefore, too fragile to benefit from simple repair.
 b. Commercial rebinding of hard-cover books.
 Positive aspects: relatively inexpensive method of providing primary protection for text block.
 Drawbacks: usually cannot be used for brittle papers; not a long-term solution to unstable or brittle papers; generally not suitable for rare materials.
 c. Full conservation treatments, including aqueous/nonaqueous deacidification with polyester encapsulation and/or conservation rebinding.
 Positive aspects: retains the original item in a stable format.
 Drawbacks: high labor cost of treatments; lack of skilled personnel/resources to take on such treatment; cannot be expected to make an impact on large-scale masses of brittle materials.
 d. Protective enclosures/phase wrapping of books.
 Positive aspects: maintains all bibliographic pieces together in original format at a relatively low cost; provides a microenvironment to buffer storage environment.

Drawbacks: does not stop ongoing deterioration; is only a "phase" of preservation, a step to keep all parts of a volume together until other treatments become available or affordable.

e. Protective enclosure of single sheets by encapsulating with polyester film.

Positive aspects: retains original format and protects with a stable material.

Drawbacks: ideally, is preceded by a deacidification process, which is specialized and expensive; encapsulated item is heavier and bulkier than the original; cost of polyester is significant.

f. Mass deacidification processes.

Positive aspects: large quantities of materials can be safely stabilized at low unit cost, and thus retained in original format.

Drawbacks: not all types of materials can be deacidified in existing processes because of effects upon inks, leathers, etc.; capital cost of facility is high and unavailable to most institutions at this time; neither restores strength to weakened papers nor repairs binding structures.

2. Options to replace items with hard (paper) copy

a. Replace with hard copy—from out-of-print market.

Positive aspects: collection receives exact or near-exact duplicate of deteriorated/damaged item.

Drawbacks: high expense for some items; lack of availability of rare, scarce, or unique items; exact replacement copy unlikely to be a permanent/durable copy and will require treatment in the future.

b. Replace with hard copy—new in-print copy.

Positive aspects: collection receives near-exact duplicate of item, usually at reasonable cost.

Drawbacks: strong possibility that exact edition is unavailable in print; may not be a permanent/durable copy.

c. Replace with hard copy—reprint edition.

Positive aspects: collection receives exact or near-exact duplicate.

Drawbacks: reprint edition may not be permanent/durable; cost of reprints often high.

d. Replace with hard copy—create a photocopy in-house or purchase one and bind.

Positive aspects: exact text replacement in similar format of original; can use permanent/durable papers.

Drawbacks: cost of duplication and binding can be considerable for materials in bulk; only one copy made, so inexpensive copies not available for scholarly use generally.

3. Option to replace item with commercially available microform

Positive aspects: often the least expensive method of preserving an item; with reader-printers, microforms can be relatively easily enlarged in the form of paper copies for users; space reduction can be significant, especially with longer serial runs, because of the space efficiency obtained with full 100-foot reels of micro-

film (at approximately 1500 frames per 100 feet) or with micro-fiche.

Drawbacks: not all materials are appropriate for, nor available in, microform; often, commercial sources do not make monographs available individually; parts of serials and series might be commercially available in microform, but, if acquired, could present difficulties in circumstances where part of the title is found in hard copy at one place and part in microform in another place within the library; not all commercially available microforms are produced in compliance with archival standards (e.g., they are not produced on silver-gelatin film); microforms require somewhat more extensive recataloging than other replacements; microforms require equipment and facilities for reading and service.

4. Option to discard/deaccession with no replacement

Positive aspects: since preservation selection decisions function like acquisition decisions, decision to discard indicates lack of value to the collection; decision "not to preserve" reserves funds for items in the collection that warrant preservation treatment.

Drawbacks: has limits in research collections where all materials acquired can often be assumed, for the most part, to have long-term research value in some format; use of the discard/deaccession option in research collections may result in significant loss to the collections.

5. Option of no action, i.e., reshelve as is

Positive aspects: if this option is used conscientiously with a plan of priorities for preservation treatment, it has an effect of "benign neglect," one that frees resources to preserve more important items in the collection.

Drawbacks: as in the discard/deaccession option, this option has limits in a research collection where materials are acquired for their permanent research value; use of the "do-nothing" option will result eventually in permanent loss to the collection.

6. Option of providing preservation by storage environment (placing items in controlled temperature, relative humidity, light, air quality conditions)

Positive aspects: by slowing down rate of deterioration, preservation in original format for many types of materials is possible; long-term storage of items can be maintained at a low unit cost.

Drawbacks: major capital outlay required to build and equip a facility that maintains cool temperatures, moderate relative humidity, appropriate light levels, and purified air; materials that have significantly deteriorated in physical strength or have damaged structures are not restored in this method; deterioration is considerably slowed, but not stopped altogether in this option; if storage is in a remote location, there is the added expense of selecting and changing catalog records of items to be moved.

7. Option to preserve intellectual content in microform by using an in-house facility or a filming service agency

Positive aspects: intellectual or informational contents of materials

are captured and preserved on a very stable medium; after initial filming service, copies are easily and cheaply produced for wider dissemination to other institutions; space reduction, especially for serial publications, is significant; for certain materials this is the only viable option for preserving content; hard copy (e.g., Copyflo[1]) can be created for appropriate items (music, dictionaries, etc.).

Drawbacks: strict adherence to technical standards for the selection of film stock, processing procedures, and storage of master negatives is necessary; microforms require more extensive recataloging than other replacements; not all materials that are damaged or deteriorated are suitable for this type of preservation; it can be at times an irreversible process, because damage may occur in filming certain types of materials (e.g., tightly bound volumes with very brittle paper), and others must be disbound to be properly filmed.

This broad menu of preservation/conservation options recognizes that different situations and problems require a variety of solutions. As a knowledgeable librarian or archivist, you will have access to as many of the methods and techniques available as your institution can reasonably provide, but be wary of indiscriminate or wholesale applications of any option in the management of the collection. By following the guidelines for identification, screening, and curatorial responsibility described below, you can determine more easily when preservation microfilming is the best option.

Responsibility for Screening and Decision Making

The responsibility for making preservation decisions about individual items may rest on a variety of people, depending on the size of the institution and the expertise of the staff. Faculty members, scholars, and other users of the collection may also have a role. This process is known as the curatorial review and is critical to ensuring that preservation funds are spent wisely. The sections that follow outline a potential division of duties in institutions with a full complement of staff.

All persons involved in the process of decision making should be equipped with a clear understanding of the institution's collection management and development or accessions (in the case of archives) policy. If the institution has a written statement, it is the ideal planning instrument. In it can be found the short-, intermediate-, and long-term objectives the institution will follow in selecting and maintaining its collection. The policy will contain valuable information on:

the relative strengths of portions of the total collection (especially strong subject collections are top candidates for preservation)
the relative value of current and retrospective collections in different subject areas

1. *Copyflo* is a registered trademark of the Xerox Corporation for the equipment and process that creates paper copy from negative microfilm in a continuous roll. The equipment is no longer manufactured or serviced by Xerox, but the service is available from some commercial microfilm agents and older library photographic service departments.

the level of use (high-use collections may require higher priorities in preservation activity)

the historical importance or research value of various parts of the collection.

Preservation decision making becomes one of the most important methods for implementing the collection development or acquisitions policy. Of course, not all institutions will have formal, written policies. In the absence of such a document, preservation decision makers will need to rely on informal agreements and understandings that guide collection development practices.

Preservation Administrators and Conservators

The person who oversees the institution's entire preservation program has responsibility for:

1. Administering all preservation identification and screening routines
2. Developing a range of preservation options to provide appropriate and suitable treatments for varied types of deteriorated materials
3. Knowing relative cost and benefits of various options
4. Interacting with the selector, bibliographer, subject specialist, or scholar to obtain final preservation decisions for all items.

The preservation administrator provides advice on the availability and relative costs of various preservation options, but the bibliographer, subject specialist, or scholar should generally be responsible for the final decision on disposition of individual items. Conservators provide technical advice to the preservation administrator and subject specialist on the costs and feasibilities of conservation treatments for those items with artifactual value. Usually, their main role is to provide the appropriate combination of method and material that will allow the institution to retain items for use in their original format, when that is important. They do not make "curatorial" decisions in regard to the importance of the items in question.

Bibliographers and Selectors

Whether they are called bibliographers, curators, or selectors, it is the subject specialists who are the best qualified to make the final preservation decision for deteriorated items that have been identified and placed into the screening process as preservation microfilming candidates. Their decisions to film or not to film, to retain or to discard after filming, and so on, must be based upon their knowledge of the subject, the language, and scholarship in the field, and their knowledge of local and national needs, as well as their awareness of factors brought to their attention by preservation officers and conservators. It is the selector's responsibility to answer the question: "What is worth preserving in this collection?"

Because everything cannot or should not be filmed in a "vacuum cleaner" approach to preservation microfilming, the selector's knowledge of the subject matter will help determine the relative importance of the individual item to the collection as a whole. The following points will influence the decision:

1. The strength or national eminence of the collection from which the item comes. One indicator here would be whether the institution has assumed primary collecting responsibilities in certain subjects in order to participate in cooperative projects.
2. The nature of the current use of the collection or item—its history of use, its support of the curriculum, and its value to research.
3. The uniqueness of the item to the area, nation, consortium or institution and its value as an artifact.
4. The nature of the discipline or subject area. This is especially important in preserving variant editions of a work. For example, research that emphasizes use of literary materials probably will require that all editions and perhaps even all printings of a work be preserved, since a complete documentary record is required for textual analysis. For some works and for some subject areas, the first or the last edition is sufficient.
5. The permanent research value of the materials' intellectual content. Items that are judged valuable for the study of the history of the subject, that document the existence of new trends and ideas, and that document a record of increased knowledge in that subject should be preserved.
6. The place of publication. Items first published in the United States might receive higher priority than those first published in Europe and whose translations were subsequently published in the United States, for example.
7. Date of publication. Items published during the author's lifetime may be given higher priority for preservation. Also, contemporary events during the publishing history of the work—political events, critics' rebuttals, etc.—influence preservation decisions.
8. How the item reflects genuine contributions to the local, national, or subject literatures; its historical significance.

The subject specialist should choose from the available options to microfilm, to treat physically, or to replace in a hard copy, as if these were acquisition decisions in competition with resources for newly acquired materials. They must be as active in making preservation decisions as they are in making acquisition decisions in order to keep up the work flow in preservation units.

Scholars and Faculty Members

In the past, scholars who have not been professional librarians or archivists have not been routinely involved in the selection of materials for preservation microfilming. If your institution lacks subject expertise in certain disciplines on its staff, faculty members, researchers, or other scholars can be helpful as advisors. The purpose of such assistance is to help determine the intellectual or long-term value of a title to the collection, to make sure that preservation dollars are spent wisely.

Involving faculty or scholars in preservation decision making requires careful planning. It is not unlike the involvement of faculty with acquisition or selection decisions, but there are distinct differences. It will probably be

easier to solicit help with a targeted project that has a definite beginning and end than with a continuing program. Harder choices must be made, because preservation dollars are less plentiful. And it is almost always easier to add something to a collection than to withdraw something from it. If you employ outside consultants in your program, make certain they are fully aware of the preservation options available and their relative costs. If scholars are thoroughly educated, their assistance can be valuable indeed.

Local review of miscellaneous titles that are potential candidates for microfilming is only one way in which scholarly expertise can be employed, however. Depending on the subject field, you may be able to use published selective bibliographies of literature that will provide the required value judgment. You might also ask local scholars to construct bibliographies of titles important for preservation in a particular field, or to review and select from comprehensive bibliographies.

There are several models for this latter approach. In a project funded by the National Endowment for the Humanities in the early 1980s, for example, a panel assembled by the American Philological Association was asked to select books and journals worthy of preservation in the field of classics. The titles were then sought for filming.[2] The American Trust for the British Library uses another approach. The American Trust is assisting the British Library in acquiring microforms of American publications to fill gaps in its collections, some of which were caused by damage suffered in the second World War. In the first project, bibliographies in the *Harvard Guide to American History* were used to select titles for filming from the collections of Harvard University. In the second, the American Trust is commissioning forty subject bibliographies from which titles to be filmed will be selected. The Library of Congress will film the items, and records for items filmed will be entered into the RLIN database. The Andrew W. Mellon Foundation and the Pew Memorial Trust are underwriting these activities.

Smaller institutions may find it impossible to organize scholarly input on such a massive scale. But extending the decision-making process can have benefits even in a small, local program if it results in a better understanding among library and archives users of the institution's preservation needs.

Methods of Identification

Let us suppose that you have secured agreement to have selectors/scholars make the preservation decisions. How do you identify appropriate candidates for preservation? You will quickly turn to a systems approach. This part of the program has complex aspects, but its operation can be rather simple and straightforward.

2. The advantages to the involvement of scholars, as well as the pitfalls, are discussed by Roger S. Bagnall in "Who Will Save the Books? The Case of the Classicists." *Humanities* 8:21–23 (Jan./Feb. 1987). Also found in *The New Library Scene* 6:16–18 (April 1987). A more detailed account appears in "Involving Scholars in Preservation Decisions: The Case of the Classicists," by Carolyn L. Harris and Roger S. Bagnall, *Journal of Academic Librarianship* 13:140–46 (July 1987).

Suitable Categories

There are broad categories of materials that are, by their nature, more amenable to conversion to microform and the most endangered if treatment is not undertaken. Experienced institutions have concentrated their attention on the following:

brittle monographs and pamphlets (usually published after 1870)

newspapers

long serial runs on poor paper

statistical materials

scrapbooks

vertical files (clippings, etc.)

letter books and manuscript materials

ledger books and account books

certain types of atlases or maps

government reports, foreign and domestic

carbon copies, stencil-mimeograph, thermofax, verifax, and other reproductions of correspondence.

Generally *not* suitable or appropriate for preservation microfilming are:

materials containing certain kinds of illustrations (especially color illustrations)

materials having artifactual, intrinsic, bibliographic or historical value in their original format, and that might be damaged in the filming process

offprints from journals, which are themselves already available in microform

materials that are extremely discolored and have very poor contrast between the text and the background

materials that are being or have been microfilmed by other institutions or commercial firms, which make high-quality microform copies available for purchase or loan.

The screening process will sort out individual items with these characteristics, but if you know, for example, that another organization is comprehensively filming Slavic serials, you could exclude that whole category from the identification process.

Identification as Byproduct of Other Operations

Depending upon many factors—the size and age of the collection, the magnitude of its deterioration, accessibility of bookstacks to users, circulation policies, the capacity of preservation units and their relationship to other units—a workable system for the identification of materials that are preservation microfilming candidates will employ one or several routines. Some methods are byproducts of other library or archival functions:

1. Staff of the commercial bindery preparation unit may set aside books in which the papers lack sufficient strength to benefit from or withstand commercial binding or rebinding.

2. Circulation, reference, or photoduplication staff may spot brittle items as they are returned from loan, or identified through patron requests or customer orders. These items might be considered high priority titles because of the clearly indicated level of reader interest. Readers may also bring brittle books to the attention of repository staff.
3. Stack maintenance or collection management staff may identify materials requiring various ranges of preservation attention. Library staff who are trained to be alert for problem materials usually have little difficulty in identifying deteriorated items, as they carry out maintenance tasks, including shelving, shelf reading, shifting, or inventory projects. Bibliographers, subject specialists, special collections curators, and individual collection development staff may identify materials as part of their collection evaluation reviews.
4. Serial department staff may select certain titles to film on an ongoing basis in lieu of binding. This should be done with the permission of the publisher, in compliance with the copyright laws, and with assurance that they are not duplicating other libraries' efforts.
5. Staff of acquisition departments routinely forward for filming incoming new or retrospective monographic materials for preservation microfilming, when these materials have a known limited shelf life due to the obviously poor quality of the text paper.

While these methods of ongoing identification are effective, a more focused project can bring good results and provide a more steady flow of materials to be filmed.

Identification as Focus

Survey Projects. Item-by-item comprehensive surveys of entire stack areas or of known deterioration problem areas can be an effective systematic method of identifying materials for screening. This comprehensive, shelf-review approach is similar to an inventory process and will work well if criteria for selection are well defined and if the organizational apparatus is of sufficient size to deal with the quantities of materials gleaned.

Random sampling in certain discrete areas of a collection can also provide information to the preservation officer or collection maintenance officer about the degree of deterioration or the suitability for conversion to microform in that portion of the collection. This has been successful in some collections to identify important subcollections that are high priority for micropreservation. Elaborate sampling may be unnecessary. If you know a collection largely contains imprints from 1870 to 1930, the age of particularly bad paper, sampling may tell you what you already suspect: considerable brittleness exists, and screening for microfilming will be worthwhile.

Review of collections for imprint date is a third useful method to identify preservation microfilming candidates, especially if the process can make use of computerized catalogs to generate lists of material with particular imprint dates. Another method is simply to review the shelflist and flag records for volumes with certain imprint dates.

Bibliographies. Identification of candidates for preservation microfilming can also be accomplished by using comprehensive subject bibliographies or published catalogs. This may be especially valuable if the collection is particularly strong. The institution might decide to create a coherent microform collection on a specific subject (e.g., film all the items in a bibliography) or to use the catalog as an indication of the intellectual value of the materials listed, and therefore a selection tool. Commercial micropublishers often use this approach.

Special Collections. A library or archives may decide that an entire collection is worthy of preservation and that all suitable items in it should be filmed. For example, an archives might select either a collection of all the papers belonging to an individual or all notebooks of an expedition. A library may seek grant funds to enhance a collection that is significant nationally (e.g., folklore at Indiana University) and make preservation microfilming a part of the proposal.

Systematic/Cooperative Approaches. Institutions within a consortium, network, or other organization may set up a cooperative program whereby they each assume responsibility for microfilming different categories of items by subject, place of publication, date, or other variables. The parameters could be as broad as reviewing the entire publishing output in a field, or be restricted to types of material (e.g., monographs) or certain titles (e.g., long serial runs). The Research Libraries Group and the American Theological Library Association projects are useful models for this approach.

Regardless of how individual items are identified as potential candidates for preservation microfilming, they are usually brought together in a central location and batched to expedite an item-by-item review. This review is known as the screening process.

The Screening Process

The screening process is a critical stage in the management of a preservation microfilming program. Assessment of physical, bibliographical, and intellectual aspects of each item is required. If you convert a dictionary to roll film, for example, you may make it so difficult to use that its value to the collection is lost. Moving from *aardvark* to *zebra* in a book dictionary takes seconds—on a reel of film it could take several minutes depending on the size of the original and the speed of the reader. Consider and carefully examine each item identified as a possible filming candidate to judge if it is acceptable for the filming process.

To Retain the Original—or Not?

You must ask yourself a vital question early on in the screening process: "Is it necessary, feasible, or appropriate that this volume (or document) be retained after it has been microfilmed?" A satisfactory answer is critical because—and this cannot be emphasized too strongly—the filming process is often damaging and irreversible. For example, brittle book volumes that

have been bound using the oversewing process often cannot be microfilmed without cracking and breaking the pages in the inner margin. Similarly, particularly brittle or fragile volumes, in which the sewing structures are also weak, dessicated, and brittle, may not withstand even the most careful filming in a good book cradle. The damage caused by filming such volumes that are also artifactually or intrinsically valuable may not be justifiable, and suitable restorative physical treatment may be the better solution. A broad policy to discard all volumes that are filmed may not be in the best interests of your institution.

It is important to note, however, that many items with intrinsic and illustrative value have been microfilmed for the purposes of reducing the need for readers to refer to the original rare or valuable item. Also, some libraries provide a microfilm "insurance copy" for certain items in the collection. These filming decisions are made only when there will be little or no damage to the original through the filming process.

The decision not to remove the binding from volumes to be filmed may affect the film quality. This is commonly the case with tightly bound, usually relatively thick volumes that cannot be filmed adequately because of the amount of text obscured in the deep gutter margins. The degree of this inner margin loss depends a great deal upon the volume, the book cradle used, and the microfilming camera's optics.

It must be stressed that if you do remove bindings from bound volumes before filming, the quality of the film is usually improved, and the cost of producing the film is significantly reduced. The most expedient method is to use a cutting machine, known as a guillotine, for those volumes that are not to be retained.

The decisions to "film and retain" versus "film and discard" are often difficult ones. In addition to the artifactual value/damage issue, institutional policies come into play. With the enormous volume of paper-based materials that require reformatting to preserve primarily the intellectual content, can the institution justify microfilming as only an interim measure, and thus retain great quantities of printed materials after microfilming? Can it justify maintaining in "dead storage" materials that are not usable because of their fragile condition? Can it justify any additional recataloging costs for retention of both formats? And will the materials thus retained require any significant physical treatment (deacidification, repair, protective enclosure, conservation rebinding, etc.) after filming?

For archives, legal requirements may necessitate retention of hard copies for certain categories of documents, so the answer to these questions may reluctantly be "yes." But if it is "no," participants in the screening process must take great pains to select only those items that are appropriate for preservation microfilming.

Screening Criteria

We are now at the stage when a quantity of material has been identified as candidates for preservation. Applying the screening criteria will determine those items that should be microfilmed based on physical factors, cost, and curatorial review. This review may take place as the first step or the last, depending on the material. For example, if the institution has decided to pre-

Figure 1. Screening Checklist

1. Physical condition, including legibility, paper strength/ flexibility, and the condition of binding structure.

2. Bibliographic completeness.

3. The availability of acceptable replacement or duplicate copies in hard copy or microfilm, whichever is more appropriate for the item and the collection.

4. The quantity, value, and condition of illustrative or graphic materials that are part of the item.

5. The format, frequency, and type of usage the item receives or is expected to receive.

6. The artifactual, intrinsic, historical, or bibliographic value of the item as an object in its original format.

7. Donor or copyright restrictions.

8. The cost of filming.

9. Shelf space considerations.

10. The intellectual importance of the material itself, as seen by scholars, custodians, and bibliographers.

11. The likelihood that another institution will film the item.

serve an entire collection, the curators may review it first to determine which items should remain. Generally, however, this review would take place at the final stage, with all information about the item available. Figure 1 briefly lists the criteria that must be used in the screening process.

The balance of this chapter will discuss each of these criteria in detail. The new decision-maker may find the diversity and multiplicity of factors alarming, but many of them will become second nature with practice. A logical progression underpins the screening process. Figure 2 illustrates this progression in a simplified flow chart.

Physical Condition

The most common reason for the use of microfilm as a preservation option has been to capture the informational or intellectual content from weakened and embrittled papers in books and documents. These conditions, usually caused by loss of strength due to acid hydrolysis or oxidation within the paper's molecular structure, make physical treatments impractical for large quantities of paper-based materials. Brittleness is easily detected by testing a corner of the pages with a fold test: if the paper cannot withstand two (2) or three (3) double corner folds without breaking off, the paper has undergone

Figure 2. Preservation Decision Flow Chart

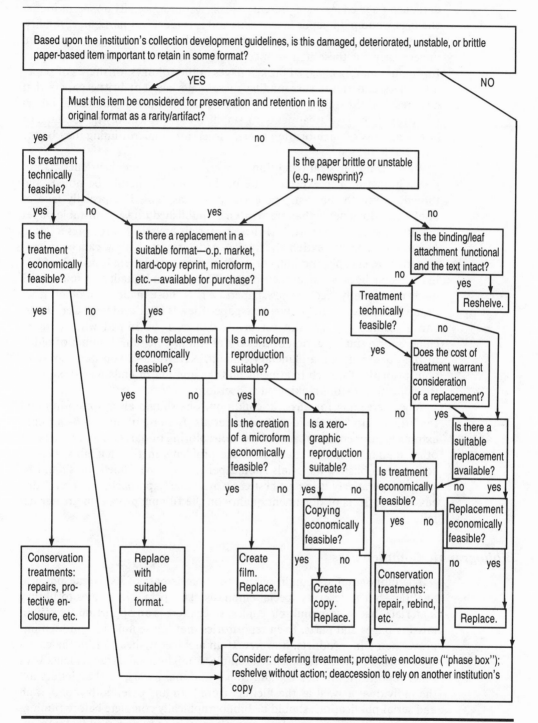

SOURCE: Wesley L. Boomgaarden, Preservation Office, Ohio State University Libraries.

an irreversible degradation of paper flexibility; it is, for all practical purposes, "brittle." It may not be necessary to test for brittleness if "haloes"—darkened page edges—are present. This is a trait especially apparent in mechanical wood pulp paper (newsprint) and is evidence of particular fragility. The paper may shatter with even delicate handling. Folding a corner is often unnecessary for these items, since the surveyor will see pages broken out from inner margins, jagged broken pages in the volumes, or shards of paper on shelves and floors surrounding these materials. For brittle papers that have reached this stage, rebinding is not possible without additional labor-intensive restorative treatments to stabilize and protect brittle leaves. For large amounts of such brittle papers, preservation microfilming may be the only viable option.

When using physical condition as a criterion, extreme brittleness is not the only factor. The expected rate of deterioration should be noted, and thought given to the item's potential problems. This is especially true of books and documents that are written or published on very unstable paper materials, such as newsprint. If these materials are selected for preservation *before* they become extremely fragile or deteriorated, they can be microfilmed more cheaply, the film copy will be better, and there is no risk of losing the text because of broken pages. The cost and quality of microfilms made of currently received newspapers, versus those made from older, fragile, and darkened retrospective newspaper files, is clear evidence. Certain archival records that are not yet brittle can even be filmed with a rotary camera for a small fraction of the cost of filming the same number of older, brittle documents on a planetary camera. Nevertheless, you must consider your priorities for such treatments and the amount of endangered paper in the collection before making such decisions.

When screening for physical condition, one should always keep in mind the "filmability" of the identified materials. Because of ink bleed-through, extremely poor contrast caused by the discoloring or darkening of papers, or other damaged images that will cause problems in film legibility, certain copies of published materials should perhaps not be filmed, or should be done cooperatively using a "best copy available" approach. Chapter 4 discusses the effects of document quality on the filming process in greater detail.

Bibliographic Completeness

The bibliographic "condition" of the item is part of its overall physical qualities, but it deserves special emphasis. This primarily relates to library materials that exist in multiple copies, since there is an opportunity to fill in missing pages and parts. Even repositories that house unique items can improve their film products, however. If an archives wished to film the correspondence of an individual, for example, it might make arrangements with other repositories to borrow and film additional letters, or the "letters to" the individual as well as the "letters from." In any case, both monograph and serial publications should be bibliographically complete before filming.

You should make every effort to replace missing or damaged text in monographs by borrowing copies through interlibrary loan. The same is true for serial publications, to fill gaps in holdings and thus obtain a "best," or most

complete, copy for filming. Borrowing missing issues or parts is one method, but you might also arrange to have another institution, one that also films according to national standards, film the affected portion (particularly if it is lengthy) and splice the film in with yours to make up a complete run. This activity is very important in a preservation microfilming program, even though it may increase costs.

Page-by-page collation during the preparation stage will reveal internal completeness of a volume. At the screening stage, you and your colleagues should look for obvious problems and determine whether an attempt should be made to solve them or to pass the item over.

Availability of Replacements

In library collections, now that you have identified some potential candidates for preservation microfilming, you will need to conduct a bibliographic search to ascertain:

1. The importance of this item to the collection as a whole
2. Its relationship to other relevant editions in the collection, including its relative rarity or scarcity
3. The availability of suitable hard-copy replacements in the commercial market
4. The availability of microform replacements in the institutional or commercial markets.

If your collection is of manuscripts or other archival records, the availability of duplicates is of much less concern. You may wish to skip to the following section on illustrative materials.

This detailed search is a necessary step to provide the selector with enough relevant information to make a rational decision on the preservation and disposition of each item. Failure to take these factors into account can seriously damage the collection as a whole.

A well-designed search form will be an invaluable tool in the gathering and sharing of information on each candidate for preservation. (See Figures 3 and 4 for examples of monograph and serial search forms.) Although the amount of information required may vary, the search form can take several physical shapes: on 8½″ × 11″ paper, 5″ × 8″ cards, data maintained in a microcomputer program, and so on. The search form should provide space for the following information:

1. Complete bibliographic information (e.g., a photocopy of the shelf list card) that provides edition-specific data on the item in hand
2. Number, call number, publication date, and condition of other copies of that item and/or edition in the collection
3. Brief information regarding the author: dates of life, existence of other titles in the collection by that author
4. The existence of any other of the author's works in special collections units
5. If a translation, the existence and condition of the edition in the original language in the collection

Figure 3. Search Form for Preservation Replacement: Monograph (side 1)

Order record:	Possible suitable replacements available/source:
	Notes:

Online catalog holdings statement:

See printout attached

Replacement search results:

Hard copy:	Author Title	Microform:	Author Title	Bibl. Util.:	Author Title	Rarity/Scarcity:
BIP	___ ___	NRMM (65-75)	___ ___	RLIN fiche	___ ___	NUC pre-56 search:
				RLIN on-line	___ ___	
BIP Suppl.	___ ___	(1976)	___ ___			more than 6 holding
Forthcoming	___ ___	(1977)	___ ___			libraries?:
GTR	___ ___	(1978)	___ ___			
		(1979)	___ ___			**NUC:**
BBIP	___ ___	(1980)	___ ___			if 5 or fewer, list
Other:	___ ___	(1981)	___ ___			locations
		(1982)	___ ___	OCLC	___ ___	
		(1983)	___ ___	Other:	___ ___	
				(specify)		
Notes:		BOD	___ ___			
		NUC fiche	___ ___			
		NYPL fiche	___ ___			
		GMIP	___ ___			
		GMIP Suppl.	___ ___			
O = not listed		Other:	___ ___			
X = listed/available		Notes:				
— = not searched				(Curatorial Review and Decision; see over)		

NOTE: Search tools identified here by acronym are explained in the lists of replacement sources that follow.

SOURCE: Wesley L. Boomgaarden, Preservation Office, Ohio State University Libraries.

Figure 3. Search Form for Preservation Replacement: Monograph (side 2)

CURATORIAL REVIEW AND DECISION

Selector's instructions to Preservation Office staff (mark appropriate area):

1. Order microform available: _____ for this edition only; _____ for any edition

 fund: _____

2. Order reprint available: _____ for this edition only; _____ for any edition

 fund: _____

3. Create microfilm (for those not available as commercial replacement): _____ .

4. Create photocopy facsimile (for those not available as commercial replacement): _____ .

 fund: _____

5. Disposition of original (for items being replaced): _____ withdraw from collection

 _____ provide enclosure, reshelve

 other: _____

6. Do not replace, instead: _____ provide enclosure, reshelve

 _____ withdraw from collection

7. Other:

Selector _____ Date: _____

PRESERVATION OFFICE DISPOSITION Give date completed; indicate with a check (✔) when included in statistics; initial.

1. Replacement search completed _____

2. Replacement microform order sent to Acquisitions: _____

3. Replacement hard copy (reprint) order sent to Acquisitions: _____

4. Page-by-page collation for "create film" and "create photocopy" items:

 _____ complete _____ ILL pages ordered

 _____ pp. missing _____ ILL pages received

5. Sent to be filmed _____

 received _____

 inspected _____

6. Sent for photocopy facsimile _____

 received _____

 inspected _____

7. Sent to cataloging _____ .

8. Disposition of original: repaired, sent to stacks _____ enclosure, sent to stacks _____

 sent for withdrawal _____ transferred to _____ .

IF IN DOUBT, OBTAIN SELECTOR'S APPROVAL FOR ANY OPTION OR DISPOSITION.

Figure 4. Search Form for Preservation Replacement: Serial (side 1)

Order record:	Possible suitable replacements available/source:
	Notes:

Online catalog holdings statement:

See printout attached

Replacement search results:

Hard copy:		Microform:		Bibl. Util.:		Rarity/Scarcity:	
BIS	_____	SIM	_____	RLIN fiche	_____	NUC pre-56 search/ ULS/CRL search:	
GTR	_____	NRMM (65-75)	_____	RLIN on-line	_____	more than 6 holding libraries?:	
		(1976)	_____				
		(1977)	_____			if 5 or fewer, list locations:	
		(1978)	_____				
Notes:		(1979)	_____			**NUC:**	**ULS:**
		(1980)	_____				
		(1981)	_____	OCLC	_____		
		(1982)	_____	other:	_____		
		(1983)	_____				
		GMIP	_____				
		GMIP Suppl.	_____				
		NST	_____			**CRL** holdings:	
O = not listed		Other:	_____				
X = listed/available		Notes:					
— = not searched				(Curatorial Review and Decision; see over)			

NOTE: Search tools identified here by acronym are explained in the lists of replacement sources that follow.

SOURCE: Wesley L. Boomgaarden, Preservation Office, Ohio State University Libraries.

Figure 4. Search Form for Preservation Replacement: Serial (side 2)

CURATORIAL REVIEW AND DECISION

Selector's instructions to Preservation Office staff (mark appropriate area):

1. Retrieve the following other copies or editions for review (specify call number):

2. Order microform available: _____ for this edition only; _____ for any edition

3. Order reprint available: _____ for this edition only; _____ for any edition
 Notes:

4. Microfilm in-house: _____

5. Create photocopy in-house: _____

6. Do not replace, instead: return to shelves _____ withdraw from collection _____
 transfer to _____ repair or provide enclosure _____

7. Disposition of original (for items being replaced):
 return to shelves _____ withdraw from collection _____
 transfer to _____ repair or provide enclosure _____

8. Other:

Selector _____ Date: _____

PRESERVATION OFFICE DISPOSITION Give date completed; indicate with a check (✓) when included in statistics; initial.

1. Search completed _____

2. NOS _____ 2nd search _____
 Notes:

3. Page-by-page collation for in-house copy items: _____ complete _____ ILL pages ordered
 _____ pp. missing _____ ILL pages received

4. Print ordered _____
 received _____
 inspected _____

5. Microform ordered _____
 received _____
 inspected _____

6. Sent to Cataloging _____

7. Sent to be filmed _____
 received _____
 inspected _____

8. Sent to Cataloging _____

9. Photocopy produced _____
 sent for binding _____
 inspected _____

10. Disposition of original: returned to stacks: _____ sent for withdrawal: _____
 transferred to: _____ sent to Conservation: _____

IF IN DOUBT, OBTAIN SELECTOR'S APPROVAL FOR ANY OPTION.

6. If a multivolume set or serial, description of holdings in collection
7. The relative rarity or scarcity of the item (as defined by the selector) ascertained by a search in the *National Union Catalog of Pre-1956 Imprints*[3] (number of copies listed, with location symbols) or the *Union List of Serials*[4]
8. The availability, cost, and publisher of hard-copy replacement editions listed in in-print sources; these sources (and the microfilm sources) should be listed as abbreviations on the form, with sufficient space for the searcher to enter availability and source
9. The availability of microform copies, with cost and source
10. Space for an indication of bibliographic completeness after collation
11. Space for the selector's decision on treatment and disposition (e.g., "film and discard," "film and retain," etc.).

Complete searches to gather the above information can be very time-consuming. For this reason, you should try to increase search efficiency by outlining policy with regard to the types of materials and the priority and extent of replacement searches. Search forms should be batched in groups of 30 to 50 items and organized alphabetically by main entry to make searching time most efficient.

It may be more efficient with certain types of materials to allow the selectors to review materials before this detailed search is undertaken. A good example of the type of material that will not require extensive microform replacement searching would be a heavily used (but embrittled) novel or standard historical work available in print or as a reprint. Materials that receive significant use because of their color illustrations also could be spared the detailed search for a microform copy. When selectors review these materials before searching, they can easily specify "hard-copy search only" or "microform search only" on the search forms.

The search should begin by verifying the item's basic bibliographic information. A copy of the shelf list or public catalog card can be attached to, or copied onto, the search form, after ascertaining that the card represents the item in hand. This step may include a database search for verification. Gleaning the other necessary bibliographic data to record on the form (information on other copies, the author, translations, rarity/scarcity, etc.) should follow.

Add to this information the existence and availability of hard-copy reprints and/or of available microform copies. The order of the search in these sources should follow library policy on preference for format of replacement. Type of material (long serial runs versus shorter monographic items, for example) will affect preference for microform over hard-copy replacements.

The following are the significant tools that could be used in a comprehensive replacement search.

3. *The National Union Catalog, Pre-1956 Imprints: A Cumulative Author List Representing Library of Congress Printed Cards and Titles Reported by Other American Libraries* (London: Mansell, 1968–1981), 754 v. Also in microfiche edition (London: Bemrose UK Ltd., 1981).

4. *Union List of Serials in Libraries of the United States and Canada*, 3d ed. (New York: H. W. Wilson, 1965), 5 v.

Hard-Copy Replacement Sources

Books in Print (New York: R. R. Bowker, annual editions) and *Paperbound Books in Print* (New York: R. R. Bowker, spring and fall editions).

arrangement:	Authors, titles, subjects in separate alphabets.
scope:	A list of books available in the United States from U.S. publishers or distributors; not an absolutely comprehensive source, since it is an "index to the *Publishers' Trade List Annual.*"
information provided:	Author, title, publisher, International Standard Book Number (ISBN), edition, price; entries may vary in spelling and/or form; new information is a designation for alkaline paper if so noted by the publisher.

Books in Series (New York: R. R. Bowker, 4th ed., 1985).

arrangement:	By series.
scope:	Original, reproduced, in-print, and out-of-print books published or distributed in the United States by popular, scholarly, and professional series.
information provided:	Author, title, publisher, series, publication date.

Books on Demand (Ann Arbor, Mich.: University Microfilms International, irregular updates); available in hard-copy or fiche format.

arrangement:	By authors or titles.
scope:	Formerly out-of-print titles (monographs, specifically) now available from University Microfilms as paper copies or as 35mm or 16mm microfilm.
information provided:	Author, title, publisher, date of publication, price; some coding of numbers (AG3-200 or AG3-2000 numbers) indicates that these are paper print masters and have better quality illustrations.

British Books in Print (London: J. Whitaker & Sons, annual editions).

arrangement:	Authors, titles, subject, in one alphabet.
scope:	A list of books available and sold in the United Kingdom.
information provided:	Author, title, subtitle, volume or part, size, number of pages, illustrations, edition, series, binding (if not cloth), price, publisher, date of publication, ISBN.

Canadian Books in Print (Toronto: Univ. of Toronto Press, quarterly) with one hard-copy edition per year, updated by three fiche editions yearly.

arrangement:	Author and title in two alphabets; separate annual subject index.
scope:	Books published in Canada in English and French.
information provided:	Author, title, price, publisher, edition, ISBN.

Catalogo dei libri in commercio (Milan: Editrice Bibliografico Associazione Italiana Editori, annual editions).

arrangement:	Author, title, subject, in three alphabets.
scope:	Italian language books from Italy and elsewhere.
information provided:	Author, title, date, size of volume, pagination, publisher, price.

Guide to Reprints (Kent, Conn.: Guide to Reprints, Inc., annual editions).

arrangement:	Alphabetical by main entry.
scope:	Titles available from reprint houses; reprints are defined as materials that have gone out-of-print and are now back in print by virtue of a photo-offset process.
information provided:	Author, title, original and reprint, publisher, ISBN or International Standard Serial Number (ISSN), edition, original publishing date, reprint date, price; not all entries are actually available from reprinters.

Libros en venta en Hispanoamérica y España 2d ed. (Buenos Aires: Bowker Editores, 1974; supplements: San Juan, Puerto Rico: Melcher Ediciones, irregular).

arrangement:	Author, title, in two alphabets.
scope:	Spanish language books in print.
information provided:	Author, title, place, publisher, price, pagination.

Libros Españoles: Catalogo ISBN (Madrid: Ministerio de Cultura, Instituto Nacional del Libro Español, annual editions).

arrangement:	Author, title, subject, in three alphabets.
scope:	Spanish language books, with concentration on publications from Spain.
information provided:	Author, title, publisher, price, pagination, size, ISBN.

Les Livres Disponibles: French Books in Print (Paris: Cercle de la Libraire, annual editions).

arrangement:	Author and title in two alphabets.
scope:	Books published in the French language.
information provided:	Author, title, date, publisher, pagination, volume, size, price, ISBN.

Verzeichnis Lieferbarer Bücher: German Books in Print (Frankfurt am Main: Buchhändler-Vereinigung GmbH, annual editions).

arrangement:	Author, title, "und Stichwortregister," in one alphabet.
scope:	German language books from the Federal Republic of Germany, Austria, and Switzerland.
information provided:	Author, title, date, publisher, pagination, volume, size, price, ISBN.

Microform Replacement Sources

Association pour la Conservation et la Reproduction Photographique de la Presse (ACRPP). *Catalogue de microfilms reproduisant des périodiques*. (Paris: 1984–85, No. 13, irregular updates). Available from the Association at 4 Rue Louvois, 75002 Paris; also available from US distributor Clearwater Publishing, 1995 Broadway, New York, NY 10023, (800) 231-2266.

arrangement:	Alphabetical by title, in several alphabets.
scope:	Primarily French language periodicals from the late 18th century to the late 20th century, on microform.
information provided:	Title, date and place of publication, price.

Books on Demand (Ann Arbor, Mich.: University Microfilms International, annual editions); available in hard copy or fiche format.

arrangement:	Alphabetical by author or title.
scope:	Formerly out-of-print titles (monographs, generally) now available from University Microfilms as paper copies or as 35mm or 16mm microfilm.
information provided:	Author, title, publisher, date of publication.

Center for Research Libraries Catalog (Chicago: 1982, with supplement planned); microfiche; tapes available to load onto local online catalogs.

arrangement:	Alphabetical by main entry.
scope:	Holdings of the Center, including microform holdings.
information provided:	Author, title, place, publisher, date, pagination, CRL access number.

Guide to Microforms in Print (Westport, Conn.: Meckler Publishing, annual edition and supplement).

arrangement:	Author and title in one alphabet, subject in another.
scope:	Titles (serial, monographs, sets) that are available to be purchased from commercial and some noncommercial sources in the United States, Canada, and abroad.
information provided:	Brief entry, ISBN or ISSN, format, cost; for microform sets, little information is available on what contents of individual reels are; there are some "apply" notations, indicating that the title has not been filmed and that the publisher is waiting for a sufficient number of orders.

Guide to Russian Reprints and Microforms (New York: Pilvax Publishing, 1973).

arrangement:	Alphabetical by main entry in one volume, with no recent editions.

scope:	Russian books in reprint, with some microforms. There are no updated editions, but many titles are still available.
information provided:	Author, title, date and place of publication, price.

Microforms Annual: An International Guide to Microforms (Elmsford, N.Y.: Microforms International Marketing Corporation and Oxford Microform Publications, annual cumulations).

arrangement:	Broad subject arrangement of items available from Pergamon Press; journals are in separate list arranged by publisher.
scope:	Listing of scholarly journals and research collections published in microform.
information provided:	Title, place of publication, dates of publication, dates available for purchase, format, price.

National Register of Microform Masters (NRMM) (Washington, D.C.: Library of Congress, 1965–1975 cumulation, annual volumes for 1976–1983).

arrangement:	Alphabetical by main entry, Library of Congress cataloging.
scope:	Monograph and serial titles available from noncommercial and commercial sources.
information provided:	Author, title, publisher, place, date, source; no prices are given; information is provided only on "preservation masters," although by inference service copies are usually available.

National Union Catalog: Books microfiche (Washington, D.C.: Library of Congress, 1983–, monthly, with cumulations through the year). Starting in 1983, includes entries for microforms of monographs that formerly went to the *National Register of Microform Masters*.

arrangement:	Register and index format; register provides full bibliographic data. Access to register is provided by indexes (name, title, subject, and series) which display a shortened version of the record.
scope:	Bibliographic or catalog entries prepared by the Library of Congress or by a reporting library. Includes monographic microform publications (both microform reissues and items originally issued in microform).
information provided:	Full bibliographic record in the register, which includes type and source of microform.

Newspapers in Microform: United States (Washington, D.C.: Library of Congress, 1948–1983 cumulation)

Newspapers in Microform: Foreign Countries (Washington, D.C.: Library of Congress, 1948–1983 cumulation).

arrangement:	Main entry for newspaper titles within state or country, indexed by title.

scope:	Newspapers microfilmed and reported to the National Union Catalog by libraries and others in the United States and Canada.
information provided:	Institutional or commercial publisher where film is available, format of microform, no price given.

New York Public Library Register of Microform Masters: Monographs microfiche (New York: New York Public Library, The Research Libraries, 1983).

arrangement:	Alphabetical by main entry on 128 fiche.
scope:	Monographs (including many pamphlets) microfilmed by the library and available for sale by the library; 190,000 titles included.
information provided:	Author, title, place, publisher, pagination, date; information varies; master negative numbers often indicated, for ordering from the library's Photographic Service; no prices are listed.

Online Computer Library Center (OCLC) online database (available through OCLC, 6565 Frantz Road, Dublin, OH 43017-0702).

arrangement:	Access points include author, title, Library of Congress card number, ISSN, ISBN, series, corporate/conference name.
scope:	Incorporates some bibliographic records of commercial microforms purchased and cataloged by OCLC users and of master negatives produced by OCLC users, from whom copies can be obtained; also includes master negatives produced by users of the RLIN database through a tape exchange agreement.
information provided:	Main entry, title, edition, imprint, pagination, number of reels or microfiche, Library of Congress card number, institutional location, microform physical description.

Research Libraries Information Network (RLIN) online database (available through the Research Libraries Group, Jordan Quadrangle, Stanford, CA 94305). See also *RLG Preservation Union List.*

arrangement:	Access points include author, title, subject, series, corporate/conference name, Library of Congress card number, classification number, ISBN, ISSN, microfilming queuing date.
scope:	Incorporates bibliographic records of commercial microforms purchased and cataloged by RLIN users and master negatives produced by RLG members (from whom copies can be obtained), as well as some Library of Congress holdings; also includes some master negatives produced by both the British Library and users

of the OCLC database through tape exchange agreements.

information provided: Main entry, title, edition, imprint, pagination, number of reels or microfiche, Library of Congress card number, institutional location, microform physical description, "queuing date" for items scheduled for filming, holdings statement for serials.

RLG Preservation Union List (Stanford, Calif.: Research Libraries Group, irregular).

arrangement: Author and title in one alphabet.

scope: Microform masters held by RLIN and OCLC users, copies of which are available for purchase or loan, and titles scheduled for filming.

information provided: Main entry, title, edition, imprint, pagination, number of reels, Library of Congress card number, holding library, microfilm physical description, "queuing date" for those items scheduled for filming, holdings statement for serials.

Serials in Microform (Ann Arbor, Mich.: University Microfilm International, yearly catalog).

arrangement: Alphabetical by title.

scope: Over 13,000 titles, with many indicated with an "inquire" entry when the publisher has had insufficient orders to create a master for its file; masters meet national standards for archival quality; nonsilver film is available for discount over silver film; only service positives are available.

information provided: Title, dates of publication, volumes, ISSN, cost per reel, and cost of entire run. The phrase "previously published as" is used for some titles that appear as parts of other University Microfilms collections. For example, the "A" symbol indicates that the title is part of the American Periodical Series, "B" indicates a part of the British Periodicals I series, and so on. The library may already hold these titles in microform as part of one or more of these series.

Union List of Microfilms (Philadelphia: Bibliographical Center and Union Library Catalog; two volumes: 1942–49, 1949–59).

arrangement: Alphabetical by main entry.

scope: Predecessor to the *National Register of Microform Masters*; 77,000 mainly rare book and pamphlet items in microform, available from

institutional sources. No longer available, but for repositories that have it, best used for pre-1850 imprints or manuscript collections.

information provided: Author, title, date and place of publication, source and type of microform.

Detailed bibliographic and replacement searching can be a time-consuming process. Estimates for such searches average about 20 minutes or more per title for full searches, perhaps 7–10 minutes per title for all microformat replacement searches. For this reason, it is important to maintain files on previous searching done in this process to avoid expensive duplicate searching and to avoid overlooking an important microform replacement source. Every effort must be taken to locate and purchase existing microform rather than create duplicates, especially for extensive serial holdings.

Suggested Order for Searching Replacement Tools. To facilitate the searching process, search for replacements in the order suggested here. Search sources are arranged in a ranking, based on institutional experience, of those that most frequently contain citations for replacements, with the most comprehensive tools first.

For Microform Replacement

Monographs:
 Online bibliographic databases
 (RLIN, OCLC, etc.)
 NUC: Books
 National Register of Microform
 Masters (NRMM): 1965–75 cum.,
 then annual volumes through
 1983.
 NYPL Register of Microform
 Masters: Monographs
 Books on Demand
 Guide to Microforms in Print
 (GMIP) & Suppl.

Serials:
 Online bibliographic databases
 Serials in Microform (SIM)
 NRMM
 GMIP & Suppl.
 Microform Annual
 Others

Newspapers:
 Online bibliographic databases
 Newspapers in Microform (NIM)
 SIM
 GMIP & Suppl.

For Paper Copy Replacement

Monographs:
 Books in Print (BIP), its Suppl.
 & international editions
 Guide to Reprints
 Books on Demand (BOD)
 Others

Serials:
 Guide to Reprints (GTR)

Illustrative Materials

Materials that contain illustrations may not be entirely suitable for reformatting by preservation microfilming.[5] Certain types of illustrations can be filmed satisfactorily, but the quality can vary greatly, depending on the filming agent and the cost. In general, books or documents that contain original photographs, original lithographs, half-tone reproductions, plates, portraits, etc., do not convert well to film.

Depending upon the nature of the textual and illustrative materials under consideration, the screening process may result in decisions to (a) film and retain the entire volume or unit, (b) film the entire volume and retain the illustrations only, or (c) film and discard the entire volume.

The basis for any of these decisions will depend upon the aesthetic quality and value of the illustrations, their satisfactory (or unsatisfactory) rendering on film, their degree of deterioration or hope for conservation treatment, their physical bulk, and their relationship to the text. Illustrations are also a means of determining artifactual value. These might include illustrative processes or examples of considerable artistic merit; engravings; original photographs; high-quality photographic reproductions; colored plates; woodcuts, lithographs, etchings, or other prints; or "artists' books."

Color illustrations are rarely reproduced satisfactorily in standard black-and-white archival filming processes. Materials with important color illustrations should be considered for retention in original format, or should have the illustrations retained after filming the text, whenever possible.

Formats, Frequency, and Type of Usage

Dictionaries, encyclopedias, indexes, music scores, maps, and other materials have been successfully converted to a preservation microformat in several institutions. Certainly, numerous bibliographic catalogs receive heavy use in microform. However, you should consider whether microfiche or self-contained roll-film (35mm or 16mm cartridges) is better suited for use by researchers than is the open reel.

Consider preservation microfilming combined with Copyflo production for such items as important, heavily used, and brittle music or reference materials such as dictionaries or encyclopedias. In this application, the negative microfilm is used to create an acid-free paper copy, which can then be bound as a book. Drawbacks of this option are: (1) the bulk of the copy is often increased over that of the original; (2) there may be loss of image quality; (3) Copyflo capabilities are not easily found in many locales; (4) cutting the paper must be exact or there will be difficulties in binding; and (5) cost.

Folded maps from monographic and serial publications may or may not lend themselves to reformatting by filming. Colored maps may be particularly difficult to film, due to the slight differences in contrast when the colors are filmed on black-and-white film stock. Such maps should be considered for retention in their original format, especially if your institution

5. See "Preservation Microfilming and Illustrated Materials," *National Preservation News* 6:12–13 (Oct. 1986) for an explanation of the Library of Congress approach.

can house them properly. Maps printed before certain dates, notably the year 1850, should be seriously considered for retention in the original format, regardless of size, because of their artifactual value. The size of some maps can make their film reproduction an unsatisfactory option for selectors. Large maps must be filmed in segments, making them difficult for researchers to use. A careful consideration of how researchers use such material in oversized or unusual formats must underpin preservation decisions.

Value

Even though most items in a research collection are valued primarily for their intellectual content, certain items may possess intrinsic value as artifacts or objects and should be preserved and retained in their original or near-original forms, although it may be wise to consider making a microform copy for security reasons or to reduce handling of the original. Various authors have used the terms "artifactual," "intrinsic," "historic," and "bibliographic" value to emphasize the special status of the original and the caution with which decisions to microfilm and/or discard should be approached. The terms are often used interchangeably, despite their technical definitions, but their importance in a microfilming program is clear:

> *Intrinsic or artifactual value:* "the value of a single book, (or other library item) alone, without consideration of the aggregate value when a book is considered part of a collection of great worth"[6] *or* "the archival term that is applied to permanently valuable records that have qualities and characteristics that make the records in their original form the only archivally acceptable form for preservation. Although all records in their original physical form have qualities and characteristics that would not be preserved in copies, records with intrinsic value have them to such a significant degree that the originals must be saved."[7]
>
> *Bibliographic value*: "the importance of information to be gathered from a book through a study of its physical parts, structure, format, and printing."[8]
>
> *Historic value*: "the interest that a book or binding has beyond the information transmitted by the printed words; the integrity of a book in terms of the original production details and accidents of time."[9]

These materials have qualities—either physical qualities (as physical evidence) or intellectual qualities (as information)—that are totally or significantly lost in their reproductions. It is the physical *and* informational nature of an item—its age, its rarity, its historical or technological or bibliographic

6. Carolyn Clark Morrow, *Conservation Treatment Procedures: A Manual of Step-by-Step Procedures for the Maintenance and Repair of Library Materials* (Littleton, Colo.: Libraries Unlimited, 1982), p. 182.

7. U.S. National Archives and Records Service, *Intrinsic Value in Archival Material*, Staff Information Paper 21 (Washington, D.C.: 1982), p. 1.

8. Morrow, *Conservation Treatment Procedures,* p. 179.

9. Ibid., p. 182.

importance, its close connection with an event, etc.—that should prevent its discard, even if it is reproduced in some fashion. The responsibility for determining which items possess intrinsic, historic, or bibliographic or other artifactual value lies in the archives with the curator or archivist, and in the library with the selector having curatorial responsibility for that portion of the collection. Several institutions (among them the Library of Congress, the National Archives and Records Administration, and the New York Public Library) routinely microfilm portions of their collections and have outlined guidelines for retention of certain items in original format because of intrinsic value. Materials having intrinsic or artifactual value will possess one or more of the following physical or information qualities or characteristics.

Date of Publication or Creation. Institutional usage varies in the setting of arbitrary dates that dictate when an item is to be retained in its original format. Some libraries set 1850 as a cut-off date, others 1801. More often, however, the importance of the date of publication or creation is dependent upon the place and circumstances of publication.[10]

Certain 20th-century materials possess as much intrinsic or artifactual value as those of the 19th or earlier centuries. Documentary records concerning the radio industry, nuclear power, or computing are examples of items with growing artifactual significance.

Rarity or Scarcity. The qualities of rarity or scarcity must be based upon information found in a search in the *National Union Catalog of Pre-1956 Imprints*, or in another specialized bibliography that verifies rarity, scarcity, or uniqueness. This may include items issued in very limited editions; copyright deposit editions; publishers'/reviewers' advance copies of certain works that may differ in content and form from the published edition; or, certain published editions of which very few copies exist.

Association Value. Some books may not be valuable in themselves but become so because of their association with persons or events. For example, the book may contain marginalia written by a locally or nationally important person in his or her hand, or have valuable ownership marks or book plates. Presentation copies or other inscribed copies are another type, as are books with manuscript material attached or added.

Items of Aesthetic or Design Value. Books with interesting overall designs are best kept in original form. These include 19th- and early 20th-

10. Some commonly cited categories of material having artifactual value are: incunabulum, items printed in England before 1640, any Confederate imprint, imprints with early regional importance (e.g., Chicago imprints before 1871, etc.). Many libraries follow Library of Congress practice in terms of determining when a title should be considered a rare book. For a list of cut-off dates, see: Tamara Swora and Bohdan Yasinsky, *Processing Manual* (Washington, D.C.: Library of Congress, Preservation Microfilming Office, 1981), p. MONO-11. The same list can also be found in: American Imprints Inventory, *Manual of Procedures*, 5th ed. (Chicago: Historical Records Survey, 1939), p. 46.

century cloth-bound volumes with aesthetically interesting cover designs, or that document the history of such bindings; fine bindings; period bindings; and signed or designer bindings.

Unique, Unusual, or Curious Physical Features. Items that possess unique physical features, such as the quality and texture of the paper, imprints, watermarks, decorated endpapers, gilded and gauffered edges, fore-edge paintings, wax seals, inks, or unusual covering materials, are not suitable candidates for film replacement.

Exhibition Value. If items have value for use in exhibits for their ability to convey the immediacy of the event, or depict a significant issue or quality that only an item in original form can impart, they should be retained. These may include:

1. Items of questionable authenticity, date, authorship, or other characteristic ascertainable primarily by physical examination.

 Books or documents that are suspected of being forgeries or fakes, or some photographs of UFOs, are examples of questionable items that may be artifactually significant.
2. Items with significance as a record of the establishment or continuing legal basis of an agency or institution.

 As outlined by the National Archives, these are archival documents with the common characteristic of documenting the shifts in function of the agency or institution at the highest level.
3. Items with significance as documentation of the formulation of policy at the highest executive levels, when the policy has significance and broad effect throughout or beyond the agency or institution.

 Again, as outlined by the National Archives, the characteristics that give policy records intrinsic value are the origin of the records at the highest executive levels, breadth of effect, and importance of subject matter.
4. Items whose physical form may be the subject for study if they provide meaningful documentation or significant examples of the form.

 Examples of artifactually valuable items of this type are: glass plate negatives; an edition that was the first to be produced by the linotype process; early cloth bindings; early machine-made papers; early Rotogravure pictorial reproductions.
5. Items that must be retained in original format by law.

 Depending upon the institution or organization, these might include articles of incorporation, constitutions, bylaws, titles, deeds, policies, and so on.

Donor or Copyright Restrictions

Certain volumes, documents, manuscripts, or papers may not be suitable preservation microfilming candidates if donor restrictions affect either the use of the materials or their withdrawal from the collection. Depending on how the films are to be used, the issue of copyright may also affect selection

of items for filming. If your intent is to create more than one copy of a film and to sell the copies, then the title to be filmed must either be in the public domain or copyright permission should be obtained. How can you tell?

Under the 1980 Copyright Law (Title 17, United States Code), works in the public domain include the following:

those that bear a notice of waiver of copyright;

those published before 1978 without a notice of copyright;

those whose copyright has expired, because they were published more than 75 years ago;

those whose copyright has expired because they were published between 28 and 76 years ago and copyright was not renewed.

While the first three will normally be self-evident from the information in the book, the latter may require considerable research to determine, starting with a letter to the publisher and perhaps proceeding to a full-scale search of records in the Copyright Office in the Library of Congress. For manuscripts, permission must be obtained from the author or donor.

The copyright law does allow for preservation of copyrighted works. Section 1086 states that unpublished works can be "duplicated in facsimile form solely for purposes of preservation and security." Further, Section 1086 states that published works can be "duplicated in facsimile form solely for the purposes of replacement of a copy that is damaged, lost, or stolen if the library has, after reasonable effort, determined that an unused replacement cannot be obtained at a fair price." Copyright is not a serious issue, if the items being filmed are esoteric and unlikely to be in heavy demand. But if, for example, an institution is planning to contract with a commercial vendor to film titles that will be packaged and sold as a set, copyright clearance is crucial.

Cost of Filming

The cost of filming an item may be so high, because of either length (a long serial run) or characteristics that require special handling (extreme brittleness, odd size, etc.), that it would overpower the budget. While the item may meet all the criteria for inclusion in a microfilming program, it may have to be set aside until special funding is available.

Shelf Space

Conversely, the institution may decide that filming long runs of serials or other coherent collections will so significantly improve space constraints that these items should be filmed as a unit, even if some individual pieces are less suitable (e.g., one issue of a serial has important illustrations).

Intellectual Importance of the Material

Most of the foregoing have dealt with physical characteristics. This element in the screening process responds to the intellectual value of the item in the subject or discipline and in the local collection, as seen by scholars, cus-

todians, or subject specialists. The knowledge these evaluations should bring to this task is outlined in the preceding section on responsibilities of participants and can be applied at a variety of points in the identification and screening process.

Potential for Being Filmed Elsewhere

Microfilming is not a new technology. As early as 1938, the Library of Congress and other institutions began to mount large-scale projects devoted to categories of material. Newspapers received, and continue to receive, great emphasis, as have serials. Certain institutions have staked out territories for filming, based on geographic imprints or subjects. For years the Center for Research Libraries filmed African, Southeast Asian, South Asian, and Latin American materials, for example. A large-scale classics filming project is under way, supervised by the American Philological Association. The participants in the Research Libraries Group's cooperative program have divided responsibilities by broad subject classes. Commercial micropublishers are also involved in establishing large collections.

You must educate yourself as to what projects are in progress and what the criteria for inclusion are in order to make decisions that complement these efforts. Finding the information, however, is no easy task. There is no centralized source for vetting current or potential projects, although the Library of Congress's National Preservation Program Office is planning to develop just such a clearinghouse role. You must constantly peruse the library and information science press and communicate with other institutions and with vendors to keep abreast of developments. If it is likely that an item may be covered elsewhere, the decision to put it aside for the time being (or even to ask another institution specifically to include it!) is not an unwise one.

Conclusion

Selection for preservation in the research collection is essential and often difficult. There exists no easy, simple formula to tell librarians and archivists just what to save and how, or what to toss and why. In this process of selection lies the future of the documentary record. It cannot be undertaken lightly.

Although large amounts of textual materials are assured of a future through preservation microfilming, it is clear that not all library and archival materials are suitable for this or other reformatting techniques. The screening criteria outlined here can be used as a general guide, which, combined with common sense and sound judgment, will lead to wise decisions. The only alternative is to let chance and accident make the decisions for us.

List of Suggested Readings

Association of Research Libraries. Office of Management Studies. Systems and Procedures Exchange Center. *Basic Preservation Procedures*. SPEC Kit No. 70. Washington, D.C.: ARL, OMS, 1981.

Atkinson, Ross W. "Selection for Preservation: A Materialistic Approach." *Library Resources and Technical Services* 30:341–53 (Oct./Dec. 1986).

Bagnall, Roger S. "Who Will Save the Books? The Case of the Classicists." *Humanities* 8:21–23 (Jan./Feb. 1987). Also in *The New Library Scene* 6:16–18 (April 1987).

_____ , and Carolyn L. Harris. "Involving Scholars in Preservation Decisions: The Case of the Classicists." *Journal of Academic Librarianship* 13:140–46 (July 1987).

Banks, Paul N. "Preservation of Library Materials." In *Encyclopedia of Library and Information Science*, vol. 23, pp. 180–222. Ed. by Allen Kent, Harold Lancour, and Jay E. Daily. New York: Marcel Dekker, 1978.

Borck, Helga. "Microforms." In *Preservation of Library Materials*. pp. 71–76. Ed. by Joyce R. Russell. New York: Special Libraries Assn., 1980.

Bourke, Thomas A. "The New York Public Library Register of Microform Masters: Monographs." *Microform Review* 13:17–21 (Winter 1984).

Child, Margaret S. "Selection for Preservation: Deciding What to Save." *The Abbey Newsletter: Bookbinding and Conservation* 6:1–2 (Aug. 1982). Supplement.

_____ . "Further Thoughts on 'Selection for Preservation.' " *Library Resources and Technical Services* 30:354–62 (Oct./Dec. 1986).

Columbia University, New York. The Libraries. "The Preservation of Library Materials: A CUL Handbook: Guidelines and Procedures." Rev. ed. New York: Columbia, 1985.

Duckett, Kenneth W. *Modern Manuscripts: A Practical Manual for Their Management, Care, and Use*. Nashville: American Association for State and Local History, 1975.

Haas, Warren J. *Preparation of Detailed Specifications for a National System for the Preservation of Library Materials*. Washington, D.C.: Association of Research Libraries, 1972.

Hazen, Dan C. "Collection Development, Collection Management, and Preservation." *Library Resources and Technical Services* 26:3–11 (Jan./Mar. 1982).

Henderson, James W. "Memorandum on Conservation of the Collections." New York: New York Public Library, 1970.

_____ , and Robert G. Krupp. "The Librarian as Conservator." *Library Quarterly* 40:176–92 (Jan. 1970).

McCrady, Ellen. "Selection for Preservation: A Survey of Approaches." *The Abbey Newsletter: Bookbinding and Conservation* 6:1,3–4 (Aug. 1982). Supplement.

Magrill, Rose Mary, and Constance Rinehart. "Selection for Preservation: A Service Study." *Library Resources and Technical Services* 24:44–46, 51–57 (Winter 1980).

Mills, T. F. "Preserving Yesterday's News for Today's Historian: A Brief History of Newspaper Preservation, Bibliography, and Indexing." *Journal of Library History, Philosophy and Comparative Librarianship* 16:463–87 (Summer 1981).

Morrow, Carolyn Clark. "A Conservation Policy Statement for Research Libraries." Occasional paper no. 139. Urbana, Ill: Univ. of Illinois, 1979.

New York Public Library. The Research Libraries. *Permanent Retention of Materials in the General Collections in Their Original Format*. Technical Memorandum No. 40. New York: NYPL, 1975.

"Preservation Microfilming and Illustrated Materials." *National Preservation News* 6:12–13 (Oct. 1986).

Robinson, Lawrence S. "Establishing a Preservation Microfilming Program: The Library of Congress Experience." *Microform Review* 13:239–44 (Fall 1984).

Sajor, Ladd E. "Preservation Microfilming: Why, What, When, Who, How." *Special Libraries* 63:195–201 (April 1972).

Tanselle, G. Thomas. "Bibliographers and the Library." *Library Trends* 25:745–62 (April 1977).

Tomer, Christinger. "Identification, Evaluation and Selection of Books for Preservation." *Collection Management* 3:45–54 (Spring 1979).

U.S. National Archives and Records Service. *Intrinsic Value in Archival Material*. Staff Information Paper 21. Washington, D.C.: NARS, 1982.

_____ . *20-Year Records Preservation Plan*. Washington: NARS, May 1984.

Walker, R. Gay. "Preserving the Intellectual Content of Deteriorated Library Materials." In *The Preservation Challenge: A Guide to Conserving Library Materials*, pp. 93–113. Ed. by Carolyn Clark Morrow. White Plains, N.Y.: Knowledge Industry, 1983.

3

Production Planning and Preparation of Materials

Once you have completed the selection of volumes, documents, or newspapers to be microfilmed, a new phase of the preservation microfilming program begins. The materials must be prepared, sorted, packaged, and delivered to the camera. In a large institution, the work might pass at this stage from the preservation administrator to the preparation manager; in the smaller institution, the administrator simply puts on a different hat.

Simple common sense is the key to preparation of materials for microfilming, bolstered by (1) a thorough understanding of the filming process; (2) good communication with the filming laboratory; and (3) an analysis of the intended use of the film product. The preparation step is filled with endless details, but it is equal in importance to the processes of selection and filming. Thinking through and understanding the consequences of each decision of the preparation process will have a major impact on the value of the microforms created.

Preparation is a labor-intensive, production-oriented task. This chapter explains how to go about planning the production of materials that are camera-ready and how to communicate with the filming agent. Second, it rehearses for you the administrative decisions that must be made before you begin the preparation process. The chapter closes with an in-depth discussion of preparation procedures. Some of the routines to handle internal recordkeeping and statistics, as well as bibliographic control of the microfilm, may need to be integrated with the preparation process. See Chapter 5 for a discussion of these functions.

Production Planning and the Filming Agent

A library or archival repository may have several possible options for handling the actual filming when planning a microfilm project. Your institution may have an in-house photoduplication laboratory, either as an administrative adjunct to a preservation department or as an independent department, or it may use an outside film laboratory (sometimes known as a service bureau) or commercial micropublisher. Whatever the organizational relation-

ship between the preparation unit and the filming agent (used here to refer to either in-house camera operations or external service bureaus or vendors), certain responsibilities need to be assigned, with a clear understanding between both parties of these duties. In some cases a formal contract delineates these tasks; in others, informal agreements may suffice.

Preparation of documents for microfilming cannot be undertaken without a full discussion of a number of topics with the filming agent, whether in-house or outside. Your in-house laboratory may not have been involved in high-quality preservation filming or have worked with fragile materials before. You cannot assume that an external service bureau has worked with libraries or performed preservation microfilming, even if the bureau uses the word "archival" to describe its service. Nor can you assume that, if a service bureau has worked for another institution, you will receive the same level of service. The definition of "archival" for business purposes may only be seven years, the legal requirement for retaining business records, not the permanency required by archives and libraries.

Preliminary discussions are a good way to determine the level of experience and interest a filming agent may have in your project. If a contract is to be let, these discussions may take place as part of a meeting of potential bidders, and some points may also be included in the final contract specifications. (See Appendix 2 for a sample contract.) Figure 5 lists the topics that must be thoroughly explored and understood by all to ensure a satisfactory relationship.

Figure 5. Discussion Checklist for Preparation Manager and Filming Agent

1. Filmer's adherence to standards published by the American National Standards Institute and other technical specifications prepared by repository.

2. Type of material to be filmed.

3. Type of film and final product (e.g., film or fiche) desired.

4. Type of equipment available in the filming laboratory.

5. Types of targets to be supplied and by whom.

6. Policy on whether volumes are to be disbound and by whom.

7. Technical inspection procedures and report.

8. Bibliographic inspection.

9. Policy on correction of errors and splicing.

10. Number and type of film copies required.

11. Pricing structure.

12. Quantity of documents, rate of work flow.

13. Need for reel programming and frame counts.

14. Insurance.

Standards and Guidelines

Before you meet with the filming agent, you should be familiar with the various standards, specifications, and guidelines relative to archival film and its stability in manufacture, use, processing, and storage. These same documents touch briefly on preparation of materials for filming. At a minimum these include micrographics standards produced by the American National Standards Institute (ANSI) and the Association for Information and Image Management (AIIM). But you may also adapt or build on guidelines produced by such organizations as the Library of Congress, the Research Libraries Group, the National Historical Publications and Records Commission, or the Society of American Archivists (see Appendix 1). It is your responsibility to prepare the technical specifications and filming instructions for the materials you wish to have filmed. But the minimum requirement for any negotiation with a filming agent should be the ANSI/AIIM standards. A description and discussion of these standards and specifications follows in Chapter 4.

Preparing a Sample for Filming

Prior to beginning discussions, assemble a group of at least three sample volumes, folders, series, or other physical units for the filmer. The sample should reflect the variety and range of items to be included in the project or likely to be found in your collection. Examples are volumes with very yellowed or discolored paper, bound and unbound materials, volumes that contain variations in paper color or illustrations, oversized materials, etc. Following your preliminary discussions, ask the potential filmer to film the sample in accordance with your prepared technical specifications and instructions.

This sample film may be the only information available to evaluate the filming agent's technical quality, judgment, common sense, and ability to follow instructions, so it is important to include challenging examples to see how the given technical specifications are applied to the work performed. The sample will allow you to find out the agent's strengths, weaknesses, or limitations, or, if the laboratory is in-house, to correct problems.

Meeting the Filming Agent

If your institution has an in-house filming laboratory that reports to the preservation administrator, constant communication is part of the process of supervision. But if you will be working with an internal photoduplication laboratory in another department or with an external contractor, meeting with the filming agent is crucial. Filming agents are a great resource of technical capacity, knowledge, and expertise, but they must be willing to work closely with the library or archives to perform the services required. The better informed the filming agent is about preservation microfilming and the goals and objectives of the institution, the better the agent will be able to respond and provide a quality service. As preparation manager, you should

not underestimate the judgment necessary to interpret and apply the technical specifications. If, through constant communication, the institution and the filming agent think alike, the foundation for a productive relationship is established.

Filming agents performing work for libraries or archives for the first time may not really know how much it will cost to fulfill the requirements. This step may be as much a learning process for the agent as it is for the institution. It may be that only time and experience will allow an agent to estimate accurately costs that can be held stable for a reasonable period of time. Some agents may make prices attractive because they want to get into the growing preservation microfilming market, develop your institution as a continuing customer, or obtain useful subsequent references.

Equipment and Film Inspection

A site visit, preferably unannounced, is a good opportunity to see if an operating filming facility lives up to its billing. You should note whether the facility is clean and orderly and dust free. Note where materials are received and stored, and how they are handled in unpacking and throughout laboratory processing. Observe the equipment in operation: familiarity with the equipment is important to the complete understanding of what is required of physical preparation. If you anticipate filming from bound volumes, for example, make certain the agent owns and uses a book cradle. Are there heat and/or ultrasonic butt weld splicers on the premises? Splicing tapes are not to be used on archival films. Ultrasonic splicers are required for polyester films and preferred for cellulose ester films. Ask to see how targets are prepared and/or what stock targets are available (see section on targets elsewhere in this chapter). Knowing the filmer's options for target production will affect preparation procedures and should be understood in advance.

The filming laboratory needs reasonably good temperature and humidity controls to avoid, among other things, the ill effects of static electricity, especially during high-speed duplication of roll film. Static electricity can interfere with the proper functioning of electronic parts of cameras and other equipment, and it can also result in minute sparks, which may register on film in such forms as star-shaped spots, round spots, or minute streaks. Inquire into how the laboratory monitors temperature and humidity.

If valuable originals are to be filmed, then look for a safe or vault to store the documents while they are not being filmed. Such materials should not be left unguarded when the technician interrupts filming. Note, if you can, whether materials are handled with the care that precious documents require. Inquire into the agent's insurance coverage and make certain you understand the points in the process where the agent's coverage begins and ends.

In addition to the filming cameras, look for work stations to support two types of inspections of the finished film. A *technical inspection* requires that inspectors examine the film over a light box, using a pair of film rewinds to maneuver the film. A loupe (a magnifying instrument), a densitometer (to

measure the optical density of an image or base), and a 50–100× microscope (to measure resolution) should be nearby. Notice whether inspectors are wearing lint-free gloves to avoid damaging the film. The filming agent should prepare a report based on the laboratory's inspection and relay it to the preparation manager (see Chapter 4, Figure 17). A full frame-by-frame *bibliographic inspection* requires use of a microfilm reader to spot missing pages or illegible text. Since the filming agent may accept responsibility for both inspection roles, you should see that the proper equipment is in place.

Film Correction

Once you have learned of the inspection procedures and splicing equipment of the filming agent, the policy on film corrections should be scrutinized. The filmer should perform corrections for errors in filming (omitted pages, obscured text) at no charge. This is ordinarily done by refilming the necessary pages and splicing the new film into the old. Because each splice weakens the film, the number should be kept to a minimum. The Research Libraries Group guidelines are the most specific on this topic: they permit only six splices on the standard 100-foot reel of film (camera negative only) and, following general practice, none at all on the printing masters or service copies.[1] There should be no splices between the technical target and the adjacent ten frames of text.[2]

Working with this guideline, there must be some flexibility. Larger sections may be refilmed (known as retakes) and spliced in to cover an area with many mistakes. Retakes should include at least two frames preceding and succeeding the pages being refilmed. It is not a good policy to depend on splicing to correct mistakes in preparation, such as having pages out of sequence, and the filmer should not depend on splicing to correct poor filming practices. Corrections are possible but expensive and not to be encouraged; careful and thorough preparation and subsequent camera work are the keys to minimizing the need for corrections.

Review of Completed Microfilm Samples

When the film samples are returned, you should review them thoroughly and promptly for quality and adherence to specifications and instructions. If samples have been given to several filming agents as part of the selection process, give clear comments and suggestions to the best of them. Ask the agents to refilm and make corrections as necessary until the sample is fully acceptable. If needed, additional samples should be prepared and filmed until you are confident about the quality of the film and its adherence to required standards and specifications.

1. *RLG Preservation Manual*, 2d ed. (Stanford, Calif.: Research Libraries Group, 1986), p. 23.

2. *Specifications for the Microfilming of Books and Pamphlets in the Library of Congress* (Washington, D.C.: Library of Congress, 1973), p. 3.

The Institution's Role in Quality Control

This initial quality control step on the sample materials should be performed by the preparations staff. Even without technical support, the staff can check for adherence to filming instructions (proper targeting, quality control forms filled out, correct order and completeness of material) and image legibility. Testing for density and resolution requires technical equipment found in a film laboratory. Another institution or colleague with preservation microfilming experience might be able to assist you if your institution does not have sufficient expertise in this area.

Requiring 100 percent quality control from your filming agent and inspecting the sample films does not conclude your institution's role in assuring the continuing quality of the filming agent's work. Chapter 4 discusses the procedures for routine film inspection by the filming agent. A second inspection for quality or a spot check on completed film is your ongoing responsibility. Since it will logically fall to the preparations staff to perform this work, you must take this into account when planning production goals and workload. If you plan to use a service bureau for preparation of materials, you must still make provision for final film inspection by institution staff. Errors can happen. In one case, for example, an experienced filming agent accidentally used on each reel of an entire shipment a target that specified the wrong institution as the owner of the film. The institution's film inspectors caught the error.

The inspection process begins by reviewing the filmer's quality control reports. Data should be complete and within the required range. Film should be checked for image quality to make sure that it is legible, clear, and sharp, the contrast is good, and the density even throughout. The film should be free of scratches, defects, or marks that obscure text. The documents or pages should be complete and in correct order, and targets should appear as specified. Occasionally, the same page may be filmed twice for no apparent reason. Unless this happens frequently, you may wish to establish a local policy to ignore it.

Usually, the only equipment needed for inspection is a microform reader. Make sure it is cleaned frequently. The rollers and glass flats of microform readers, a primary cause of abrasion, should be inspected and cleaned weekly or biweekly to prevent damage to the film from dust particles. *Inspect only the printing master or service copy.* The preservation master negative should not be put on a reader. If a problem in the preservation master is suspected, use a light box with rewinds and loupe to check it.

Copies and Costs

After the sample is filmed, agents should supply cost data or estimates based on the actual materials they have filmed. Prices for filming are usually on a per-exposure basis, with surcharges possible for bibliographic target preparation, special handling in filming, certification of the filming process or processing, or special boxing/labelling requirements. This cost covers the original preservation master negative. Charges for additional cop-

ies (i.e., printing master, if required, and service copies) may be at a flat rate or based on film footage. It may be possible to establish an inclusive per-exposure charge that would cover a standard order (e.g., three copies of each reel: a preservation master, a printing master, and a service copy). If you require a copy-on-demand service or expect the filming agent to provide archival storage for master negatives, supply the relevant specifications and ask the filmer to provide for these costs.

Work Flow

You should discuss expectations for work flow with the filming agent prior to project initiation. The rate of preparation of materials must be compatible with the filming rate so that staff in each stage are best utilized. Keep in mind the time required for the preparations staff to perform quality control and postprocessing routines, that is, assembling materials and documentation, closing out records, forwarding master negatives to storage and service copies to cataloging. Are x number of titles (or x number of pages) to be delivered and filmed at one time, or over a period of time? Will the filming agent use all cameras for a short time or dedicate a smaller number on a continuing basis? Is there an end date for project completion, for instance, grant funds that must be used? What happens if either side does not meet expectations for work? A clear understanding of requirements and concerns in advance is the best policy for successful work flow.

Preparation Procedures

With some elements of the project firmly under control, we now turn to preparation of individual items for microfilming. Not surprisingly, you will find a number of administrative decisions to be made and communicated to the filming agent before you begin.

Procedures Manual

Planning a procedure for preparation means anticipating problems, as far as possible, so that once begun the process will continue with few interruptions. This allows efficient use of staff as well as a steady flow of materials to the filming agent. A detailed procedures manual is almost always a requirement, especially if you plan to use students or clerical workers to undertake preparation with minimal supervision. If yours is a new project—and likely to be long-term—plan a start-up phase to include preparation of a precise procedural manual. Projects with immediate goals for completion, because of funding or filming schedules, publication deadlines, or other reasons, will demand more administrative-level supervision for on-the-spot policy decisions, which will eventually generate a procedures manual. Common sense still prevails, but it must be coupled with an understanding of the aims and goals of the project.

Administrative Decisions

Preparation of items for microfilming involves two levels of concern: physical and editorial (or bibliographic). *Physical preparation* covers collating the materials (checking the volumes or documents for completeness and making sure they are in order), disbinding (a term used to describe the process of removing a volume's binding and separating the leaves into individual sheets), cleaning, and repairing materials, decisions based on the format, age, and condition of the originals, as well as an understanding of the filming process. *Editorial preparation* includes preparing additional bibliographic information and finding aids to be filmed with the volume or document. Administrative decisions at the preparation level will guide the approach to aspects of both editorial and physical preparation.

Staffing Requirements. The actual number of full-time staff needed to prepare materials for a filming project is not a figure to be read from a table. Some institutions have found that it takes one full-time staff member to search, collate, and prepare targets for enough materials to keep one camera filming full-time; the type of material (serial runs, monographs, or scrapbooks, for example) would affect the amount of time required. The division of labor may vary, with different units responsible for searching, collating, targeting, and filming. The preparations staff may also be responsible for postfilming processing of microforms, which will add to the workload. Offered here are guidelines as to what procedures to undertake and how to evaluate the materials chosen for filming for possible preparation problems. With this information it is hoped that you will find sufficient resources to complete the task. The labor of preparation is too often overlooked in program development; skimping on it will seriously compromise the microforms produced.

Some of the decisions and subsequent actions in preparation of materials will involve a variety of services in the usual library or archives setting. Once materials are identified for filming (curatorial/bibliographic review), they are collected and assembled (public service/paging activity), their presence in a project status noted to patrons (circulation/reference activity), and finding aids or other guides provided. Repair, disbinding, or other physical treatment may be required (conservation function), and bibliographic records must be located and prepared (cataloging). At this point it is clear that one central coordinating office or position (here called the preparation manager) should be designated to push and pull materials through the necessary hoops; this becomes even more important when dealing with an outside service bureau, which will need one contact for problems that arise. A small organization may have one person doing it all; in larger organizations a full-time position may be needed just to coordinate the flow of materials, with each separate activity the speciality of a different person. A greater degree of specialization of tasks may allow a project to handle large numbers of materials efficiently, but it also emphasizes the preparation manager's role in project supervision.

Expected Use of Microform. The expected use of a microform will affect preparation procedures and should be considered in advance. For example, will the film be used frequently to generate paper copy, either through Copyflo or reader-printer equipment? This may affect the way the pages are oriented on the film and should be discussed with the filming agent for consideration in the technical set-up of the film. Is the filming project based on an existing bibliography, or are you preparing a guide or other finding aid for it? If your users will normally use these tools first, you may need to consider including the bibliography's citation numbers on the film or a location key from the film to the guide, so that users can easily locate specific items.

Will your end product be roll microfilm or microfiche? The advantages and disadvantages of each were detailed in Chapter 1, but either format is suitable for preservation microfilming programs. In some cases, roll film is retained for the preservation master negatives, with microfiche produced for the service copies. But microfiche master negatives can also be successfully produced and stored according to archival standards. Consultation with your institution's reference staff and/or microform specialists regarding microformats and associated bibliographic tools in local use may be the key to a wise decision on the most appropriate format.

Generally, microfiche turn out to be more complicated to produce and thus more expensive. Chapters 4 and 6 discuss production methods and costs. If microfiche is your choice, you will need to decide this well in advance and determine what information your filming agent needs in order to plan the layout of the microfiche.

Disposition of Originals. The previous chapter pointed out the necessity for making a decision regarding disposition of the originals as part of the selection routine. This decision has a substantial impact on preparation procedures. The filming process may not damage materials, but knowing they will be discarded after filming permits you to disbind them and to make less costly minor repairs to ready the pages for filming. While disbinding a bound volume is not a prerequisite for microfilming, it may be necessary to obtain the best quality product. The intrinsic value of the document may justify full restoration of pages prior to filming, but this expensive process is not, of course, appropriate if the item is to be discarded.

Record Keeping and Statistics

Once materials are charged out to preparation, there must be a mechanism in place to keep track of the many items flowing through the whole processing stream (through preparation stages, filming, and postprocessing to cataloging). What goes in at one end must come out the other. The larger the flow of materials, the more important, but also the more time-consuming, record keeping becomes.

If a unique microform shelf or location number can be assigned early in the process, this may suffice for tracking purposes. Otherwise, the simplest

method is to assign a control number for each title and to track the workflow by maintaining a log book. As preparation begins, the title is logged in. When filming and inspection is completed, the title is logged out. The log book can be expanded to include the date materials are sent to the filmer, and a check in when they are returned. This may be the best way to tell if something has gone astray. If an outside vendor is used, information about quantity and contents of shipments can be used to verify invoices for work completed. The degree to which a system needs expansion depends on the size of the project or work flow, and whether filming is performed inside or outside the institution. A more sophisticated tracking system might involve the development of an online database that can be updated at various points throughout the process and also generate statistics.

There is information associated with each title or collection that needs to be maintained, in one place, through processing. This is an in-process record or file that can be linked to the material through the title control number. It might consist of a bibliographic record and worksheet or decisions form for recording search information, the decisions to retain or withdraw, and a borrowing history. Files for serials and manuscript collections will often include collation information used for preparation of targets, instructions for filming, or information for cataloging.

Statistics should be collected to measure how much work is accomplished by the unit over time, and to measure individual as well as unit production levels and performance. Decide what you need and how it will be used before you decide what to collect. In preparation, you want to know how many titles, volumes, or items have been processed. A breakdown by staff member and type of material (e.g., books, serials and newspapers, manuscript collections) may be useful. Clearly, a title count would be inappropriate to measure the production level of a staff member working on serials compared to one processing monographs. In filming, you need to know how many items were filmed, the number of exposures, and the number of feet or reels duplicated, along with a breakdown by staff member and by project. If an outside vendor is used, the amount invoiced for completed work should be recorded.

Three Stages of Preparation

There are three stages to preparation: physical, editorial, and final. Your initial review considers the *physical state of the materials*. For routine library materials, this is the point for title collation and identification of missing pages, issues, volumes, etc., needed to complete the title prior to filming. Note which volumes need to be disbound. Manuscript collections require one pass through to note whether the documents need cleaning, repair, or flattening, followed by another to perform repairs.

The second review is *editorial*. At this point you will prepare targets and construct title or collection guides and finding aids for serials and manuscript collections. Here also you will "program" the reels, that is, determine what will be on each one before filming takes place, if necessary.

Third is the *final preparation* stage. This is the time to check the accuracy

of all phases of preparation and compile instructions to the filmer. This is the most important step for large serials and manuscript collections, where preparation and filming decisions may have been made over a substantial length of time.

When preparing books, the novice should learn the series of tasks or steps in each stage before moving on to the next. After tasks are mastered, it is best to process several titles at a time to gain efficiency. Each stage in the preparation of an archival or manuscript collection should be approached individually, concentrating on one theme or task in each complete pass-through of the materials. Serials fall somewhere in between, but are generally complex enough to be processed one title at a time. With practice, staff experienced in preparation routines will think simultaneously about editorial preparation and physical preparation and what instructions need to be prepared for the film.

Physical Preparation

In the initial review, materials are examined for physical condition. Pages that are uniform in size and contrast and in good condition, and that lie flat on the camera bed, can be filmed most efficiently. But there are many other factors that can affect the quality of the film and may require special handling at, or before, filming: filming of bound volumes, treatment of folded material, minor repairs, unusual items in archival collections, etc. The paper may have yellowed and darkened, be brittle to the touch, or have been folded or curled. Those items that have deteriorated due to acidic paper, dirt, poor storage conditions, simple mishandling, or even ordinary wear and tear are likely to require the most attention.

Although produced on high-quality paper, older materials may have suffered as a result of earlier attempts at repair or restoration. Manuscripts from different periods will reflect greater variations in the paper, the types of inks, or writing instruments used and hence may present greater problems in exposure control. Printed materials are generally more uniform in size and contrast and may be easier to film than archival or manuscripts materials. Given careful preparation and filming, however, it should be possible to reproduce the significant record detail in most collections. You must combine a knowledge of the filming process, the value of the materials, and the time and money available to select from the many options in physical preparation that will affect both the final film quality and cost.

Bound Volumes. A review of library materials to determine whether they can be filmed intact usually involves examining volumes for the tightness of the binding. On a flat surface, open the volume 180 degrees to see if pages lie flat. If the inner margin is too narrow and the binding is tight, a gutter shadow may appear in the film. If text falls in this gutter, it will be obscured in shadow and out of focus. As pages are turned, check to see whether brittle paper cracks along the stiff ridge created by the cover's hinge. This typically occurs in the first and last few pages and is particularly prevalent with oversewn volumes. In some cases, the stress of opening volumes

Left, a newspaper is cut from its binding; right, after the binding has been removed, an electric guillotine cuts away the rest of the spine. Sources: left, Northeast Document Conservation Center; right, Library of Congress

180 degrees can break sewing or loosen the text block from its case. Sort out the materials that will not make it through the filming process and have them reviewed before any further processing takes place. With this kind of condition information, a curator who had originally decided to retain the volume may wish to reconsider and withdraw it instead. If filming proceeds and materials will need repair, set up a routine to have volumes flagged so they can be treated at the end of the process before they are returned to the shelf. Another alternative for problem materials that cannot be filmed is to locate another copy more suitable for filming.

For the remainder, a camera operator may avoid damage by using careful filming procedures, which may involve support of the book during the filming or use of a glass plate or book cradle. If you anticipate problems, alert the curator before filming, and if necessary note the volume's prefilming condition in case questions arise during postfilming inspection. Materials that will be discarded after filming should be disbound. Flat sheets are more easily filmed and result in a better quality film. The most efficient means is simply to slice off the spine using a machine appropriately known as a guillotine.

Collation. Collation for library materials requires going through the volume once, examining each page. It provides the opportunity to note missing pages, damaged pages where text is lost, irregularities in pagination, and any other problems. Remove clips, staples, or other extraneous material to allow pages to lie as flat as possible. If materials are to be disbound, this is also the opportunity to flag pages that must be separated by hand, such as folded materials, plates or charts sewn through the fold, or text with floating inner margins. Good quality photocopies should be acquired to replace missing or damaged pages identified during collation, or preparation staff can borrow volumes and photocopy needed pages themselves. These should be cut to size and inserted in their correct places within the volume. If full volumes are missing, they should be borrowed and filmed in correct sequence.

Minor Repairs. It is unusual for paper or binding repairs to be undertaken on bound materials before filming. One can rarely justify expensive or even routine repairs as necessary to the filming process, unless the quality of the film will be affected. Examples of necessary physical treatments include separating pages that are stuck together and repairing torn pages if it is unlikely they will make it to the camera in one piece. Japanese tissue or heat set mends may be warranted for materials that will be retained, while ordinary pressure sensitive tapes, used sparingly, can be used to repair torn pages in books to be discarded. Because of expense and delays in processing, always keep prefilming repairs to an absolute minimum.

Fold-outs. Fold-out sheets in bound volumes may be handled several ways, although most involve removing the piece from the volume for ease in handling. The sheets may be placed under glass and filmed in one exposure (using a higher reduction ratio, which should be indicated) or may be filmed in overlapping sections, moving from left to right and from top to bottom, with at least a one-inch overlap between adjacent sections, as shown in Fig-

Figure 6. Sectionalized Filming of Oversized Illustration

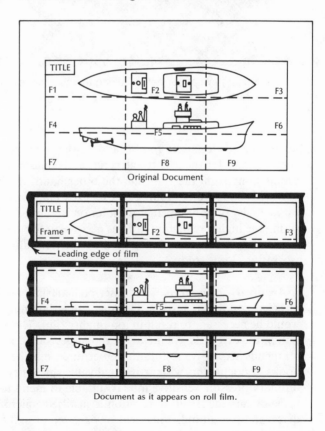

SOURCE: **Practice for Operational Procedures Inspection and Quality Control of First Generation, Silver-Gelatin Microfilm of Documents,** ANSI/AIIM MS23–1983, p. 13.

A camera operator flattens a newspaper before taking the next film exposure. Note electric iron on right to help remove hard creases. Source: Library of Congress

ure 6. This sectionalized filming adds to the frame count for the job, may be very difficult for the user to interpret, and could be impractical for later reproductions from the film. On the other hand, the higher reduction ratio used for single frame filming of oversized materials may not record necessary details. A more satisfactory solution is to use the single frame, full view (using the higher reduction ratio as necessary) for the user's orientation, followed by sectionalized filming (at the reduction ratio used for the rest of the work) for closer study.

Archival Collections. Manuscript materials are initially reviewed for physical condition: repairs, cleaning, and flattening of the originals that would be necessary to result in top-quality film. The value and final disposition of the originals will influence repair decisions. Japanese tissue and heat set mends, expensive restoration procedures, may be warranted for pages in books or documents with artifactual value since they will be retained, while ordinary pressure sensitive tape is suitable to mend torn pages in materials to be discarded. If full restoration is justified, microfilming should be undertaken after all individual leaf or page repair and cleaning is completed, but before binding or other fastening techniques are undertaken. The time

To help straighten out curls and creases and flatten the pages before filming, newspapers and other materials can be sprayed lightly with water and each page placed between sheets of non-adhesive material (e.g., silicone paper) before stacking in a large press. Source: Library of Congress

required for this procedure, as well as the condition of the original materials, must be considered. In some cases, lengthy time estimates for repairs may signal a need to reconsider a filming decision, or to acknowledge that a compromise needs to be made.

Remove clips, staples, and other fasteners to allow materials to lie as flat as possible. Curled or folded single sheets can be pressed in a weighted folder or flattened using an ordinary iron, if they are to be discarded later. Serious creases and wrinkles can be removed by humidifying the unbound pages (spraying lightly with distilled water) and stacking them neatly in a large press for 24 hours. Crumbling or loose pages, clippings, etc., can be placed in Mylar sleeves to hold them in place as they are filmed. Newspaper pages that are stuck together may be steamed apart, a nonadhesive material such as silicone paper inserted, and left to dry for a few hours before filming. Humidification might be skipped in a project short on time, but actual camera time may increase (and special handling charges may be incurred) for work on materials in poor condition.

Where it is possible, without compromising the bibliographic or archival integrity of a collection, group the materials by size. A wide range of sizes in a collection will probably require changes in reduction ratios, which will in-

crease filming time and may increase filming costs. For some records series, it may be more sensible to move items to an end position using an OVERSIZE ITEMS FILMED AT END OF (FOLDER, REEL, etc.) target.

Preparing newspaper clippings or scrapbooks for filming presents a real challenge, if you are concerned with both film product quality and filming costs. Clippings should be trimmed of extraneous information, but not of notations or dates that may be useful for identification. Group small pieces on carrier sheets, using either "quick-and-dirty" fastenings or archival procedures (as determined by the final disposition decision) to facilitate handling by the camera operator. This will also assure editorial control of the groupings. Large clippings or full pages of newspaper may also be grouped together, if the resulting rearrangement does not adversely affect access to the information. Scrapbooks will require certain editorial decisions on what is and is not to be filmed; notes made during the physical preparation stage will be cumulated for later targeting and general instructions to the filmer.

The physical problems of manuscript and archives materials are noted in the first pass through the materials. In the second pass, repairs are made and instructions, both general and specific, are assembled for the camera operator.

Editorial Preparation

Library Materials. The second review addresses editorial concerns. Monographs and pamphlets, the least affected by editorial decisions, are usually straightforward. They require only the preparation and insertion of targets.

Serials, consisting of volumes, parts, supplements, indexes, etc., can be complex. The arrangement should be checked and volumes assembled in correct order. In some cases, other arrangements, which might be attributed to such factors as the library's binding policies, may be acceptable, as long as they are logical and consistent. Variant arrangements that might be confusing to the user should be noted in the introductory sequence of targets or with the eye-legible target FILMED AS BOUND. Indices generally are filmed preceding the text of the serial or series to which they relate. The serial title guide is then prepared based on information from the final arrangement of volumes and the notes collected during collation. The editorial review is completed with the preparation and insertion of targets.

Targets. Targets are separate sheets of paper or board containing technical or bibliographic information, which are filmed along with the publication or document and thus become part of the film itself. They are used to identify or add information about the materials on the film, or to refer to the filming process. A series of targets usually accompanies each title or collection. Target preparation is usually the responsibility of the library or archives, although the filming agent may be able to supply certain ones. To guard against errors or misunderstandings, you should provide the filming agent with clear instructions about the use of targets, including copies of

those you wish to be used and the sequence desired. Review the targets to be supplied by the filming agent, and reach an agreement about those to be supplied by the institution.

Targets may be made informally, using a wide-tipped felt marker or a typewriter, if they do not need to be eye-legible. If prepared by hand, be sure they are neat and clear. More sophisticated versions can be constructed with a Leroy lettering system or a computer-driven printing machine.[3] You can find detailed descriptions of targets and illustrations of target series in a variety of documents published by the American National Standards Institute, the Library of Congress, the Research Libraries Group, and other organizations.[4]

The following discussion provides an overview of the targets and instructions required for filming books, serials (including newspapers), and manuscripts. The range of required targets is described, as well as extra or optional targets that may be used at your discretion. When preparing targets, try to find a balance between the minimum number of required targets and the necessary extras that will assist the user with special problems. You can err on the side of too many targets just as easily as too few. Remember that unnecessary targets can be time-consuming to prepare, costly to film, and distracting to the user.

Two types of filmed targets are generally used in preservation microfilming. The first are *informational targets*, which provide important information to the user of the film, including the bibliographic data that identifies what is on the film. The second is a *technical target*, which is used to help determine film quality.

Informational Targets. Informational targets provide bibliographic data about the material filmed and technical data about the filming process. Some are *constant*: standard targets at the beginning and end of every reel and at the beginning and end of each title or collection—for example, START or END OF REEL, PLEASE REWIND. Others are used on an *as-needed* basis. These provide additional information or indicate variations from what a user would expect to see on the film. They precede the material or are inserted in their appropriate place among the pages. Some of these must be

3. *Leroy* is the brand name of a well-known and inexpensive lettering set that includes a template (different sizes and styles of alphabets are available), a pen or pencil, and a scriber. A complete system with one template would cost about $50.00 and can be purchased in a good art supply store.

4. *Practice for Operational Procedures/Inspection and Quality Control of First-Generation, Silver-Gelatin Microfilm of Documents* (ANSI/AIIM MS23-1983) (Silver Spring, Md.: National Micrographics Association, 1983), pp. 5–12; *American National Recommended Practice for Microfilming Newspapers on 35mm Roll Microfilm* (ANSI/AIIM MS111-19--), prepared by Ad Hoc Group 57, Association for Information and Image Management, pp. 10–13 (unpublished); *Specifications for the Microfilming of Books and Pamphlets in the Library of Congress* (Washington, D.C.: Library of Congress, 1973), pp. 2–5; *Specifications for the Microfilming of Newspapers in the Library of Congress* (Washington, D.C.: Library of Congress, 1972), pp. 3–5; *Specifications for Microfilming Manuscripts* (Washington, D.C.: Library of Congress, 1980), pp. 2–4; *RLG Preservation Manual*, 2d ed. (Stanford, Calif.: Research Libraries Group, 1986), pp. 33–49.

eye-legible; that is, they can be read from the film without the use of a film reader or other optical device. Letters on eye-legible targets must produce images on films that are at least 2mm (0.08 in.) high.[5] Consequently, the letters must be large enough to allow for reduction.

Bibliographic information should include an eye-legible title and imprint (primary bibliographic target); a copy of the catalog record; list of missing pages, volumes, etc.; title or collection guides; and perhaps longer notes such as series notations, references to separate indexes, finding aids, or supplementary bibliographic and descriptive data. These are usually typed (eye-legibles lettered) or otherwise prepared on separate sheets of paper. This introductory bibliographic data forms the preliminary target sequence that accompanies each title or collection and is filmed at the beginning of each title or preceding the first page of the material described. The filming agent also supplies technical data on reduction ratio, image orientation, film size, and name and location of filmer, either as a separate target or written in on the Catalog Record target supplied by the institution. This, too, becomes part of the film itself.

Further informational targets, both typed and eye-legible, are used on an as-needed basis, and may be required throughout. In library collections, particularly multivolume sets of serials, informational targets are used to identify each bibliographic or physical unit (e.g., volumes, issues, parts) and include volume numbers and/or dates. In archival collections, informational targets are used to identify each organizational unit (e.g., record series, file folders, etc.) and include its number and a title or short description of the contents.

Additional informational targets used on an as-needed basis often indicate problems or irregularities on a page, within a volume, or throughout a serial or collection. The most typical use is to indicate that material is missing. If practical, of course, you should assemble the complete title prior to filming, possibly using the resources of other library collections to fill in gaps in individual volumes or serial publications. Since you are preserving materials once (and we hope for all time), you should set up procedures through interlibrary loan or other local borrowing networks to accomplish this. While some may feel that incomplete serials or other volumes are not worthy of filming, an exception may be made if they are the most complete, or best copies available.

When missing pages occur in books, their numbers should appear on a separate list in the preliminary sequence of targets. Gaps in serials are included in the serial title guide. Information missing from manuscript collections, or folders not filmed, should also be indicated in the introductory bibliographic targets. Gaps within the text must also be marked with an eye-legible target, for example, PAGE(S) MISSING, in the appropriate place within the text. This notifies both the reader and staff performing film inspection that the omission is intentional and not a filming error, as well as allowing space for splicing in the missing pages if they should be located later. The same procedure can be followed to indicate damaged pages where the meaning of the text is obscured, and when other physical conditions of the origi-

5. ANSI/AIIM MS23-1983, p. 6.

nal will affect its legibility on film. Examples include DAMAGED PAGE(S), TIGHT BINDING.

As-needed targets may be used to indicate sequences of irregular pagination, extensive changes in a series title, unusual variations in the arrangement of a serial file or manuscript collection, or other problems that would mislead readers. It may also be a good idea to repeat the primary bibliographic target and reel number target, if any, at the end of a reel, when titles fill more than one reel, for purposes of quick identification if the materials on the reel are unusually complex. This is especially true of some manuscript or archival collections.

Technical Target. A technical target, also called a test card, contains combinations of numerals and lines of varying widths and lengths and serves as a technical control to test the reduction and resolution of the film. Illustrations of them appear in the relevant American National Standards Institute standards. The filming agent normally supplies this target (see Chapter 4, Figure 16). It is filmed at the end of the preliminary sequence of targets and immediately precedes the volume/year target or folder target and/or the first page of text.

Target Series. The target series for each publication or set of manuscripts includes both constant and as-needed targets, some typed and some eye-legible, as explained earlier. A target series must agree in every detail with the final collation of material being filmed. You must make sure that it accounts for all items or pages, missing pages, and mutilations that affect the text, or other irregularities in the publication. Although there are many similarities, target series differ somewhat, depending on whether the material being filmed is a monograph or pamphlet, a serial, or manuscript collection. The best illustration of a target series is the sequence itself. In the following pages are required target series for monographs, serials, and manuscripts. Some targets are listed as optional, depending on your particular group of materials. Target names are underscored; literal wording for targets appears in small capital letters.

Since most monographs are self-contained and can be housed on a single reel of film, a target sequence for monographs is generally straightforward. Figure 7 graphically illustrates the following narrative sequence:

<div align="center">

Target Sequence for Monographs[6]

* = eye-legible target

</div>

At the beginning of each title:
 1. *START
 2. Filming agent identification and date of filming, permission statement (include special project identification or funding support here also, if applicable).

6. *RLG Preservation Manual*, pp. 33–35.

Figure 7. Target Sequence for Monograph

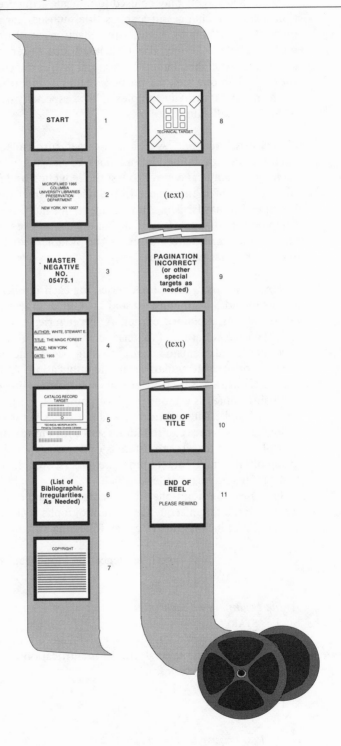

Example:

MICROFILMED 1983
UNIVERSITY OF MICHIGAN
PRESERVATION MICROFILMING OFFICE
ANN ARBOR, MI 48109
Reproduction may not be made without permission.

You may prefer to have a longer permission, or copyright, statement appear as a separate target.

3. *Storage number (if required).
4. *The primary bibliographic target, consisting of author, title, place, and date of publication, and volume number as needed. Titles may be abbreviated as needed for eye-legibility. When filming a multivolume work, film the primary bibliographic target with correct volume number and publication date at the beginning of each volume.
5. Catalog record target, printed or typewritten (see Figure 8).
6. Typewritten list of missing pages, mutilations, and other irregularities that cannot be corrected prior to filming.
7. As appropriate: location of the original volume (if different from the institution responsible for filming), references to separate indexes or supplementary bibliographic data, note of any restrictions on reproduction or use, specific to the individual title filmed.
8. Technical target (must meet the specifications contained in ANSI/ AIIM MS23-1983).
9. *Additional as-needed targets such as the following must be inserted:

PAGINATION INCORRECT
PAGE(S) MISSING/NOT AVAILABLE

10. *END OF TITLE

At the end of each reel:
11. *END OF REEL. PLEASE REWIND

Targets for Serials. Because serials such as journals and newspapers often are lengthy and require more than one microfiche or microfilm reel, they require a slightly different target series. Each title requires identification, as does each reel. Make sure the filming agent leaves "flash spaces," or blank frames, between targets and first page of text, between volumes filmed sequentially, and between the last page of text and the final target.

A useful way of alerting the reader to the actual contents of a serial is to prepare a *title guide* (see Figure 9). Use a form or a typewriter, but include the volumes, issues, etc., being filmed; the lacking volumes, issues, pages, or mutilated pages where text is obscured, which cannot be corrected prior to filming; and the contents of each reel. Figure 10 provides a sample target series for a serial.

Figure 8. Catalog Record Target

Storage Number (SN) _____

ORIGINAL MATERIAL AS FILMED—Copy of existing catalog record.

Restrictions on use:

TECHNICAL MICROFILM DATA—Filmed by _____
(Insert name and location of filmer)

Film Size: 35mm

Reduction ratio: _____ × or: _____ (fill in for each title)

Image placement: IA IIA IB IIB

Date Filming Began: _____

SOURCE: **RLG Preservation Manual,** 2nd ed. (Stanford, Calif.: Research Libraries Group, 1986), p. 36.

Figure 9. Sample Title Guide for a Serial

LIBRARY OF CONGRESS Preservation Microfilming Office Guide to Contents	Shelf Number Microfilm (o) 85/9215 MicRR
Author Belgium. Institut national de statistique.	**Call Number** HF203.A17
Title Bulletin mensuel du commerce avec les pays étrangers.	Page 1 of 3
Inclusive Volumes	**Inclusive Years** 1901–1940

CONTENTS

Reel	Date	Reel	Date
1	Jan. 1901–June 1901	25	May 1924–Oct. 1924
2	July 1901–Dec. 1901	26	Nov. 1924–Feb. 1925
3	Jan. 1902–Apr. 1903	27	Mar. 1925–Apr. 1925
4	May 1903–Dec. 1903	28	May 1925–June 1925
5	Jan. 1904–Aug. 1904	29	July 1925–Aug. 1925
6	Sept. 1904–Apr. 1905	30	Sept. 1925–Oct. 1925
7	May 1905–Dec. 1905	31	Nov. 1925–Dec. 1925
8	Jan. 1906–Dec. 1906	32	Jan. 1926–Feb. 1926
9	Jan. 1907–Aug. 1907	33	Mar. 1926–Apr. 1926
10	Sept. 1907–Apr. 1908	34	May 1926–June 1926
11	May 1908–Dec. 1908	35	July 1926–Aug. 1926
12	Jan. 1909–Aug. 1909	36	Sept. 1926–Oct. 1926
13	Sept. 1909–Apr. 1910	37	Nov. 1926–Dec. 1926
14	May 1910–Dec. 1910	38	Jan. 1927–Mar. 1927
15	Jan. 1911–Aug. 1911	39	Apr. 1927–June 1927
16	Sept. 1911–Apr. 1912	40	July 1927–Sept. 1927
17	May 1912–Dec. 1912	41	Oct. 1927–Dec. 1927
18	Jan. 1913–July 1913	42	Jan. 1928–Mar. 1928
19	Aug. 1913–Feb. 1914	43	Apr. 1928–June 1928
20	Mar. 1914–Apr. 1914	44	July 1928–Sept. 1928
	[1919]	45	Oct. 1928–Dec. 1928
	Jan. 1920	46	Jan. 1929–Mar. 1929
	1919 & 1920 [1st 5 months]	47	Apr. 1929–June 1929
21	1919 & 1920 [1st 11 months]	48	July 1929–Sept. 1929
	1919 &1920 Annees	49	Oct. 1929–Dec. 1929
22	1921 & 1922 [1st 3 months]	50	Jan. 1930–Mar. 1930
	1922 [various months]	51	Apr. 1930–June 1930
	Jan. 1923–Feb. 1923	52	July 1930–Sept. 1930
23	Mar. 1923–Sept. 1923	53	Oct. 1930–Dec. 1930
24	Oct. 1923–Apr. 1924	54	Jan. 1931–Feb. 1931

WANTING

July 1902–Dec. 1902
Jan. 1906–Apr. 1906
May 1914
 [1919]
 [1921]

NOTES: Publication suspended June 1914–Jan. 1919.

ISSUES LISTED AS MISSING WHEN ORIGINALLY FILMED. IF LOCATED AT A LATER DATE MAY BE INCLUDED AT THE END OF THE APPROPRIATE REEL.

SOURCE: Tamara Swora, Assistant Preservation Microfilming Officer, Library of Congress.

Figure 10. Target Sequence for Serial

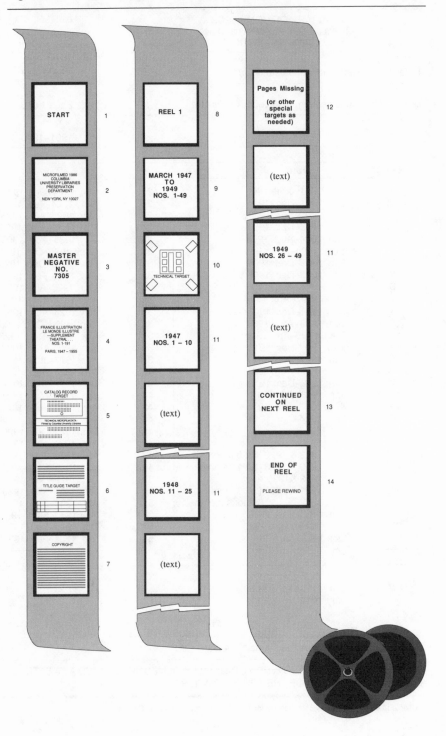

Target Sequence for Serials[7]
* = eye-legible

At the beginning of the first reel:

1. *START
2. Filming agent identification, date of filming, permission statement (include special project identification or funding source information as required).
3. *Storage number, if needed.
4. *The primary bibliographic target, consisting of title, place of publication, inclusive dates, and/or volume numbers of the material being filmed. Titles may be abbreviated as needed to fit eye-legible targets.

 For newspapers, the bibliographic target follows the START target and also precedes the END OF REEL target on each reel. This target contains, at a minimum, (1) the country (which usually is omitted in filming newspapers published in the United States), (2) the state for U.S. newspapers or province for Canadian newspapers, (3) the city of publication, (4) the title of publication, and (5) the inclusive dates filmed. The masthead of the newspaper should also be included, especially if printed in a non-Roman alphabet.
5. Catalog record target, printed or typewritten (see Figure 8).
6. Title guide, consisting of a typewritten list of volumes, issues, etc., being filmed; the lacking volumes, issues, pages, and mutilations that cannot be corrected prior to filming; and the contents of all reels (see Figure 9).
7. As appropriate: location of the original volume (if different from the institution responsible for filming), historical background information (for newspapers), references to separate indexes or supplementary bibliographic data, statement of variant order or arrangement of the file, note of any restrictions on reproduction or use, specific to the individual title filmed. Some of this information might be included on the title guide rather than handled in a separate target.
8. *REEL number target.
9. *The reel contents target, indicating the contents of that particular reel when the material covered by the primary bibliographic target extends over more than one reel.
10. Technical target (must meet specifications contained in ANSI/AIIM MS23-1983).
11. *Volume/year target. When filming several volumes, film a target indicating each volume (or year, or both, as appropriate) before the issues for that volume or year.

Begin text.

7. Ibid., pp. 41–43. Also incorporated are specifications from *American National Recommended Practice for Microfilming Newspapers on 35mm Roll Microfilm*, ANSI/AIIM MS111-198 , now being reviewed, pp. 10–12.

12. Additional as-needed targets must be inserted as follows:
 a. At the beginning of the title:

 BEST COPY AVAILABLE
 FILMED AS BOUND

 b. In the exact location, ahead of the page, issue, or volume concerned:

 ISSUE(S) MISSING
 MUTILATED PAGE
 PAGE(S) MISSING
 VOLUME(S) MISSING
 PAGINATION INCORRECT
 IRREGULAR PAGINATION

At the end of each reel:
13. *CONTINUED ON NEXT REEL (if needed).
14. *END OF REEL. PLEASE REWIND

At the beginning of second and subsequent reels:
If the material covered by the primary bibliographic target extends over more than one reel, the following targets shall be filmed at the beginning of additional reels.
1. *START
2. Filming agent identification and project target (if required).
3. *Storage number.
4. *Primary bibliographic target.
5. (Optional: Title guide.)
6. *REEL number target.
7. *Reel contents target.
8. Technical target.
9. *Volume/year target.

Begin text.
At the end of last reel:
10. *END OF TITLE
11. *END OF REEL. PLEASE REWIND

Archival Collections. For archival collections, the second review provides an opportunity to consider the arrangement of the pages and other matters of editorial concern. You must first decide what arrangement is appropriate; rearrangement after filming is not possible. This decision can be difficult and time-consuming for collections that have not been processed. If the materials have become brittle to the point of breaking at a touch, you may find it necessary to omit even basic arrangement prior to filming. The decision to microfilm may provide incentive to reprocess an older collection using new standards. As with matters of cleaning and repair, there may be limits to the amount of time available for this stage of preparation.

 There are six basic steps to arranging a collection of records or manuscripts. How much time and difficulty are involved will, of course, vary according to the materials. The novice preparer should follow these steps

separately, but as experience grows they can be combined in whatever way is convenient. Some may be covered in general instructions to the filming agent; others will require preparation of specific targets or instruction sheets at the point they occur.

1. Do not film blank pages. If they are paginated, this should be explained on the corresponding volume target or, if the problem recurs, in a general target at the beginning of the reel.
2. Remove duplicates or target them so that they will not be filmed. Also remove handkerchiefs, dried flowers, and other extraneous items. Include an explanatory note about your decisions in the introduction or guide, if produced, or on the folder target.
3. Film endorsements appearing on the backs of wills, deeds, letters, or contracts before the text of the document.
4. An enclosure should follow immediately after the letter to which it corresponds or after the pages of a book between which it was found. Envelopes, if filmed, should precede their contents.
5. Indices should be filmed immediately *preceding* the text or document series to which they relate. Use a target in each case to alert the filmer; if not, the index is apt to appear on the film at the end of the text and will be difficult to use. (If the index is an integral part of the item to be filmed, such as an average monograph, it is filmed in place.)
6. Folder labels, if filmed, should precede the contents of the folder. If the information is both sufficiently complete and legible—rarely the case—the label can be used in lieu of a folder target.

After the initial arrangement is complete, check everything again to make sure that all items are accounted for and in the proper sequence. If the sequence of pages or items is not clear and easy for the camera operator to follow, pencil in a page number or other identifying sequence enclosed in brackets in the upper right-hand corner of the page being filmed. For manuscripts and other unpublished materials especially, it may be necessary to follow this practice throughout the collection. Alert the camera operator to pages with holes or other missing sections by slipping a sheet of paper in back of such pages. The editorial review is completed with the preparation of targets, collection guides, and finding aids.

Targets for Archival Collections. For the most part, the guidelines for target preparation and the target sequences that were described earlier can be adapted for manuscript collections, with appropriate substitutions. For example, instead of a copy of a serial title guide, a target might consist of another type of finding aid, such as a guide inventory, register, or folder listing for the collection. (See Chapter 5 for a discussion of the desirability of preparing guides.) This may include an introduction to the collection with information concerning provenance or scope, as well as a brief biographical sketch. The use of an automatic frame counter during filming makes it possible to correlate the numbers appearing along the top or side of each frame with the starting points of specific records series or file folders, for example, and its use should be explained in the finding aid.

Informational targets may also add notations from sources outside those at hand; an example of this is "J.S. refers to John Smith, brother of the letter's author." When this type of information is added, the microfilm is less of a pure facsimile and more of a creative publication.

Instruction Sheets. Instruction sheets, used primarily for archival collections (and often also called "targets" although they are not filmed), tell the camera operator how to film a specific item that requires handling not covered in the general instructions to the filmer. These appear in the appropriate places in the stack of documents, often attached to the page. The camera operator removes the sheets, follows the instructions about filming, then replaces them. Since all of this takes time, you should try to keep instruction sheets to a minimum. Typical examples are: DO NOT FILM REVERSE SIDE; UNFOLD CLIPPINGS BEFORE FILMING; FOLLOWING PAGES BOUND OUT OF ORDER—FILM IN CORRECT SEQUENCE. Instruction sheets may be typed or handwritten legibly, preferably on one color of paper (other than white), which is used consistently throughout.

Figure 11 illustrates a target series for a manuscript collection.

Target Sequence for Archives and Manuscripts[8]
* = eye-legible

At the beginning of the first reel:
1. *START
2. Filming agent identification, date of filming, and permission statement (include special project identification or funding source information as required).
3. *Storage number, if needed.
4. *The primary bibliographic target, consisting of title of collection (e.g., PAPERS OF SUSAN B. ANTHONY) and shelf or accession number. Titles should be abbreviated as needed to fit eye-legible targets.
5. Catalog record target (or other finding aid) (see Figure 8).
6. Guide to collection, including container (boxes, and/or volumes) list.
7. As appropriate: references to separate indexes or supplementary bibliographic data, note of any restrictions on reproduction or use specific to collection, copyright notice.
8. *REEL number target.
9. *Reel contents target.
10. Technical target.
11. *Series/container number target.
12. Folder titling or bound volume target. This can be the file folder itself, or a target that precedes each folder. Ideally, it repeats the name of the collection and series, as well as the folder title. If a bound volume of manuscripts, such as diaries, journals, and account books, are

8. Adapted from *Specifications for Microfilming Manuscripts* (Washington, D.C.: Library of Congress, 1980).

Figure 11. Target Sequence for Manuscript Collection, Reel 1

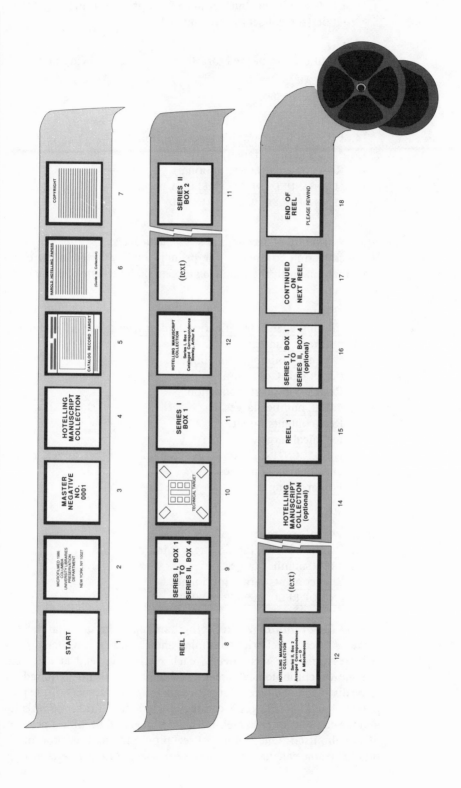

inside containers but not in folders, prepare a title target that also includes the collection title and series.

Begin text.

13. Additional as-needed targets such as the following must be inserted:

> BREAK IN TEXT
> PAGE MISSING

At the end of each reel:

14. Primary bibliographic target (optional).
15. *REEL number target.
16. Reel contents target (optional).
17. *CONTINUED ON NEXT REEL (if needed).
18. *END OF REEL. PLEASE REWIND

At the beginning of second and subsequent reels:

If the collection covered by the primary bibliographic target extends over more than one reel, the following targets shall be filmed at the beginning of additional reels:

1. *START
2. Filming agent identification and project target (if required).
3. *Storage number.
4. *Primary bibliographic target.
5. (Optional: Collection Guide.)
6. Restriction on reproduction.
7. *REEL number target.
8. Reel contents target.
9. Technical target.
10. Add *CONTINUED to series/container number target, or insert new one for new container.
11. Folder titling or bound volume target.

Begin text.

At the end of last reel:

12. Primary bibliographic target (optional).
13. *REEL number target.
14. Reel contents target (optional).
15. END OF REEL. PLEASE REWIND

Reel Programming. Reel programming is the step that determines the contents of each reel prior to filming and should be considered for all material exceeding one reel. Ideally, each reel should end at a logical bibliographic or chronological break. Although this is not required, there are some distinct advantages. Targets containing the contents of each reel can be prepared and the title guide can then include the number of reels for the set and the contents of each reel. Both are filmed and become a permanent part of the film itself. One method of reel programming uses procedures and tables for frame calculation from the *Processing Manual* developed by the Li-

brary of Congress.[9] Preparation managers and filming agents must agree on guidelines for reel programming. Without definite instructions, a filming agent could simply fill reels to maximum capacity, breaking the text at the end of the reel whenever it might come, such as in the middle of a single issue of a journal. Conversely, if programming is to be handled by in-house staff, the filming agent must provide reel capacity ranges.

You may work with guidelines from the filming agent to sort materials and compile frame counts to determine the precise places where reels will break. A second option is not to predetermine exact reel breaks, but to give the camera operator instructions on where a reel break is or is not acceptable (whichever can be more clearly described). This could include instructions as "Do not break a reel within the contents of a box/folder/volume," or "Keep each year's issues on a single reel." Certainly, titles less than one roll in length should not be split between reels, nor should reels include microfilm of more than one month or more than one year unless all months or all years contained on the reel are included in their entirety.

Acceptable and unacceptable types of bibliographic units for newspaper and serial runs are shown in Figure 12.

Figure 12. Reel Contents for Serials

Acceptable

 a. January 1–10 January 11–20 January 21–31

 b. January 1–15 January 16–31

 c. January 1–31

 d. January 1–February 28

 e. January 1–March 31

 f. January 1–June 30

 g. January 1–December 31

 h. January 1, 1960–December 31, 1961

Unacceptable

 a. January 1–January 17 January 18–February 9

 February 10–February 26 February 27–March 15

 b. January 1, 1960–January 5, 1961

 c. January 6, 1961–December 25, 1962 (unless these are **exact** dates on beginning and ending issues)

SOURCE: **Specifications for the Microfilming of Newspapers in the Library of Congress** (Washington, D.C.: Library of Congress, 1972), p. 1.

9. Tamara Swora and Bohdan Yasinsky, *Processing Manual* (Washington, D.C.: Library of Congress, Preservation Microfilming Office, 1981), pp. P2–P7.

When filming smaller publications (materials that do not have enough pages to fill the standard 100-foot reel of microfilm), you may consider two approaches that will affect user copies of the film. The first is to fill reels to capacity by putting several titles on one reel, which ensures the most efficient use of storage space. A decimal system is often used for bibliographic identification of individual titles on a reel, that is, number 468.3 is the third title on reel 468. The limitations to this method are in duplicating film copies of individual titles: in most cases, it is necessary to copy the whole reel of film and not the individual titles, which may increase the cost to be passed on to the customers. The second approach is to allow only one title per reel, or a large space between titles (4 ft.) which is more practical if your institution plans to supply film copies of individual titles on demand. If little copying activity is anticipated, reels should be filled, with bibliographic access provided for individual titles to allow easy retrieval for use. For single monographs and records series, common logic is needed to balance the editorial sense with technical efficiency.

Final Preparation

The final steps in preparation are to check volumes and documents, review the materials for instructions to the camera operator, and disbind materials scheduled for withdrawal. Are all materials and accompanying targets in the correct place? Are all operating instructions and problems included in the instructions to the filmer? The final review is most important for complicated serials and manuscript collections.

Frame Counts. The number of camera exposures (a single exposure equals one frame of film) required for a job will determine the cost of filming. Prices are usually listed in cents per frame. However, some agents may charge by the hour, not by the frame, to film collections containing materials that are in extremely poor condition, exhibit poor contrast, or are difficult to follow in the proper order. Under these circumstances, counting frames may not be necessary.

Bound volumes are generally filmed two pages per frame, so a 300-page book will result in slightly more than 150 frames, depending on how the book is paginated. But special features may add to the frame count. Since enclosures (extraneous material not part of the book) are filmed immediately following the pages between which they are found, they will add an additional frame or more, depending on the number of items and the exposures required for each one. Maps or other illustrations that are attached to and overlap the text are first filmed in place, and then folded back or out to reveal the text beneath. This, too, will add frames to the count. Any folded material that must be filmed in segments requires careful calculation.

Single sheets of manuscript or archival material with writing on one side will require a single frame of microfilm each or two frames if there is writing

on both sides. Letters and documents with overwriting, writing that runs in several directions, or writing with different colored inks and papers may well require intentional duplicate exposures in order to produce a legible microfilm copy. Assorted sized clippings, notes, and other small miscellany can be grouped together in the preparation phase for the camera operator's ease in handling, or they may be filmed in single frames. The single frame option is easier for the person arranging the clippings and will expedite subsequent reference to the items on film, but it will not make the most efficient use of the film stock. Scrapbooks containing overlapping newspaper clippings, layers of photographs, multicolored items (e.g., tickets or flyers), and multipaged pamphlets (not all of which may have to be filmed) will elevate the frame count. The total number of reels required for a collection will be calculated on the basis of the frame count, the bibliographic criteria for determining reel breaks, the size of the materials, and the reduction ratio at which it is filmed.

General Instructions to the Filmer. General instructions to the filming agent tell the camera operator how to film materials. These are separate from technical specifications and usually involve handling procedures, editorial decisions, and directions that reflect local options. Instructions can be general, covering procedures for handling broad categories of materials or formats (e.g., monographs, serials, manuscripts), or specific, applying to individual items. You will gather them throughout the preparation stages and provide them to the filming agent before filming begins.

Some general instructions can be provided at the beginning of a project or contract year. They outline routine operating procedures that are followed for the majority of materials. Instructions to accompany materials with special requirements or problems are then prepared as the need arises. If you provide thorough general instructions at the outset, the need for special instructions will be minimized.

As mentioned earlier, a typical set of instructions will tell the filming agent how to assign reel numbers and determine reel breaks. General instructions should also cover the amount of space left between multiple titles filmed on a single reel, the number of blank spaces left between serial volumes or file folders, or that a counter should be used for manuscript and other unpaginated materials.

Another large category of instructions includes filming procedures for special materials, those that occur on a regular basis. Guidelines for filming folded materials, overlays, blank pages, loose items or enclosures, folded news clippings, and file folders that precede manuscript materials are a few examples.

One final, but important, instruction covers what the camera operator should do when problems are encountered at the camera—for example, how to target pages when their physical condition affects legibility. Clear procedures for handling such situations should be established, so filming schedules are not held up.

Postfilming Processing

In addition to the prefilming preparation of materials, preparations staff may be responsible for receiving, processing, and forwarding materials and microforms after filming takes place. Postfilming procedures involve assembling originals, microforms, and accompanying documentation; closing out records; forwarding master negatives to storage; and forwarding data about the negatives along with the service copies so both can be cataloged.

To ensure prompt and efficient processing, the microforms must carry sufficient information and instructions to allow library or archives staffs to incorporate them easily into the normal processing routine. Determine in advance what cataloging information is required and, therefore, what data should travel with the materials. For example, catalogers need to know the final disposition of the original materials, whether newspapers or other serials holdings have been completed by using borrowed issues, and how to describe the various generations of microforms (see Chapter 5 for details concerning cataloging microforms).

Completed materials may flow from the filming agent at a steady rate (most typical of an in-house laboratory), or they may be returned from a filming agent in large shipments on a scheduled basis. The flow of materials may also be dependent on the format: monographs in a steady flow, manuscript collections in large batches.

Assembling materials for postfilming processing involves matching the original materials—monograph titles, serial volumes, or manuscript boxes—with their microform counterparts and relevant in-process records. All materials should be complete and represented on the microform. Borrowed volumes are sorted and prepared for return. Materials for retention or withdrawal may be separated for different processing procedures. Serials and manuscript collections might be held aside and processed when the full bibliographic unit is completed and gathered in one place. This is also the final opportunity to annotate title guides and finding aids with reel information and frame numbers that may have been omitted or unavailable before filming.

Microforms must be boxed and labeled (or be accompanied by information that will enable other library staff to do the labeling). If the institution has a policy of keeping only one title per reel, preparations staff may need to divide the 100-foot reels containing several titles and place each title on a separate reel.

Records can then be logged out, master negatives sent to storage, and service copies forwarded to cataloging staff for updating in bibliographic access tools. The original materials are either withdrawn, returned to the shelf, sent to storage, or forwarded for physical treatment.

Conclusion

Microfilming is one type of preservation activity that libraries and archives in increasing numbers are utilizing to meet a variety of needs. Preparation of materials for filming is the step most likely to be overlooked in initial planning of a project, or compromised, even when recognized for its importance,

due to other pressing demands in a project's implementation. Much of preparation is a matter of common sense, based on careful consideration of the materials to be filmed, their intended use, and the process of microfilm production. This chapter has attempted to alert you to the many possibilities and limitations of particular options, so that each microfilm project may result in useful products.

List of Suggested Readings

National standards and specifications also include preparation procedures. See Appendix 1.

Borck, Helga. "Preparing Material for Microfilming: A Bibliography (revised April 1984)." *Microform Review* 14:241–43 (Fall 1985).

Byrne, Sherry. "Guidelines for Contracting Microfilming Services." *Microform Review* 15:253–64 (Fall 1986).

Dearstyne, Bruce W. *Microfilming Historical Records: An Introduction*. Technical Leaflet 96. Nashville, Tenn.: American Association for State and Local History, 1977.

Jones, Robert B. *Microfilm: Preparation Techniques. . . Filming Procedures*. Columbus, Ohio: Ohio Historical Society, 1974.

Knapp, Sharon E. "Microfilming Manuscript Collections: A Preliminary Guide for Librarians." *Southeastern Librarian* 28:16–20 (Spring 1978).

Minnesota Newspaper Microfilming Project. *Document Preparation Procedure Manual*. Saint Paul, Minn.: Minnesota Historical Society, 1982.

Perez, Madeleine, Andrew Raymond, and Ann Swartzell. "The Selection and Preparation of Archives and Manuscripts for Microreproduction." *Library Resources and Technical Services* 27:357–65 (Oct./Dec. 1983).

Ronen, Naomi. "Creating a Micropublishing Project: A Non-Commercial Perspective." *Microform Review* 11:8–13 (Winter 1982).

Swora, Tamara, and Bohdan Yasinsky. *Processing Manual*. Washington, D.C.: Library of Congress, Preservation Microfilming Office, 1981.

4

Microfilming Practices and Standards

For most librarians and archivists, the most challenging aspect of setting up a preservation microfilming program may be learning enough about the filming process itself to: (1) work effectively with filming agents, whether they are located within the institution or are external contractors, or (2) set up an in-house facility. This is especially the case if you are expected to evaluate the services offered by several film laboratories, as in a competitive bidding situation. Fortunately, of all aspects of the process, this is the one where there is the most help for novice managers. In addition to the accepted national and industry standards, which an institution can adapt for its own filming specifications, there are numerous books and articles written on aspects of the process. The problem may be, in fact, that there is too much material, much of it extraordinarily technical in nature. Yet it is important that you learn enough of the filming process to make wise decisions.

This chapter is designed for the librarian or archivist unacquainted with the technical aspects of microphotography. It provides enough information to enable the manager to understand the basic terminology and processes that take place in a microfilming laboratory and to make an intelligent assessment. Further, it explains the nature of micrographics standards, how they are developed, and the most important features of them, so that the manager may understand their importance in this complex field. The previous chapter emphasized the importance of good communication between the preparation manager and the filming agent, and that point must be underscored here. High-quality filming practices and adherence to standards will ensure the longevity and stability of microforms for the next century.

The Filming Process

Under normal circumstances, the filming process begins when the filming agent (whether an in-house laboratory or an external service bureau) receives prepared materials from the library or archives and ends when the completed films, accompanying paperwork, and the originals are returned. The steps in between divide into four: preparation procedures, camera operation, film processing, and quality control.

Preparation Procedures

If you have prepared your materials well, this step will go quickly for the filming agent. Nevertheless, the agent's first task is to read carefully your general instructions and check the items to be sure that they are arranged in reasonable order, are in physical condition to be filmed, and are enhanced by all needed bibliographic and technical targets (see Chapter 3 for a discussion of targets). Since the material may contain both informational targets to be filmed and instruction sheets on colored paper intended to convey messages to the camera operator, the agent must take care that the latter are not inadvertently incorporated into the film.

The camera operator may supply certain informational targets that explain the camera operator's observations or procedures, although you may prefer to supply all targets. Typical targets of this type read: PRECEDING PAGE ILLEGIBLE or INTENTIONAL DOUBLE EXPOSURE. Unless the filming agent has received clear instructions, the camera operator will also determine reel breaks. As mentioned earlier, it would be safer for you to work these details out with the filming agent prior to the start of the project.

Camera Operations

Cameras and camera peripherals should be well-maintained mechanically, but they should also be uncluttered by extraneous materials, such as personal effects, taped notes, pictures, unwieldy stacks of original materials to be filmed, film supplies, and so forth. This applies to the area immediately surrounding the camera also. Dirty, cluttered facilities with storage materials and supplies stacked under and around equipment are not likely to yield good film or fiche. Cameras should be surrounded by dark curtains or enclosures to prevent light reflections from interfering with the illumination provided by the camera equipment itself.

What Makes a Good Camera Operator? Trained camera operators are not easy to find. Most come to the job without any prior experience, and the microfilming laboratory takes on the responsibility for their training. Consequently, the quality of the work depends heavily on the strength of the laboratory training program and the knowledge and skills of the laboratory supervisor. It takes about two months to train a camera operator to the point of being comfortable at the camera. With time, he or she develops the judgment and skill to handle the wide range of materials and problems that may be encountered. If your institution plans to establish an in-house laboratory and cannot offer appropriate and well-supervised training, you should make arrangements to have your staff trained by a more experienced laboratory. No amount of self-training can substitute for the experience of working with skilled staff in a well-functioning laboratory.

Reduction Ratio. The technician or technical supervisor will determine the proper settings on the camera so that the reduction ratio is optimal for the material. The reduction ratio expresses the relationship between the size of the original document and the corresponding size of the microform im-

A camera operator carefully turns the pages of a disbound brittle book on a planetary camera bed. Source: Library of Congress

age. It refers to the number of times the original is reduced on film, a linear measurement. For example, a 14:1 reduction ratio means that any line on a microfilm image is 14 times smaller than the corresponding line on the original. A typical ratio for microfiche is often expressed as 24×, which refers to an image 24 times smaller than the original. The actual image area, however, is reduced exponentially. Figure 13 illustrates these two concepts.

Selection of a reduction ratio depends on the size of the documents or volumes to be filmed and the type of microform to be produced. The RLG guidelines for its cooperative microfilming project state that the reduction ratio should be such as to approximately fill the image area across the width of the film as seen on the camera's projected image area, but not to go lower than 8:1. The guidelines reiterate common practices, such as that all edges of the document shall be visible in the image. Moreover, reduction ratio changes within the same title should be avoided, but if unavoidable, changes should be identified by target.[1]

Traditionally, preservation microfilming has been based on the use of 35mm roll film. Compared to 16mm roll film and microfiche, 35mm film is

1. *RLG Preservation Manual*, 2d ed. (Stanford, Calif.: Research Libraries Group, 1986), p. 23.

Figure 13. Reduction Ratio

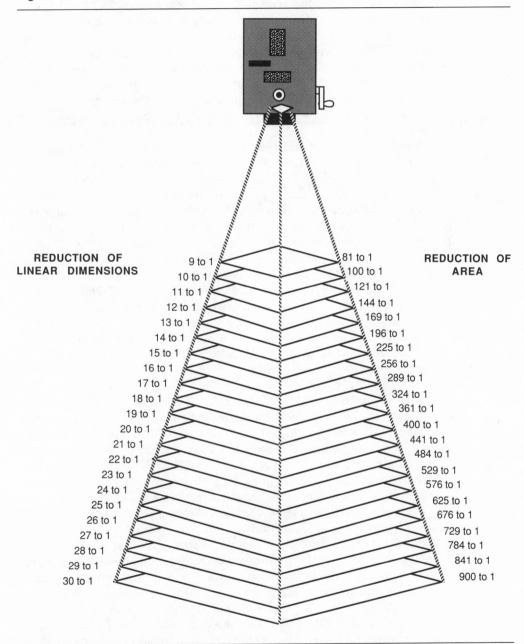

REDUCTION OF LINEAR DIMENSIONS		REDUCTION OF AREA
9 to 1		81 to 1
10 to 1		100 to 1
11 to 1		121 to 1
12 to 1		144 to 1
13 to 1		169 to 1
14 to 1		196 to 1
15 to 1		225 to 1
16 to 1		256 to 1
17 to 1		289 to 1
18 to 1		324 to 1
19 to 1		361 to 1
20 to 1		400 to 1
21 to 1		441 to 1
22 to 1		484 to 1
23 to 1		529 to 1
24 to 1		576 to 1
25 to 1		625 to 1
26 to 1		676 to 1
27 to 1		729 to 1
28 to 1		784 to 1
29 to 1		841 to 1
30 to 1		900 to 1

SOURCE: Albert H. Leisinger, Jr., **Microphotography for Archives** (Washington, D.C.: International Council on Archives, 1968), p. 45.

capable of producing larger images, images at a lesser reduction than the other two media, and this is an important quality consideration.

16mm film requires higher reductions and may be used for materials that are legal size ($11^{1}/_{2}'' \times 14''$) or smaller. The production of a 16mm film on a planetary camera is quite as expensive in labor as the production of a 35mm film. The cost differential between a 16mm and a 35mm master film lies merely in the cost of the raw stock and this, overall, is not meaningful. If, however, you plan to create many duplicate service copies in addition to the preservation master negative, then the total savings in a 16mm edition is substantial and ought to be considered (see Chapter 6 for further discussion of costs).

If roll film is your choice, the camera operator will select the smallest reduction ratio that will accommodate the manuscripts, documents, or volume pages on hand. If the sizes of the pages in a given collection vary substantially, it would increase the cost of the project unduly if the reduction ratio were changed for each manuscript. Instead, the camera operator will choose a compromise reduction ratio accommodating the bulk of the documents. For example, if the bulk of the material consists of $8^{1}/_{2}'' \times 11''$ pages and there is but a handful of oversized pages, then the reduction ratio should be set for the $8^{1}/_{2}'' \times 11''$ pages and the reduction ratio changed whenever the larger pages require it. If, however, a substantial mix of sizes is present, then the entire film, for the sake of reasonable economy, should be filmed at the reduction ratio that accommodates the bigger documents. The Quality Index (QI) computation should be used to make certain that the reduction ratio chosen is compatible with a QI over 5 (see explanation of Quality Index later in this chapter).

If you choose microfiche for your project, then the reduction ratios and spacing of images should follow the national standard (ANSI/AIIM MS5-1985), and the $24 \times$ reduction format would normally be chosen. There are a number of ways in which microfiche can be created. The two most common for preservation microfilming programs are: (1) to film directly onto 105mm microfilm using a step-and-repeat camera; or (2) to use 16mm film in a planetary camera and insert strips of the film into microfilm jackets. The former is certainly the least laborious; the latter requires more explanation.

Microfilm jackets are plastic, transparent carriers that contain either five or seven grooved channels to hold the film strips. A filming agent may use a five-channel jacket with 16mm film when documents that are $11^{1}/_{2}'' \times 14''$ are filmed at $24 \times$. Jackets with seven channels require that the 16mm film be trimmed to 11mm; these are used when $8'' \times 10''$ documents are filmed at $24 \times$. The jackets, with film inserted, are then used as camera masters to make duplicates on single sheets of film. To meet the standard for microfiche (ANSI/AIIM MS5-1985), the frames on the film inserts must line up in a grid pattern that meets certain requirements for image distribution, which is usually difficult to achieve. The sheet film copies can meet the standard in external dimensions, but neither the internal distribution of images in rows and columns nor the placement of the heading are likely to conform, except in extraordinary circumstances. Further, the film inserts may slip or slide in storage over the long term. The use of microfilm jackets will generally result in a product that does not meet the ANSI/AIIM standards.

Filming agents may mention other ways of creating microfiche from roll film: "strip-up," which involves taping strips of film together to create a fiche; "adhesive master," a piece of mylar coated with adhesive strips to which pieces of film can be stuck; and a third method, whereby the film is attached to a sheet of plastic by molecular adhesion. None of these are advisable for preservation microfilming programs. The first two methods utilize adhesives, which may harm film in the long run, while in the third, air bubbles and lint tend to get trapped between the film and the plastic sheet.[2]

Dimensions, Orientation, and Placement. There are several ways an image can be oriented on a piece of film: for textual material, the lines of print either run lengthwise on the film or at a right angle to the film edge. Preferred orientations, as well as the standard dimensions for 16mm and 35mm roll film are covered in ANSI/NMA MS14-1978. The standard also prescribes the limits of the images on the film lest they intrude on the film edges, where they would be subject to abrasion in roll film readers. You should specify your institution's preferred orientation. The RLG guidelines for filming monographs and serials require filmers to use an image placement of 2A (two pages positioned side by side with the lines of print at a right angle to the edges of the film) whenever possible. This placement allows the most efficient use of the film. The second choice is 2B (two pages positioned side by side with the lines of print parallel to the edges of the film). Figure 14 illustrates these positions. Archival materials or documents of unusual sizes or shapes may require other arrangements.

Figure 14. Microfilm Image Position Chart

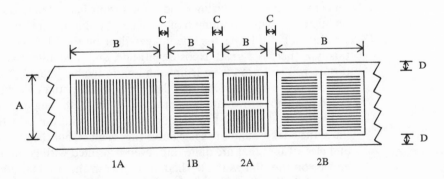

Positions 1A and 1B are single-page exposures; positions 2A and 2B are double-page exposures. In positions 1A and 2A the text is perpendicular to the long axis of the film; in positions 1B and 2B the text is parallel to the long axis of the film.

SOURCE: **Specifications for Microfilming Manuscripts** (Washington, D.C.: Library of Congress, 1980), p. 7.

2. Information on microfiche production methods supplied by Eileen F. Usovicz, Reprography Department, Columbia University.

Image Legibility. The creation of legible images on microfilm remains an art rather than a pure science. Various standards recommend ways to produce sharp, legible images, but they are not totally scientific and depend in part on the camera operator's judgment. Cameras must be monitored on a daily basis for sharpness over the entire image area. The best standard to consult with respect to image quality is called *Practice for Operational Procedures/Inspection and Quality Control of First Generation, Silver-Gelatin Microfilm of Documents* (ANSI/AIIM MS23-1983).[3] The standard provides two guidelines for the creation of legible images. One concerns *background density*, the other is called the *Quality Index*. While there are other technical aspects to the filming process that affect image quality, you must understand these two in order to communicate successfully with your filming agent. They will be explained here in turn.

Background Density. Background density is the degree of blackness of the part of the negative film image that corresponds to the page background. It is measured after the film is processed by using a piece of equipment called a densitometer, which must be designed and calibrated to conform to ANSI standards. Density is expressed numerically, usually in ranges (e.g., 1.3 to 1.5). This is the common logarithm of the ratio of the amount of light *striking* the image to the amount of light *passing through* the image. Both the ANSI standard mentioned previously and Library of Congress specifications for filming manuscripts (see Appendix 1) contain a table that describes the appearance of documents, groups them according to contrast and type of writing, and recommends ranges of background density most compatible with the microfilming of each group (Figure 15).

There is a substantial problem in microfilming pages of low contrast, as well as those containing fine lines, and the problem becomes greater as the fine lines become even finer in films that use higher reduction ratios. A document with black, heavy lines and a good white background can be recorded on microfilm with a minimum of difficulty by aiming for a high background density that still leaves the line images clear on the film. With originals of this type there is a great exposure latitude, and moderate over- or underexposure will still produce a legible and reproducible image.

However, if fine lines, or lines that are gray rather than black, or that have faded to a light brown are present in a document, the slightest overexposure of the original will tend to produce a negative film image with "filled-in" lines: the background of the negative film is black but the lines are not open and clear. Lines that are quite thin, even if printed with good black ink will appear on the film as if they had been gray in the original document. The greatest challenge to a camera operator is a document that contains lines

3. This standard contains much valuable information on aspects of preservation microfilming. It also contains discussions of microfilming of documents by means of high-speed, rotary cameras intended for the recording of business records, and not as a rule used for preservation filming. The preservation administrator will benefit from a study of the entire standard to extract those portions relevant to archival microfilming, skipping occasional pages and paragraphs clearly intended for microfilming of business records.

Figure 15. Background Density

Gross densities of micro images may be classified into the following five groups according to the characteristics of the documents copied.

Classification	Description of Documents	Background Density
Group 1	High quality, high contrast printed books, periodicals, and black typing	1.30–1.50
Group 2	Fine-line originals, black opaque pencil writing, and documents with small high contrast printing	1.15–1.40
Group 3	Pencil and ink drawings, faded printing, and very small printing, such as the footnotes at the bottom of a printed page	1.00–1.20
Group 4	Low contrast manuscripts and drawings, graph paper with pale fine-colored lines, letters typed with a worn ribbon, and poorly printed, faint documents	0.80–1.00
Group 5	Some poor contrast documents	0.70–0.85

The base plus fog density of unexposed processed clear base film must not exceed 0.12. When using a tinted base film, the density will increase by .1 or .2. This must be added to the 0.12 value.

The ultimate density criterion is that the microfilm be legible for its intended use (reading, duplicating, or printing hard copies) and that all images in a reel can be duplicated at the same duplicator exposure.

SOURCE: **Specifications for Microfilming Manuscripts** (Washington, D.C.: Library of Congress, 1980), p. 13.

that are both fine and light in color. To choose the correct exposure, a microfilm camera operator must judge the entire character of the document, as well as the reduction ratios employed. Good quality in a first-generation, camera negative, the preservation master negative, means the creation of images of maximum background density *commensurate with the retention of completely clear lines of text*.

The density recommendations of various standards are based on the premise that a heavily lettered, "contrasty" original should be given maximum exposure, while all documents with fine lines or less black lines require a compromise exposure resulting in a lower background density but retaining the clear, open character of the lines. This exposure principle cannot be taken to an extreme since substantial underexposure will result in too light a background and the widening of heavy, bold lines of text, which will also lead to a loss in definition.

There are other factors, such as color or glossiness of the document, which also affect proper exposure. Figure 15 groups documents into five categories: high contrast printed books, fine line originals, pencil and ink

drawings or faded printing, low contrast documents, and completely sub-standard documents. Density ranges run from 1.3 to 1.5 at the high end of the scale to as low as 0.7 to 0.85 at the low end of the scale. The Library of Congress specifications call for normal density readings to fall between 1.0 and 1.4, while the RLG specifications call for the average density for all film produced to be within a range of 0.9–1.4.[4] Any variations required must be explained to the library in writing on an inspection report form.

It is not easy for a camera operator to determine exactly which category a given document falls into, which is where judgment enters. In the case of manuscript material, the problem is particularly acute, since any one page may have a range of different problems from background stains to extremely faded lines. If manuscripts predominate in your filming project, the filming agent may need to construct a more detailed exposure guide specific to your collection.

When a page exhibits a range of problems, it may not be possible to film it legibly in a single exposure. Two different exposures should be made to render each segment legible. An operator's target reading DUPLICATE EXPOSURE should be inserted between the two frames.

Proper camera exposure of manuscript or decaying materials, and these tend to predominate in preservation microfilming projects, is the single most difficult technical challenge. The adoption of a high Quality Index, the use of well-maintained cameras, the most careful handling of the film in subsequent processing, and careful checking will not produce a good film if poor judgment was used in the choice of exposure. Either inferior training or inadequate experience of a camera operator frequently causes the production of substandard film images. How exposure is controlled constitutes a primary difference between filming of business records and the filming of library materials or archival documents. Customarily, commercial filmers of records use either automatic exposure control or a single, preset exposure. However, as we have pointed out, such complex original materials as manuscripts require the exposure to change as frequently as the characteristics of the documents vary with respect to background color, fineness of line, stains, or faded text.

Complex materials cannot be filmed optimally utilizing fully automatic exposure control. Automatic exposure controls tend to produce images with similar background densities but different degrees of grayness of the text. These films have filled-in lines, which are not easily duplicated or re-enlarged with good legibility.

Good exposure control also includes monitoring the light emitted by the camera lamps. The camera lights must be adjusted in such a manner that the film image of a white page shows even density from edge to edge. This requires *uneven* illumination of the copyboard, the platform, or other device that holds the material to be filmed, because some of the light reflected from the edges of the copy is lost before it reaches the film. Control of expo-

sure is normally exercised in microfilm cameras by a change in light intensity, rather than by altering shutter speed or lens stop as in normal photography. Variations in light intensity are achieved by altering the voltage to the lamps with the aid of a rheostat. In less critical, commercial operations, voltage settings are used for exposure control. However, altering the voltage setting does not necessarily result in the desired intensity change. Preservation microfilming should be based on light meter readings of the actual light emitted by the lamps, not on the presumed change in light intensity resulting from voltage changes.

It is essential to include in each film a resolution chart, normally the National Bureau of Standards 1010A resolution chart (Figure 16), as a part of a technical target. The chart contains many patterns of fine lines, each pattern containing finer and more closely spaced lines than the previous one and associated with a numerical value. By recording these patterns on film and viewing the resultant film image under a microscope, an inspector can determine which bundle of lines is still distinguishable on the film as a line pattern, rather than as a gray mass. The number associated with the smallest of these "recognizable" patterns, multiplied by the reduction ratio that was used to record it, represents the resolving power of the system in lines per millimeter and is a measure of the quality of the system.

"System," as it is used here, covers the camera, lens, film, illumination system, book cradle, the camera room, even the film processor—in short, everything that might affect the definition of the image. Contractual microfilming agreements frequently state that the completed film resolve a minimum number of lines, typically a minimum resolution of 120 to 150 lines in the preservation master negative (camera master).

Quality Index. The resolution patterns provide the means to evaluate the system's inherent ability to record fine lines; it does not take into consideration the quality of the documents to be filmed or the effect which the point size of the text has on the legibility of the microfilm. A concept called the Quality Index (QI) takes point size into account; obviously, it can only be used with films containing images of printed text. It is described in detail in ANSI/AIIM MS23-1983.[5]

The Quality Index utilizes the resolution chart described above, but adds to it a measurement in millimeters of the type size utilizing the lower case letter "e," as read from the original document. This measurement is then multiplied by the smallest resolution pattern that is resolved on the film and the resultant number is used as the Quality Index. This does not involve as complex a mathematical computation as it sounds. The relationships have been plotted on a graph contained in ANSI/AIIM 23-1983; all your filming agent has to do is measure the "e" and follow the directions for reading the graph. The standard states that a QI of 5.0 is considered acceptable, that a QI of 8.0 is considered excellent (the figure required in the RLG specifica-

5. ANSI/AIIM MS23-1983, p. 20.

Figure 16. Resolution Chart

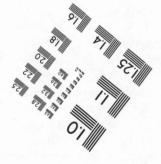
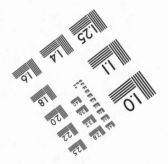

NOTE: This is an 8½″ × 11″ camera test card for planetary camera microfilming. This chart as reproduced here cannot be used for actual tests.

When a bound volume is filmed, either side of a book cradle can be adjusted for height so as to avoid undue pressure on the binding. Source: Library of Congress

tions), and that values below 5.0 are increasingly poor as the number decreases.[6]

Critics of the Quality Index method, and they are justified, say that it fails to consider the quality of the original document. However, if the Quality Index is linked with the guidelines for background density in the tables previously described, the best possible results can be obtained.

Glass Plates and Book Cradles. Loose-leaf documents can be filmed on a flat camera bed without cover glass. If the pages curl and refuse to lie flat, the filming agent will use glass covers. The glass should be plate glass, since window glass frequently has impurities, which may impair the quality of the film image. In the case of bound materials, glass-topped book boxes or cradles, which will present a flat, single or double page to the camera, are required.

Frame Counters. An internal numbering system is desirable to facilitate access within, and reference to, images on the film. For most library materials, the volume's own page numbers will provide this point of reference. For manuscripts and archival collections, preparations staff may wish to add numbering sequences that correlate filmed materials with external

6. *RLG Preservation Manual*, p. 23. See also: National Historical Publications and Records Commission, *Microform Guidelines* (Washington, D.C.: NHPRC, 1986), p. 5, which states: "An index of at least 5 (preferably 8) is required at the level of the specific number of generations used in the system."

finding aids or published bibliographies, for example. It is also possible for the camera operator to use an automatic frame counter, a numbering device located within the camera's field of view. You should keep in mind, however, that some frame counters allow little flexibility if corrections require later retakes, but there are now on the market frame counters that are infinitely adjustable. Your filming agent may have one of these.

Latent Image Fade. Competent filming agents will take an extra step between filming and processing. The latent image (the invisible image that only becomes visible when the film is developed) on the film loses density slightly between exposure and processing. If a camera operator needed an entire day to expose a roll of film, and if the film were processed directly after the last image was exposed, then the first images on the film would have been subject to eight hours of latent image fade, but the last images to only a few minutes. This causes an undesired, if small, density difference between the pages at the beginning and those at the end of the film. Since latent image fade becomes, for all practical purposes, insignificant after approximately eight hours, there is little difference between images exposed eight hours ago and those exposed any time before that. Consequently, the filming agent should give film a minimum rest period between exposure and processing. An overnight delay is desirable.

Processing the Film

Between the camera operation and the processing room lies the splicing room. In a micrographics operation using a large processor, the short, 100- to 200-foot films inserted into the camera commonly are spliced temporarily into longer rolls before they are processed. Processing of 1000-foot reels of film is not unusual. Needless to say, the splicing room has to be dust free and devoid of stray light. Too dry an atmosphere in the splicing room, associated with fast winding of the films into 1000-foot lengths, is frequently the cause of static marks on film. Unless care is exercised, scratches can also be introduced into the film at this point.

The splicing that is performed before rolls are processed is entirely separate from the archival splice used on the master negative to correct filming errors. Almost any temporary splicing method may be used. At the end of processing, the splices are cut off and the rolls returned to their original 100-foot lengths for quality control and inspection procedures.

Processors. If the filming agent uses a small, tabletop processor, the splicing operation to create 1000-foot reels is not necessary, since the tabletop units accept films only in short lengths. Tabletop processors use very high temperatures, typically 90°F to 110°F, to make up for their lack of tank capacity. The process involves short immersion in hot solutions for development, fixing, and washing, followed by high temperature drying. While this can leave the film apparently meeting all the fixing and washing requirements of permanence standards, there are numerous objections to the use of these small processors. Some of the problems can be readily seen. Clear areas of the film are less transparent as a result of this hot processing, and uni-

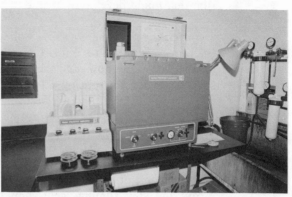

On the left is the drying cabinet of a large film processor, which can hold up to 1,000 ft. of film at one time; the rest of the processor is located in a darkroom. On the right is a table-top film processor, which can be operated in daylight. Note the automatic fixer and developer replenisher on the left and the water filters on the right. Sources: left, Library of Congress; right, Northeast Document Conservation Center

formity of processing is harder to achieve than is customary with large, low-temperature processors. There is concern on the part of experts in the processing field that high-temperature processing and drying of microfilms causes a quick surface drying that can trap undesirable moisture, and possibly chemicals, under the surface.

The small processor has another problem: it does not allow development time to be varied. Thus the more flexible large processor allows adjustment of the film contrast, while the small processor does not. Many preservation projects benefit from more contrast in the images than a tabletop processor can provide.

Achieving consistently good quality in a good processor depends almost entirely on routine maintenance, including cleaning of the equipment. Proper maintenance of a processor includes frequent cleaning or replacement of the film transport components to prevent film scratching. The chemicals must be replenished continuously, intermittently changed, and the tanks kept free from deposits. No corrosion or rust should appear on the metal surfaces. Testing of the chemical solutions periodically, at least daily, ensures that each chemical fulfills its proper function. Processing temperatures should be kept below 80°F, preferably closer to 75°F, and the drying box should have adequate film capacity so that the film dries gradually. The processor should have a wetting agent at the end of the wet cycle to avoid water spots on the film. Water coming into the processor should be filtered, and the filters should be examined frequently and changed when necessary.

It is preferable to have a processing cycle that involves two separate fixing baths. It is also useful to add a solution of potassium iodide which, it is

held, will prevent or retard the formation of microscopic blemishes on the film that might develop over time.

Splicing. Splicing is a subject on which the standards are not very helpful, nor, according to informed sources, are manufacturers of splicing equipment. Many now hold the view that for archival purposes ultrasonic splicers are best for splicing polyester films, while resistance splicers, which use heat to weld the film, are best for acetate films. Certainly this view led RLG to specify the use of ultrasonic splicers for its project participants. While some may argue that certain brands of equipment may work equally well on both kinds of film, on one point there is little dispute. Microfilm that is intended for long-term archival storage should not be spliced with tapes, cement, or glues.

You and your filming agent should establish the number of splices allowed in the preservation master negative (first generation). As pointed out earlier, there is no hard and fast rule, but generally no more than six should appear, and none at all in the printing master or service copies (see Chapter 3), although there may be unusual circumstances when this is unavoidable.

Quality Control and Inspection Procedures

After the film has been processed, the filming agent performs certain tests and inspections to ensure film quality, although some may be repeated as part of the institution's own quality control routines, as explained later. First, the filming agent tests the film for the presence of excessive residual thiosulfate. When microfilm is developed, the silver halide crystals that were exposed to light are converted into metallic silver. The fixer contains thiosulfate, which dissolves the unexposed silver complexes. Without fixation, the images on the film would lack permanence. However, excessive levels of residual thiosulfate remaining on the film after it is processed may result in staining and fading of the image as it ages. To guard against this condition, the film should be tested.

The standards that describe archival film, ANSI/ASC PH1.28-1984 and ANSI/ASC PH1.41-1984, discuss these problems in some detail. They and the RLG guidelines require the use of the methylene blue test for measuring residual thiosulfate. Information on the test, which must be performed within two weeks after the film is processed (earlier if possible), can be found in ANSI/AIIM MS23-1983 and ANSI/ASC PH4.8-1985.

These standards also discuss another test for measuring residual chemicals on film: the silver densitometric test. Unlike the methylene blue test, it can be performed reliably at any time. However, the methylene blue test is generally more popular because it is precise and a more convenient method for measuring residual thiosulfate.

In addition to the methylene blue test, the film must be inspected physically to determine whether it has scratches or abrasions. Inspectors use a light box to detect the presence of water spots, frilling, or peeling of the emulsion from the base, and other faults (see ANSI/AIIM MS23-1983 for a detailed description and illustrations of these faults).

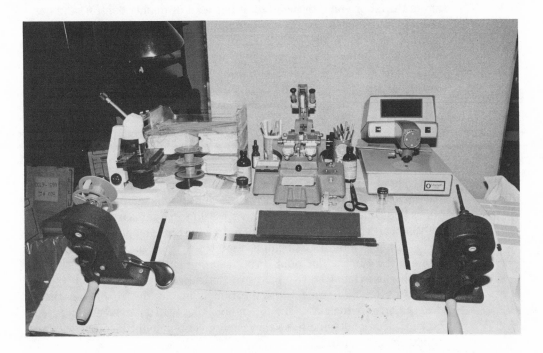

A typical inspection station with light box and rewinds. Behind light box, left to right, are a microscope for reading resolution test targets, a resistance splicer, and a densitometer. Source: Northeast Document Conservation Center

The filming agent uses a densitometer to determine whether the unexposed, clear background of the film has the desired low density reading or whether the film was struck by light or processed at too high a temperature. The densitometer is also used to determine the background density of the images. ANSI/AIIM MS23-1983 states that "the number of density measurements depends on the nature of the documents being filmed and on the tolerance desired or as required by contrast or specification."[7] The Library of Congress and RLG specifications spell this out. The library's specifications call for a visual check of background density and a double-check with a densitometer every few feet. In practice, however, the library's experienced film inspectors routinely check the film with a densitometer only at the beginning. If their subsequent visual inspection indicates a density problem, the film is checked again at the trouble spot.[8] RLG's guidelines are more detailed. The second edition of the *RLG Preservation Manual* calls for no less than twelve readings of each roll of first generation film, or five per title if more than one title appears on a roll and this requirement is stricter. If the

7. ANSI/AIIM MS23-1983, p. 32.

8. *Specifications for the Microfilming of Books and Pamphlets*, p. 12, and June 20, 1986, telephone conversation between Nancy E. Gwinn and Mary Ann Ferrarese, Assistant Chief, Library of Congress Photoduplication Service.

titles are under fifty pages, two readings per title are required.[9] Concern about the labor and cost involved in this level of quality control, and questions about the need, led the RLG microfilming project managers to recommend a revision to the guidelines. In a meeting held in June 1987, they proposed that there be no less than ten readings per roll nor less than three per *volume* if this requirement is stricter. As before, if a volume contains less than fifty pages, there should be at least two readings per volume.[10] For inexperienced staff, these guidelines may be the safer approach.

Bibliographic checking requires frame-by-frame inspection in a microfilm reader. In materials with page or frame numbering, the inspector simply runs through the reel or microfiche, viewing each frame to see that all pages have been filmed and placed in the correct order. For some manuscript materials, however, this step may require comparing each frame with the original document and noting its order in the collection, a tedious process. Water stains and other faults, not always visible during light box inspection, may only appear when the film is placed in a reader. Since reading equipment can be a primary cause of scratching, the greatest care must be taken not to damage the film at this point. The inspector must make certain that the reader's glass flats (the two pieces of optical glass that hold film flat for viewing) always separate when the film is in motion so that no film is dragged against the glass. The rollers touching the film emulsion must also be kept clean and smooth, so they do not contain embedded particles that would cause scratching.

Ideally, the inspector should not put the preservation master negative on a microfilm reader, unless there seems to be a problem that can only be explained by the first-generation film. The inspector should examine only the printing master or service copy. As a practical matter, however, even though there is a risk of damage, it is not always possible for a laboratory to go to the expense of duplicating a master negative before it is checked, at least on a light box, for errors. If inspection is performed on the master negative, cleaning and maintenance of reading equipment is critical. All staff who handle film should use lintless gloves or surgical gloves. During inspection the film is wound on a reel in the standard manner illustrated in ANSI/AIIM MS23-1983 and in ANSI/AIIM MS14-1978.[11]

The filming agent keeps records of the results of the inspection and reports this information to the repository. Figure 17 shows a sample filming agent quality control report form. An explanation of the errors listed, with illustrations of actual pieces of film that contain them, can be found in ANSI/AIIM MS23-1983. If corrections to the film are required, the filming agent should follow the specifications for splices and retakes that you have laid out.

9. *RLG Preservation Manual*, p. 23.

10. This change removes the ambiguity of basing the number of readings on a title, which could involve many volumes, as well as reduces slightly the number of readings per roll. This change had not received full review within RLG as of this writing, but it was expected that the project managers would implement it immediately.

11. See ANSI/AIIM MS14-1978, p. 4, or ANSI/AIIM MS23-1983, p. 14 (same illustration).

Figure 17. Filming Agent Quality Control Report Form

Research Libraries Group
Cooperative Preservation Microfilming Project

<div style="border:1px solid"> </div>

Storage Number

Library _____ Author _____

Filming Agent _____

Title _____

Exposures _____ Feet _____ Pub. Date _____ Vols. _____

1. Filming
 Operator _____ Camera _____ Filming Date _____
 Qual. Index e size (mm) _____ Required Resolution Pattern _____
 Image Orientation _____ Reduction Ratio _____
 Remarks _____

2. Initial Quality Control
 Processor _____ Inspector _____ Processing Date _____
 Resolution Pattern Read _____
 Density Readings 1 _____ 2 _____ 3 _____ 4 _____ 5 _____ Ave. _____

3. Filming Errors (give pages)
 Overexposed Images _____ Density _____
 Underexposed Images _____ Density _____
 Focus Defects _____
 Obstruction in Frame _____ Cause _____
 Poor Contrast _____
 Streaks _____
 Fogging _____
 Other _____

4. Physical Defects
 Finger Prints _____
 Scratches _____
 Water Spots _____
 Dust, etc. _____
 Other/comments _____

5. Action to Correct Defects
 Refilming: Whole Title _____ Pages (#) _____
 Exposures refilmed _____ Splices needed (6 max.) _____

6. Approval for Variance from Project Specifications Variant Density _____
 Other Variances _____
 Variance Approval of RLG Project Manager Initials _____ Date _____

7. Certification of this Report
 Filming Agent Initials _____ Date _____
 Project Manager Initials _____ Date _____

SOURCE: **RLG Preservation Manual,** 2nd ed. (Stanford, Calif.: Research Libraries Group, 1986), p. 26.

Returning Microforms to Repository. When the filming agent returns the film, the reels or microfiche should be accompanied by the inspection report forms and other records required by the repository. The processed film should be delivered wound with the START target at the outer end. Reels and boxes that meet the specified standards discussed later in this chapter should be used. Results of chemical tests for residual thiosulfate should also accompany the films. You should request that the hard copy be returned with the microfilm in case questions occur during your own film inspection. For better control, you should specify that all items and targets packed by the institution in one shipment are returned together with completed film in a single delivery shipment. If shipments are to be transported away from the institution, specify that transportation be carried out in closed vehicles with pickups and deliveries made indoors at agreed-upon locations.

In general terms, we have described the steps followed by the filming agent and the standards that guide the filming operation. While libraries and archives must be ever vigilant about the quality of microforms produced or purchased, there are far fewer problems today than twenty years ago. The cooperative development of voluntary standards has been a great influence. This process deserves closer examination.

National Standards: An Overview

Microforms have been subjected to more stringent standards, to a much more thorough analysis of their stability and image quality, than any other recording medium in history. Today's microform standards serve to protect the consumer, to educate the user, and to guide both the manufacturer of microfilm materials and the library, archives, or commercial producer of microforms.

How Standards Are Created

The micrographics industry benefited from early standards written under the auspices of the National Bureau of Standards to promote the production of durable and long-lived films for the motion picture industry. Today, United States standards, which are also called guidelines, specifications, recommended practices, or norms, are produced by many different organizations, primarily under the auspices of the American National Standards Institute (ANSI), but also by such industry associations as the Association for Information and Image Management (AIIM), the U.S. government in the form of federal and military specifications, library organizations, and the Library of Congress. While U.S. standards are not under the jurisdiction of the U.S. government, many foreign standards are written under government auspices. ANSI standards delegations meet with delegates from national standards organizations of other countries to debate on international standards under the auspices of the International Organization for Standardization.

As our discussion of the filming process showed, microform standards cover such topics as microform equipment, the legibility and stability of mi-

croforms, and the arrangement of images on microfiche and roll film. The committees that devise them may be lodged administratively in different organizations. For many years, for example, the responsibility for developing permanence standards, including the necessary test methods to qualify raw stock and processed microfilm, has lodged with the ANSI Committee on Photographic Films, Plates and Papers (PH1), whose secretariat is the National Association of Photographic Manufacturers. The responsibility for formatting of microforms, image quality, and microform equipment now rests with the AIIM National Standards Committee (formerly Committee PH5). AIIM is an ANSI-approved standards organization and currently has approximately twenty microform standards, many of which have been approved as ANSI guidelines, practices, or standards.

Most ANSI-accredited standards committees have subcommittees, task forces, or ad hoc committees where the actual work of debating the issues and writing the standards is performed. While the procedure varies slightly from one committee to another, all agree to operate under formal ANSI procedures. Normally, this means the basic draft is sent out for ballot to the subcommittee members and subsequently, after resolution of any negative votes, to the parent committee where it is balloted again. Negative votes must be resolved before the standard is reviewed and approved by the ANSI Board of Standards Review.

ANSI rules state that all standards committees must have a balanced mix of users and producers to assure that the standards blend the expertise (and economic interests) of the manufacturers with the preferences and best interests of the ultimate consumer. Thus, microform committees comprise film producers, equipment producers, service agencies, and industrial, commercial, and nonprofit users. Committee members are volunteers. Committees normally meet from one to four times a year; some committees conduct much of their activity by mail. Standards are written, at least all those ultimately approved by ANSI, according to strict semantic and legalistic rules. The words "shall" and "should" are frequently used with respect to stated requirements, which means that if the standard is incorporated into a contractual agreement, the "shall" items have mandatory adherence while the "should" items remain optional. Standards, as they are published in the U.S., have no automatic legal authority. However, they may be incorporated into legal, contractual arrangements.

The creation of standards involves considerable technical experimentation, which must be conducted in well-equipped laboratories. These services are normally contributed free by the manufacturers of materials and equipment.

How soon after the introduction of new processes, materials, and applications should a relevant standard be written? Practical experience is normally required before a standard can be attempted, lest the standard have a restrictive effect on innovation. On the other hand, if standards specifications come too late, arbitrary variations may create undesirable systems incompatibilities. For this reason, white papers and technical reports concerning new materials are sometimes produced prior to a standard to prevent arbitrary excursions into multiple formats. As an example, in the early days of microfiche applications in the United States, producers used $3'' \times 5''$,

$5'' \times 8''$, and $6'' \times 8''$ fiche before the $4'' \times 6''$ fiche (approximately) became a standard.

New materials and new processes create continuing challenges in standards development. Imaging materials that have not been subjected to standard specifications are in use today: electrophotographic films and dry silver films are among them. Considerable work is needed before the stability of these materials is ascertained and specifications written. Microimaging by means of optical disk falls into this area. Some of the new materials are known to be quite unstable and their use for film records is justified only with a general understanding that they will not be permanent. Until objective research is conducted, however, claims for image stability for new materials should not be accepted.

It takes many years to complete a standard. At today's hectic technological pace there is a danger that the introduction of new imaging materials and the current slow process of researching these materials for stability will be out of phase. Valuable new materials with the promise of great stability may be developed, but the current mechanism of writing standards is too slow to cope with this situation. Increased funding of technical investigations to analyze the properties of new materials would expedite the process. However, the ultimate evaluation of the test findings would still have to be conducted by volunteer committees composed of the blend of manufacturers and users characteristic of the current ANSI and AIIM committees.

The primary microform standards today contain not only the specifications for stable microforms, but include a host of comments incorporated into the forewords and appendices which, while not officially part of the standards, are of great value in the education of the user of microforms. Studied in its entirety, the standards literature describes good practice and offers clear explanations of the reasons for recommended and mandated procedures.

Standards Revision

Over the years microfilm standards have been revised many times and all of them continue to be reviewed by the designated subcommittees. Certain standards have changed almost annually. Product changes, new techniques, and unexpected events, such as the appearance of microscopic blemishes on film, have made it necessary to question and review constantly the recommendations and specifications in the standards.

The assumptions made with respect to the life of a film are based on accelerated aging tests intended to simulate natural aging. Occasionally, questions are raised about the proper correlation between natural and accelerated aging tests. Even as this manual goes to print, two issues, one pertaining to the validity of current residual thiosulfate specifications and the other concerning the photographic activity test, are seriously in contention. The thiosulfate requirement may be too stringent, since it is now thought that a small amount of thiosulfate may aid in the suppression of microscopic blemishes. The photographic activity test, which is used to discover if paper, adhesives, inks, etc., used in film containers or fiche envelopes will harm film,

may be too lax. These and other standards will continue to be improved in the light of additional research.

Keep in mind that microform standards have not been written solely for the library or archives communities, but also encompass the needs of businesses, corporations, or other organizations concerned with retention of documents on microform. The purposes and needs for longevity of these groups differ from those of libraries and archives, so a more strict interpretation of the standards may be required.

Master Negatives and Service Copies

Most preservation microfilming programs will generate at least two film copies: a preservation master negative and a copy intended for use by the repository's clientele. The preservation master negative is the film actually used in the camera, and is often referred to as the camera negative or the first-generation film. In some standards, it is called the film storage copy. Ideally, it would only be used once, to generate a second master negative, known as the printing master or a second-generation or intermediate film. The printing master is critical if there will be repeated requests for additional film copies, in order to protect the preservation master. The copy to be used by readers is known as the service copy, distribution copy, or work copy. The distinction between master negatives and service copies is important. Films prepared to be potentially archival, or permanent, are not necessarily the most durable or practical under conditions of frequent use.

The discussion that follows covers the qualities of microforms and describes what is required of both the film and the conditions of storage and care to safeguard its preservation qualities. These points are covered in a multiplicity of standards documents, all containing references and pointers to one another. Understanding the basic issues is especially important if you will be contracting work with service bureaus, which may not have long experience with the requirements for preservation microfilming.

Permanence of Microform

Definitions. The whole rationale for the process known as preservation microfilming is to create a permanent, or archival, copy of the printed material transferred to film. In 1975, the National Archives and Records Administration defined the term archival in relation to federal records:

> Essentially the term "archival" is synonymous with "permanent" and the two are frequently used interchangeably. To us [National Archives] they have the same meaning: that is, forever. To say that we are going to keep forever everything that is now classified as archival, or permanent, is a rather positive statement and one which none of us can guarantee, yet it does express our intention in relation to records which have been appraised as being of permanent value, or archival.
>
> This clarification is also important because it is necessary that whatever material is approved for permanent record filming must be equal to or better than the present materials that have been certified for permanent record use.

Permanent or archival record film can be defined as any film that is equal to or better than silver film, as specified in American Standards PH1.28 and PH1.41.[12]

This definition of the term "archival" has been accepted by all standards committees dealing with film permanence.

Recognizing that different organizations have different needs as to the longevity of film, standards subcommittees have developed two other categories in addition to archival film. These are "medium-term" and "long-term" films. Medium-term films have a life expectancy of at least ten years, while long-term films are those that will last one hundred years, given archival storage. These terms are generally applied to film stocks that are not silver gelatin, and, for preservation microfilming purposes, should only be considered for service copies. Since we know what is required for archival film, why not make all film archival? The answer is simple. It is more costly to create such films, as compared to the production of films intended to last only for ten years. Preservation administrators will find it constantly tempting, in negotiating with filming agents, to find ways of stretching their limited budgets. Adherence to archival standards, however, is not an area for compromise.

Hazards. The question is often asked: "What must films be protected against?" The basic problems are as follows:

1. Fading or staining of the images
2. Microscopic blemishes (generally tiny red or yellow spots)
3. Abrasion and scratching or other physical damage
4. Separation of the emulsion from the base
5. Embrittlement of the film
6. Fungus destruction.

These result from improperly chosen raw stock, faulty processing, imperfect storage, poor handling, fire or water, or a combination of these. All the requirements in the standards for microforms, including prescribed tests, are intended to protect the film against these hazards.

The "Big Three." There are three ingredients that will determine the permanence of a microform: the composition of the film stock, the quality of the film processing, and the conditions under which the film is stored. The composition of the film stock and the manner in which it must be processed to ensure its longevity are covered in two standards, one dealing with cellulose ester base film stock, and the other with polyester base (ANSI/ASC PH1.28-1984; ANSI/ASC PH1.41-1984). Both are silver-gelatin type films, which has long been considered the only type to qualify for archival permanence. The third standard (ANSI PH1.43-1983) describes archival storage conditions. These three standards are the most important of those pertaining to permanence of microfilm.

At first glance, these standards may appear dauntingly technical if you are

12. J. B. Rhoads, letter to P. Z. Adelstein, *Journal of Micrographics* 9:193–94 (March 1976).

just establishing a microfilming program. The forewords and appendices of the standards are written with you in mind, however, and they elaborate in lay language on some aspects of film permanence.

Film used for preservation should be the sharpest available. Most manufacturers of microfilm offer a variety of films intended for different micrographic applications. Preservation microfilming of source documents should employ only the slowest, highest resolution films available. Virtually all films offered by commercial firms for microfilming qualify under permanence standards, but not all manufacturers produce equally sharp film. Filming agents should make intermittent comparison tests to determine the sharpest films.

It is unwise to economize in the choice of film for preservation filming, since the cost ratio of materials to labor may be as great as one to twenty. The forewords to several standards state that polyester base films have greater permanence than acetate base films. Since polyester base films are also virtually tear proof both during film processing and in subsequent use, choose polyester over acetate.

Archival Film. Silver-gelatin films have been subject to permanence standards for a long time. Two other film types, diazo and vesicular, are now widely used, however. Indeed, some micropublishers use one or other of these exclusively. These two films have not been qualified as archival. However, recently issued standards (ANSI PH1.60-1985; ANSI PH1.67-1985) contain specifications and test methods indicating that if diazo and vesicular films "pass," they can be either medium- or long-term films if properly stored. The diazo and the vesicular film standards are concerned entirely with storage of films, rather than their use. Diazo and vesicular films are too "slow," that is, too little light-sensitive, to be used routinely as camera films; thus they are always made by printing from other films. Consequently, these films would never become preservation negatives and could only be considered for production of service copies.

Silver-Gelatin Film. Silver-gelatin film, either on a polyester or a cellulose ester base, is the oldest of the currently used materials. Silver is known to be a stable metal and the image on silver film is metallic silver. The gelatin in which the silver is suspended has been observed for many years in photographic film and other applications, some of which date back centuries. Silver-gelatin films have received more attention, more testing to establish their permanence, than any others. The conclusion is that these films are inherently capable of yielding an archival image.

Ironically, the same archival silver film is more at hazard than, for example, vesicular film, if not carefully treated. It is subject to fungus, vesicular film is not. It is easily scratched. It can develop microscopic blemishes (microscopic red/orange spots and rings); vesicular film does not. It is subject to image destruction if residual chemicals remain after processing. It is sensitive to water and humidity damage to a greater extent than other film materials. This is of greatest concern if silver film is used for service copies as well as master negatives. It will require care to keep it available for use in a microform reading room.

Diazo Film. Diazo films have caused concern because of the possible fading of the dyes and staining of the clear portions of the film. Diazo films qualifying under the specifications as long-term (ANSI PH1.60-1985) will show little change if kept in archival storage and away from light and humidity.

It should be stressed, since there has been some misunderstanding in the public literature, that "long-term" does not apply to *all* diazo and vesicular films; it is specifically applicable to those diazo and vesicular films that qualify under the ANSI standards. It is entirely possible that diazo films with stable dyes, kept under the proper storage conditions, and treated with the greatest care when inspected or used occasionally, will retain completely adequate legibility and change very little over an indefinite period of time.

Vesicular Film. Vesicular film is an exceptionally tough and durable material under use conditions. In many instances, it may withstand adverse conditions in libraries and archives better than silver film, but it has basic properties which, at this time, disqualify it as an archival film.

The vesicular film image consists of small bubbles within a plastic layer. These bubbles scatter light and thus produce a visible image. It is not known at this time what permanence these bubbles will exhibit over a period of centuries. Bubble collapse due to pressure is possible, as is deformation of the bubbles as a result of continuous elevated temperatures.

The industry has not yet designed reliable accelerated aging tests for this type of film. Vesicular films have shown excellent image stability under practical conditions for several decades; the new standard (ANSI PH1.67-1985) describes the type of vesicular film and the processing conditions that will produce a long-term film if it is archivally stored.

In conclusion, let us stress again that not all silver-gelatin film is permanent. Only film manufactured, processed, and stored according to the ANSI standards has the capability of being permanent. Similarly, not all diazo or vesicular films are long-term films. Only those which have the basic properties and are properly processed and stored can qualify.

Storage of Microforms

Proper storage practices are important for all film copies, but few libraries or archives house a storage vault that fully meets archival standards. While compromises are usually required for some storage aspects of service copies, and possibly printing masters if kept locally, preservation master negatives should be stored in the best conditions, even if it means leasing space in a commercial facility that meets archival standards. Some storage companies may also be able to produce microform copies, thereby avoiding the need to remove master negatives at any time.

The ANSI standard on storage (ANSI PH1.43-1983) answers most preservation administrators' questions. It contains many references to other standards on air conditioning and fire prevention that come into play if construction or remodelling a room is contemplated. The curator of a preservation microform collection must be concerned with five aspects of storage:

1. Storage rooms or vaults
2. Ambient conditions: humidity and temperature and the chemical nature of the atmosphere in the room
3. Storage housing, i.e., drawers, shelves, cabinets
4. Enclosures for microforms, e.g., boxes, envelopes
5. Inspection of stored film.

The following is a summary of good practices to observe in storing roll film and fiche.

Storage Rooms or Vaults. If you are in the fortunate position of being able to construct an archival vault, the standard gives a clear description of what is required. If you are seeking to lease, then site visits are essential. Prepare a checklist of questions and reminders to yourself. For example, the vault should contain or be within easy reach of film inspection equipment.

Either drawers or private vaults can be leased at a commercial underground storage facility if space to store preservation master negatives is otherwise unavailable. Source: National Underground Storage, Inc.

Good housekeeping is essential. If the premises are air-conditioned, the room or vault must be designed so that condensation on walls and ceilings will not occur. Care must be taken to construct the premises so as to avoid potential damage by floods, leaks, and sprinkler systems. Be sure to inquire if there have been any problems like this in the past.

Archival storage rooms must be dedicated to the function of archival storage. No other activities, such as clerical work or repair of film readers, should be undertaken within the confines of the room.

Environmental Controls. There are three considerations in environmental control of microform storage areas. The first deals with humidity and temperature. Different films have differing optimum conditions of temperature and relative humidity, and these are specified in the storage standard. If there is a mixture of different films, the recommendation is a 30 percent relative humidity and a temperature not in excess of 70°F. Lower temperatures are preferable. Constant cycling of the temperature and relative humidity is especially undesirable.

Air conditioning is normally required for archival storage, and it must provide even air circulation throughout the storage area. A portable piece of equipment, known as a hygrothermograph, should be placed in the area to monitor the temperature and humidity continuously. There are numerous publications by the American Society of Heating, Refrigeration, and Air Conditioning Engineers (listed in the ANSI storage standard) that explain aspects of air conditioning.

If it is not feasible to install air conditioning and the humidity is at high levels, you may need to consider dehumidification equipment. Desiccating chemicals such as silica gel may be used, provided that the silica gel is contained within a unit that filters out very fine dust particles. Open water trays or tanks may not be used because of the danger of over-humidification of the area immediately adjacent to such devices.

How serious is a "slight" departure from the recommended storage environment? This is difficult to answer, since many combinations of variables are possible. Departure from a maximum allowable temperature by 2°F will probably have little effect by itself. However, an increase in temperature and a simultaneous increase in the relative humidity, even if relatively slight, could be fatal to film within a matter of weeks due to fungus activity. It is, therefore, not safe to depart from the recommended practices.

Inspection of Stored Film. An important aspect of film storage is intermittent film inspection. No matter how carefully the premises are constructed, how carefully the enclosures are chosen, there is a possibility that something may go awry. It is good practice to inspect samples of stored film on a systematic basis so that each drawer or cabinet is examined at least every two or three years. If you are leasing space in a commercial facility, make sure the lease provides for periodic inspection and allows your institution to go in and perform its own inspection at any time.

The AIIM guidelines for microfilming public records (AIIM TR6-1985) are quite specific in establishing inspection requirements. They call for a one

percent sample—different each time—every two years, with a small amount of overlap to track changes in previously inspected samples. Inspectors should look for mold or fungus, film curl or discoloration, and excessive brittleness.[13] Other problems might be lack of adherence of the emulsion to the base, evidence of adhesion (films sticking together), and microscopic blemishes. Rereading the resolution test and remeasuring film density is encouraged. Inspectors should also be on the alert for signs of rust, corrosion, or other deterioration of the cans, boxes, or reels used to store the film.

The biennial inspection report, the guidelines state, should specify the quantity of microfilm in the storage room, as well as how many and which films were inspected. The condition of the microfilm is the main ingredient, but the report should also state the corrective action required if necessary. Obviously, if you should spot a problem, you will have to conduct a more extensive inspection to locate all deteriorating film.

If anything happens to alter storage conditions, such as the temporary breakdown of the air conditioner, you must immediately spot check the microforms. If there is any indication of possible damage, take corrective action with respect to the entire vault immediately, particularly if you suspect that fungus damage may have occurred.

Air Purity. Purity of the air is important in the case of archival storage. If for any reason a vault is subject to the invasion of solid particles introduced by the air conditioning system, then mechanical filters to remove these particles are needed to prevent them from damaging the film during subsequent use.

Gases contained in the air can be harmful. Sulfur dioxide, hydrogen sulfide, peroxides, ammonia, and certain acid fumes can cause deterioration of film. Filtering can also remove these gaseous impurities. An alternative is to protect the film in sealed containers (see discussion of reels and containers later in this chapter). If you are fortunate to be able to construct an archival vault with the sole purpose of preserving film, locate the vault as far from an industrial area as possible.

Nitrate Film. If you plan to consolidate housing of older films with new ones, make certain none of the older film is on a cellulose nitrate base. Nitrate-base film has not been manufactured since about 1951, but older films on this nonsafety base are occasionally encountered. As these films deteriorate, they give off toxic nitrate acid fumes. Under certain high-temperature conditions, there have been cases of spontaneous combustion of reels of nitrate film. Consequently, under no circumstances may such films be stored with safety base film. They may not even be stored in an adjoining vault, if the two areas share the same air-conditioning system. Nitrate-base films should be completely isolated.

13. See also "Micrographics," 36 CFR Part 1230, which contains requirements for inspection of stored microforms of permanent federal records. The National Archives, which prepared the text, requires a three-year cycle. Construction of samples, the process of inventory, inspection elements, and establishment of an inspection log are covered.

How do you tell if your older film is nitrate or not? First, if the film carries the word "safety" or a capital S in the border, it is a safety base, not a nitrate-base film. If those symbols are missing, and the border does not say "nitrate," then the film is suspect. There are two tests—a float test and a flame test—for determining whether film is made of cellulose nitrate. If you cut a small corner of a nitrate-base film and light it with a match, the film will flare and produce a strong acrid odor; safety film burns slowly. If you drop a corner of the film into a small bottle or test tube containing a solution of trichloroethane and trichloroethylene, the film will either sink (nitrate), float to the top (acetate), or float at mid-level (polyester). The float test is safer for the layperson to conduct. You will find a very clear illustrated explanation of these tests and the methodology for carrying them out in one of the Society of American Archivists' basic manuals: *Archives and Manuscripts: Administration of Photographic Collections.*[14]

Fire Protection. As far as fire protection of film is concerned, there are ANSI standards (listed in the storage standard) for construction that combine air conditioning with fire safety. For small quantities of film there are fire protective enclosures on the market. These enclosures are intended to keep internal temperatures below 150°F in case of fire. But there are unresolved questions with respect to fire protective chemicals incorporated into paper cartons for the storage of film or fiche, as far as their potential effect on the stability of archival microfilm is concerned. You should note that, after discussing fire protection at some length, the ANSI storage standard concludes that the best fire protection is a duplicate copy of the film placed in another storage area.

Storage Housing. With respect to housing of microforms, whether master negatives or service copies, closed housing is preferable, either chests of drawers or shelves or racks within a cabinet with outside doors. If the film is already enclosed in sealed containers, then open shelves are acceptable. Microform housing should be made of a noncombustible material, for example, anodized aluminum or steel with baked-on, nonplasticized lacquer. Wood, pressed board, particle board, and similar products are not suitable. These materials are not only combustible, but they may well give off undesirable vapors. The storage housing should be constructed in such a manner as to allow air-conditioned air free access to the films, unless previously conditioned sealed containers are used.

In the case of microform housing, and this applies to the storage room as well, fresh paint or newly applied lacquer must be avoided. Paints and varnishes contain elements that are thought to contribute to the formation of microscopic blemishes on microfilm. Some weeks, preferably four, should elapse before microforms are stored in a room that has been painted recently.

14. Mary Lynn Ritzenthaler, Gerald J. Munoff, and Margery S. Long, *Archives and Manuscripts: Administration of Photographic Collections* (Chicago: Society of American Archivists, 1984), pp. 116–19. Additional information can be found in ANSI/ASC PH1.25-1984.

Reels and Containers. Reels and containers, according to the standard, should be of a noncorroding material such as plastic, which does not give off reactive fumes. Plastics that do give off reactive fumes, notably those containing peroxides, are not acceptable. The storage standard lists both desirable and undesirable plastic materials for containers. You cannot always tell what plastics have been used in the manufacture of a commercially acquired container or film reel. If the material is unidentified, the supplier should be asked to provide the necessary information. (Specifications for materials suitable for film enclosures are discussed in both ANSI PH1.43-1983 and ANSI/ASC PH1.53-1984.)

ANSI committees have criticized certain plastics on the basis of their chemical composition and suggested that they not be used until the manufacturer can show positively that no harmful side effects will ensue. This means that certain plastics may be perfectly safe in conjunction with film, but until the manufacturer is able to prove the material innocuous, the material will not be recommended.

Stainless steel is another suitable material for reels and containers, although it is recognized that it may be too expensive in most applications. Anodized aluminum is also acceptable. If boxes are used, they should be both acid- and lignin-free and meet the detailed composition requirements contained in ANSI/ASC PH1.53-1984.

Occasionally, microfilm is stored in the form of long rolls that exceed the capacity of the standard microfilm storage reels. If that is the case, the film should be stored flat, not on edge. If it is stored on edge, the weight on the bottom of the roll is excessive.

It is preferable, according to the standards, to store rolls of film in closed containers to protect the film against dirt or physical damage. In the case of films containing dyes, for example, diazo or color films, the films must be protected against light also, possibly using an opaque container or opaque housing. (Color films are not at this time considered to be either archival or long-term films.) Closed containers may be completely sealed against the atmosphere. If they are (and metal containers can be closed and sealed by means of tape), you must be sure that the atmosphere captured within the container is of the proper humidity and was not subject to atmospheric pollution. This is very difficult to do. To illustrate: following processing, a film may contain a certain amount of residual moisture, particularly if it was processed in a tabletop processor at high temperature. If, after processing, the film is placed immediately into a stainless steel or aluminum container and sealed, the atmosphere within the container will be considerably more humid than is healthy for a film, since the controlled air of the storage room cannot penetrate the closed container to neutralize the excessive humidity.

If a collection includes films that might release acid fumes, for example older vesicular films, store them separately, not in the same cabinet or room with silver films. You must also put them in plastic containers made of polyethylene, rather than in cardboard or metal containers. Generically different types of film, such as diazo film and silver film, should not be stored within the same housing.

Rubber Bands and Paper Tapes. Paper bands should be used to secure rolls of film, provided that the paper conforms to the specifications contained in ANSI/ASC PH1.53-1984. Rubber bands are not acceptable. Even those which are chemically adequate can crimp and physically distort film. No adhesive coated tape should ever be used directly on the film.

Microfiche Storage. Paper envelopes can be used to store microfiche provided that they also conform to the paper requirements of ANSI/ASC PH1.53-1984. If the microfiche service copy is diazo, then the film should be protected against light during storage.

Store microfiche in as clean a condition as possible and not under extreme pressure. When plastics are used for the storage of microfiche, it is considered acceptable to use uncoated polyesters and cellulose acetate materials, since these materials are actually used for the film base. The standard mentioned above should be consulted with respect to adhesives that may be used for the seams of microfiche envelopes. Envelopes should not be constructed in such a way that a seam rests across the image area of the microfiche. In fact, the storage standard suggests that microfiche not be stored in envelopes that use any adhesives in their construction, but it is difficult to find such envelopes. Avoid permanently tacky, pressure-sensitive adhesives. Rubber compound adhesives are detrimental to film.

As with roll film, it is undesirable to mix microfiche with generically different film bases in the same storage housing.

Contracting for Filming Services

Familiarity with micrographics standards will greatly assist the preservation administrator or archivist who plans to purchase filming services from an outside filming agent, whether from the commercial or not-for-profit sector. Most contracts contain two sections, one devoted to general terms and conditions of agreement, the other to technical specifications. A third section contains the budget or cost figures. Both the institution and the filming agent benefit from a clear, written understanding of what is expected. A handshake is not enough. A sample contract appears as Appendix 2.

General Terms and Agreements

The general part of the contract sets out in detail the responsibilities of the institution and the filming agent and the conditions and terms under which both agree to work. Common topics are:

Pricing policies and frequency of price escalation
Compliance with specifications
Errors and delays
Cancellation of the contract
Dispute resolution
Subcontracting
Insurance and security

Responsibilities for preparation, targeting
Pick-up and delivery arrangements; turn-around time
Right of the institution to specify microfilming methods.

Technical Specifications

The contract should have detailed specifications for filming, processing, duplication, and inspection of the microfilm. You may need to add local or special filming or handling instructions, especially if you are microfilming brittle materials or volumes to be kept after filming. A sample set of targets with instructions for their use and a complete list of micrographics standards will complete the document.

Communication

As the work progresses, the library or archives should try to establish open lines of communication with the filming agent, so that problems, changes, and special instructions can be freely shared. It is in your best interest to provide the filming agent with good, constructive feedback on a regular and timely basis, based on your own quality control program. This is your primary means of maintaining control of the project.

The filming agent will need to report the inevitable bibliographic problems, missing paperwork, and other situations, but he or she will also play a vital role in suggesting methods of filming and layout of materials that take into account the way the filming agent operates. As with the library binder, any time you ask for something that is different from normal practice, regardless of whether it may seem easier or faster, costs will be higher—and, of course, the risk of error is increased. The filming agent will be able to suggest alternative ways of meeting your needs that also take into consideration their methods of operation.

Contract Review

Library or archival staff and filming agents should meet periodically to examine projects and services, to explore new services, to discuss problems, and to make sure that services are adequately provided and needs met in the most economic and efficient way possible. Evaluate the contract, services, and budget once a year. Changes should be made at the time the contracts are renewed and bids are negotiated, if that is required.

Your Role in Quality Control

Although the filming agent contracts to perform 100 percent quality control inspection in all completed film, this does not alter your responsibility for a second check to ensure quality. This is an ongoing responsibility, for if you do not point out problems to the filming agent, they are unlikely to be corrected. The inspection process helps to teach both the filming agent's

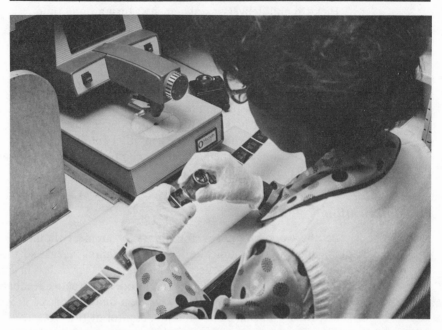

The preservation master negative is inspected with a loupe for flaws. Note the densitometer at upper left. Film is on supply and take-up reels attached to winders (not shown). Source: Library of Congress

camera operator and quality control staff what the institution expects, and to show the institution's interest in the quality of work performed.

At the beginning of the contract, when the filming agent is inexperienced or new to the project, it will be necessary for you to reinspect 100 percent of the completed master negative film to make sure specifications in the contract are adequately met. However, the preservation master negative (first generation) should not be put on a microfilm reader, unless there seems to be a problem that can only be explained by the first-generation film. Inspectors should review the service copy, checking for image quality, legibility, completeness, and correct order. Any irregularities in the original or changes necessary for technical quality of the film should have been noted in a target. This inspection should be supplemented by spot checks for density and resolution. If you cannot perform these locally, you can send samples to a reliable laboratory with technical expertise or arrange for assistance from another institution with in-house filming facilities. A list of chemical testing laboratories is available from the Association for Information and Image Management.[15] Figure 18 shows a sample quality control form that you can adapt and use to check on your filming agent's work. From the foregoing, it is obvious that your local inspectors must be well-trained in microform quality control.

15. See Appendix 4 for address.

Figure 18. Library Quality Control Report Form

Research Libraries Group
Cooperative Preservation Microfilming Project

Storage Number

Library _____ Author _____

Filming Agent _____ _____

Title _____

Pub. Date _____ Vols. _____

1. Targets	Correct/Comments
* Start	
* RLG/Member ID	
* Storage number	
* Primary bibliographic target	
Catalog record target	
Title guide target (for serials)	
List of missing pages (for monographs)	
Optional (e.g., location/restrictions)	
* Reel number (for serials)	
* Reel contents (for serials)	
Technical target	
* Volume/year (for serials)	
* As-needed targets (e.g., BEST COPY AVAILABLE or PAGE(S) MISSING)	
* End of title.	
* Continued on next reel.	
or * End of reel. Please rewind.	

Description of defects (Missing, illegible, out of sequence, typographic errors, skewed, etc.) _____

2. Conformation errors Pages Missing _____

 Other Page Defects _____

 Sequence Problems _____

 Leader, Trailer, or Spacing Error _____

 Other Format Defects (reduction, orientation, framing) _____

3. Action to Correct Defects

 Refilming: Whole Title _____ Pages (#) _____

 Splices needed (6 max.) _____ Exposures refilmed _____

 Other Action/Comments _____

4. Corrections Made and Approved Proj. Mgr. Initials _____ Date _____

5. Certification of Report Proj. Mgr. Initials _____ Date _____

SOURCE: **RLG Preservation Manual,** 2nd ed. (Stanford, Calif.: Research Libraries Group, 1986), p. 27.

 After the initial honeymoon period with the filming agent, and after you are confident that the ground rules have been firmly established and the work continues to be routine, consistent, and of high quality, you can reduce the rigorous quality control performed by local staff to a level as low as 10 percent of the completed microfilm. Frames with bibliographic targets and catalog cards should continue to be checked for each title, however. You should reinstitute higher levels of quality control whenever new activities are undertaken, different types of materials are filmed, or whenever the quality of work warrants it. The quality of the work performed and the completed microfilm are only as good as the quality control and inspection measures taken. Good quality control procedures will ensure that the institution's high expectations are met.

Conclusion

 Standards for preservation microfilming are exacting, and with good reason. Even if paper copies of the volumes filmed continue to be available for some time, the act of microfilming is making a commitment to keep that volume forever accessible. It is a charge that must be taken seriously, for it is doubtful that the funding will ever be sufficient to allow the same volume to be filmed twice. This chapter can be considered only an introduction to standards and their contents; it can not substitute for the real thing. Use it as a menu, and enjoy the feast.

List of Suggested Readings

"Archival and Its Meaning." *Microfilm Techniques* 6:18–19 (Jan./Feb. 1977).

Avedon, Don M. "Archival Quality and Permanence of Microfilm." *IMC Journal* 1:12–14 (1978).

––––––. "Microfilm Permanence and Archival Quality." *Special Libraries* 63:586–88 (Dec. 1972).

––––––, and Ann M. De Villiers. "Microfilm Permanence and Archival Quality." *Journal of the American Society for Information Science* 30:100–02 (Mar. 1979).

––––––, and Henry C. Frey. "Standards—A Dialog." *Journal of Micrographics* 11:81–83 (Nov./ Dec. 1977).

Byrne, Sherry. "Guidelines for Contracting Microfilming Services." *Microform Review* 15:253–64 (Fall 1986).

Calmes, Alan. "Microfilm as a Preservation Medium." *Journal of Imaging Technology* 10:140–42 (Aug. 1984).

Dodson, Suzanne Cates. "Microfilm Types: There Really Is a Choice," *Library Resources and Technical Services* 30:84–90 (Jan./Mar. 1986).

Dupont, Jerry. "Microform Film Stock: A Hobson's Choice. Are Librarians Getting the Worst of Both Worlds?" *Library Resources and Technical Services* 30:79–83 (Jan./Mar. 1986).

Guide to Microreprographic Equipment. 7th ed. Washington, D.C.: National Micrographics Assn., 1979.

Gunn, Michael J. *Manual of Document Microphotography*. London and Boston: Focal Press, 1985.

Hawken, William R. *Copying Methods Manual*. LTP Publication No. 11. Chicago: American Library Assn., 1966.

Hosket, Robert C. "Inspection and Quality Assurance." In *Proceedings of the 25th Annual Conference and Exposition,* pp. 265–76. Ed. by Ellen T. Meyer. Silver Spring, Md.: National Micrographics Assn., 1976.

Kidd, Harry B. "It's Standard: Micrographics Standardization in the United States." *Journal of Micrographics* 16:57-59, 62 (Mar. 1983).

_____. "Micrographics Standards in Libraries." *Microform Review* 13:93-96, 98-102 (Spring 1984).

Lee, Charles E. *Standards for the Microfilming of Public Records*. Columbia, S.C.: Dept. of Archives and History, 1973.

Lowell, Howard P. "Preservation Microfilming: An Overview." *Records Management Quarterly* 22-29, 36 (Jan. 1985).

Mezher, Glenham C., ed. *Micrographic Film Technology*. 3rd ed. Silver Spring, Md.: Assn. for Information and Image Management, 1985.

"Quick Guide to Microfilm Inspection." *Microfilm Techniques* 8:13-19 (Jan./Feb. 1979).

Robinson, W. Bryan. "Standards." *International Journal of Micrographics and Video Technology* 3:55-58 (1984).

Storage and Preservation of Microfilms. Kodak Pamphlet D-31. Rochester, N.Y.: Eastman Kodak Co., 1981.

Veaner, Allen B. *The Evaluation of Micropublications; A Handbook for Librarians*. Chicago: American Library Assn., 1971.

_____. "Microreproduction and Micropublication Technical Standards: What They Mean to You, the User." *Microform Review* 3:80-84 (Apr. 1974).

_____. "Permanence: A View from and to the Long Range." *Microform Review* 8:75-77 (Spring 1979).

Wheeler, William D. "Standards: Industry, National, International—Commentary on the Development of International Micrographic Standards." In *Proceedings of the 25th Annual Conference and Exposition*, pp. 236-42. Ed. by Ellen T. Meyer. Silver Spring, Md.: National Micrographic Assn., 1976.

Wilson, Don. "Microfilm Quality Control." *MicroNotes* 8:8-12 (May 1980).

5

Preservation Microfilming and Bibliographic Control

To the preservation administrator faced with the responsibility of setting up a new preservation microfilming program, this guide may have seemed to be nearly complete at the conclusion of Chapter 4. After all, you have moved through all the steps from identifying and screening items that are candidates for filming to the preparation for filming and production of films. What remains, you might ask, beyond giving guidelines on determining costs? Not a lot, if the only goal of preservation microfilming were to assure the continued availability of collections to local users. But as this chapter will show, making sure that the existence of a microform is recorded, and that record shared with the scholarly community, is a critical element in a responsible preservation program.

Ignore this subject at your peril, for there is much to be lost. A single monograph filmed for want of information on an existing film of the item wastes between $35 and $65. A single newspaper or periodical set filmed in duplication of another's work could waste hundreds or thousands of dollars. And the likelihood of duplication is often extremely high. For example, in two projects to film late 19th-century American literature and social sciences, more than 50 percent of the titles slated for filming were found already to have been filmed.[1]

Cataloging Preservation Masters of Books and Serials

Using cataloging to establish full bibliographic control over microform versions of books and serials has been a long-sought but elusive goal. The writings of those who have been its advocates are insistent, persuasive, and sometimes eloquent. They are also surprisingly extensive, beginning in 1940 with Fussler's "Microfilm and Libraries" and Tauber's "Cataloging and

1. The projects are components of the RLG Cooperative Preservation Microfilming Project. This information was supplied by project participants.

Classifying Microforms."[2] The reading list at the end of this chapter high-lights the contributions to this literature that have appeared since. Note in particular those of Simonton, Reichmann and Tharpe, and Cole. William J. Myrick summarized matters as they stood in 1978:

> The need for bibliographic control of microforms is generally recognized. Obvi-ously, the technology for establishing such control exists. Just as obviously, efforts so far towards achieving this end have been uncoordinated, poorly supported, and generally unsuccessful. Nevertheless, even the most jaded expect that eventually such efforts will be successful. The question is when. Keyes Metcalf first proposed establishing a national register of microform masters in 1936, a proposal which took 29 years to come into being. If it takes that long for current plans to material-ize, microforms won't be brought into the national bibliographic network until sometime early in the next century. It's a long wait, one that shouldn't be necessary.[3]

Fortunately, things have changed. Efforts are now much better coordi-nated and libraries are closing in on the goal of a national bibliographic net-work, though not in the form of a single enormous shared database, but rather as a "logical" collection of shared cataloging systems "connected" by exchanges of records via magnetic tapes and—at some future date—by electronic links. The evidence is in the direct and indirect results of the Asso-ciation of Research Libraries Microform Project.[4] These include the catalog-ing of individual titles in virtually all of the most widely held, commercially published microform sets, agreements to share these records, and mecha-nisms for providing efficient access to them. By "publishing" the contents of these large sets in this way, catalogers have not only ensured that the sets will receive greatly increased use, but also lessened the likelihood that li-braries will duplicate the work of commercial micropublishers. Further evi-dence lies in recent actions of the Research Libraries Group, OCLC, and the Library of Congress to create standards for recording bibliographic data on microforms, to encourage libraries to observe these standards, and to ex-change bibliographic records for microforms.[5] Still further evidence arises in

2. Herman H. Fussler, "Microfilm and Libraries," in *The Acquisition and Cataloging of Books*, ed. William M. Randall (Chicago, Ill.: University of Chicago Press, 1940), pp. 331–54. Maurice F. Tauber, "Cataloging and Classifying Microfilms," *Journal of Documentary Repro-duction* 3:10–25 (Mar. 1940).

3. William J. Myrick, "Access to Microforms: a Survey of Failed Efforts," *Library Journal* 103:2304 (November 15, 1978).

4. See Jeffrey Heynen, *Microform Sets in U.S. and Canadian Libraries* (Washington, D.C.: Association of Research Libraries, 1984). Since the establishment of the ARL Microform Project in 1981, all but a handful of the 50 sets given highest priority for cataloging have been cataloged in machine-readable form, OCLC and RLIN have exchanged records for three widely held sets and are negotiating further exchanges, OCLC has established a Major Microforms Project by which records for sets can be easily obtained, and RLG is developing a similar sys-tem for RLIN.

5. See "Microform Records in RLIN," *RLG Preservation Manual* 2d ed. (Stanford, Ca-lif.: The Research Libraries Group, 1986), pp. 57–79; "Microform Reproductions," *OCLC Technical Bulletin 154 Rev. 1* (Sept. 1985); "Recording of Preservation Information on OCLC's Online Union Catalog," Minutes: Research Libraries Advisory Committee, October 1984, p. 9; and "OCLC and RLG Announce Exchange of Preservation and Microform Set Records," *OCLC Newsletter* 162:2 (April 1986).

two other projects: (1) in 1981 with funds from the National Endowment for the Humanities (NEH), RLG members began to convert to machine-readable form the records for their stocks of master negatives and enter them into RLIN; and (2) with funds from NEH and the Andrew W. Mellon Foundation, ARL, and the Library of Congress embarked in 1986 on a joint project to convert to machine-readable form the monographic records appearing in the numerous volumes of the *National Register of Microform Masters*. Yet much remains to be done.

Cataloging microforms is neither quick nor cheap. Unlike microfilming itself, it has little dramatic appeal. Microfilming saves the contents of books and serials from disappearance. The crumbled remains of a disintegrated book produce a strong visual image when set beside a reel that holds the filmed version of that book.

Cataloging provides access to the microform, just as the microform provides access to the crumbled remains. But to library administrators, the task of creating microform records is difficult to reconcile with the pressing task of cataloging newly acquired books and serials. While library users rarely complain about backlogs of uncataloged microforms, they frequently complain about backlogs in cataloging new acquisitions. Given the insistence of these complaints and the heavy production pressures resulting from tight budgets, it is not surprising that library administrators sometimes have to be convinced of the importance of microform cataloging. They have to be "sold" on the idea.

Selling Microform Cataloging

The key elements of a sales pitch are not complex: preservation microfilming is the single most effective means of saving books at reasonable cost, and currently one of the most useful preservation procedures. Other procedures have little impact on cataloging operations, however, while microfilming almost always requires the creation of a new bibliographic record for each title filmed.[6]

Before computers began to replace card catalogs, libraries used various methods to note the presence of microforms in their collections. For example, if a title was filmed and the paper copy retained, a library staff member may have first pulled from a tray the catalog card for this copy. He or she would then have noted on the card that a film version had been made and indicated where it could be found. Methods like this had an obvious and serious drawback, since one had to be physically in the library, standing at the card catalog, to know the film existed. Not having access to this catalog,

6. Creation of a new bibliographic record for microforms is required in Chapter 11, "Microforms," in the second edition of *Anglo-American Cataloguing Rules* (Chicago: American Library Association, 1978), pp. 232–46. In some instances, libraries that observe these rules have departed from this requirement. The most notable departure is the U.S. Newspaper Program policy by which both microform and hard-copy holdings of a given newspaper are described in the same record. Cataloging guidelines for the U.S. Newspaper Program are given in Robert Harriman, *Newspaper Cataloging Manual*, Update no. 1 (Washington, D.C.: Library of Congress, Serial Record Division, 1985).

other libraries might, and frequently did, film the same item themselves. As Chapter 2 explains, had they known the item had already been filmed, they might have borrowed or bought a copy of the film and saved the cost of making the master. This is the main reason Keyes Metcalf and many others spoke out for creation of a national bibliography of microfilms, and this is the main reason, in 1965, that the Library of Congress began publication of the *National Register of Microform Masters.*[7]

The *National Register of Microform Masters* (or NRMM as it is familiarly known), was, in its time, the best tool that could be produced. However, as the chapter on selection makes abundantly clear, prefilming searches in printed bibliographies (NRMM and others) are tedious, time-consuming, and expensive. With the advent of online cataloging and the growth of the bibliographic networks, it has become possible—and highly desirable—to work toward full online search capability.

In the period since Myrick wrote, this has been the goal of those concerned with the bibliographic control of microforms. It is a goal within reach. Librarians who catalog preservation microforms on either RLIN or OCLC and fill in the field containing coded information about the film generation can now be assured that the records they create will be made available in both systems. To serve those who have access to neither, librarians can instruct their networks to send these records to the Library of Congress for inclusion in the successors to NRMM.[8]

Sales Points

Cataloging microforms goes a long way toward preventing costly and wasteful duplication of effort, but this is not its only benefit. Cataloging preservation microforms frequently results in the creation of new machine-readable records that afterwards can be used by other libraries as they engage in retrospective conversion of their card catalogs; it results in records that can be used by collection development and interlibrary loan librarians seeking copies of items that are needed but not available in their libraries; and it results in records that can be used by library patrons who search the soon-to-be ubiquitous online public access catalogs.

7. Also worthy of mention: *Newspapers in Microform* (Washington, D.C.: Library of Congress, 1948–83) and *Union List of Microfilms*, 2v. (Philadelphia: Bibliographical Center and Union Library Catalog, 1942–49, 1949–59). See other microform titles in "Microform Replacement Sources," in Chapter 2. For a brief history of these tools see the foreword to the 1973 edition of the *National Register of Microform Masters*, in *Microforms in Libraries: a Reader*, ed. Albert J. Diaz (Westport, Conn.: Microform Review, 1975), p. 287. Also see Nancy E. Gwinn, "The Rise and Fall and Rise of Cooperative Projects," *Library Resources and Technical Services* 29:80–86 (Jan./Mar. 1985).

8. See "Future of the National Register of Microform Masters," *Library of Congress Information Bulletin* 41:82–84 (March 12, 1982). Reports of monographs in microform now appear in the *National Union Catalog: Books* (Washington, D.C.: Library of Congress, 1983–). Reports of newspapers are intended to go into a new publication, not yet issued. Reports of other serials are intended to go into LC's *New Serial Titles*, but do not yet do so. LC will supply labels for submitting reports for inclusion in *NUC: Books*, or these reports may be addressed to: NRMM, Cataloging Publication and Management Division, Library of Congress, Washington, DC 20540.

These facts have not been lost on organizations that provide support for preservation microfilming projects. A requirement to catalog preservation microforms is now a part of the legislative history of Title II-C of the Higher Education Act (administered by the U.S. Department of Education). The guidelines given to applicants for funds from the Office of Preservation in the National Endowment for the Humanities are explicit:

> To ensure against wasteful duplication of effort as well as to provide the widest possible access to preserved materials, projects involving preservation micro-filming...must enter records for the preserved items into one of the national bibliographic databases and/or report to the Library of Congress, when pertinent. Machine-readable records of preserved items must be made available to any library or library network that wishes to obtain them. Projects involving the preservation of archival or manuscript documents or other types of materials must report to an appropriate national bibliographic source. In addition, microfilm copies must be made available on interlibrary loan or for purchase by other institutions or by individuals.[9]

With all these sales points firmly in mind, is the administration now completely sold on the need to catalog microforms? Evidence of the past few years suggests that some may remain unconvinced. A 1984 preservation survey conducted by the ARL Microform Project showed that about 10 percent of libraries do not always produce machine-readable records for preservation master negatives.[10]

As you know, the job of preservation administrator is an unusual one in that it requires generous assistance, support, and encouragement from senior administrators, as well as from librarians in other departments. Having sold the idea of cataloging microforms, you may also have to sell the goal of eliminating microform cataloging backlogs. To find the additional resources required, you and the cataloging units must work together to make this project a high priority within the institution. Obtaining this spirit of mutual support requires patience, charm, persistence, and an ability repeatedly to put forward the same message, in varied form, until it is, at last, accepted.

How to Catalog Microforms

This book is a manual and like other manuals it tells you "how to" and "why" with the emphasis on the former. Nevertheless, this chapter is of necessity something of an exception. Cataloging microforms, like other cataloging, is a technical matter best left to experts: the catalogers themselves or persons trained by them. It is a matter on which preservation administrators give advice on options, but not one on which they should attempt to become experts.

Preservationists *can* and, where appropriate, *should* be trained to perform cataloging tasks, and they can and should learn what is required in general

9. *Guidelines and Application Instructions, Preservation Programs* (Washington, D.C.: National Endowment for the Humanities, Office of Preservation, 1985), p. 11.

10. A report on this survey will be published by the Association of Research Libraries during 1987.

terms.[11] But given the complexity of cataloging practices and the frequency with which the formats, rules, and rule interpretations change, they should not independently attempt to master all the details of this difficult subject. This section gives an outline of practices and describes the tools needed by the librarians responsible for cataloging microforms. Preservation administrators should rely on the expertise of professional catalogers in arranging for this cataloging to be done.

With few exceptions, throughout the United States and Canada, microforms are cataloged in accordance with both the Library of Congress interpretation of the second edition of the *Anglo-American Cataloguing Rules* (*AACR2*) and the network and/or local system guidelines that implement and enhance the rules. In order to be shared among libraries—which is, of course, a necessity—machine-readable catalog records must be produced in USMARC format, a communications format with standard fields of data labelled by numbers, for example, 533, 007, etc. This format allows data to be exchanged among organizations with varying computer systems. In practice, microform cataloging differs little from other cataloging of books and serials. The rules (as interpreted) require that the item appearing on film be described as if it were still in its original hard-copy form with the addition of further information describing the microform copy.[12]

There are three aspects of this interpreted set of rules:

1. The term "microform" is given on the catalog record in square brackets at the end of the title statement, as shown by the following examples:

 Life and correspondence of George Read, a signer of the Declaration of Independence [microform] : with notices of some of his contemporaries / by William Thompson Read.

 Les sauvages d'Afrique [microform] : avec 79 dessins le l'auteur et 16 photographies hors-texte / préface de m. André Demaison.

 Intensionality and romance subjunctive relatives [microform] / by Donka F. Farkas.

 Poems [microform] / by Emily Dickinson ; edited by two of her friends, Mabel Loomis Todd and T.W. Higginson.

2. A statement is added (in a note field, MARC Field 533) giving the film format (e.g., microfilm or microfiche), the place of production (e.g., New York, N.Y.), the organization responsible for producing the microform (the library, not the contractor, if one is used), the number of units (e.g., 1 microfilm reel), the dimensions of the microform (e.g., 35mm), and the range of reduction ratio (e.g., low reduction— less than 16:1). Some examples:

11. At the Library of Congress, specialists in the Microform Reading Room and the Preservation Microfilming Office have been trained to do minimal level microform cataloging. Within the RLG Cooperative Preservation Microfilming Project, Yale University uses student assistants to do microform cataloging at the RLG "recon level" (i.e., without upgrading records to comply with the second edition of *Anglo-American Cataloguing Rules*).

12. As noted above, there are exceptions to this rule, notably the practice of the U.S. News-

Microfilm. New York : New York Public Library, 1982. 1 microfilm reel ; 35 mm.

Microfilm. Andover, MA : Northeast Document Conservation Center, 1 microfilm reel (in part) ; 35 mm.

Microfiche. Washington, DC : U.S.G.P.O., 1981. 1 microfiche ; 11 x 15 cm.

3. Coded data elements are entered into the MARC Field 007: Physical Description.[13] This field permits librarians to assign codes that repeat some information provided elsewhere in the record, together with some new data elements. The thirteen data elements are a "general material description" (i.e., microform), a "specific material description" (e.g., film or fiche), and the microform's polarity, dimensions, reduction ratio, color (or absence of color), emulsion type (e.g., silver gelatin), generation, and base (safety base or not). Figure 19 provides a complete list of definitions for codes in MARC Field 007. It shows that catalogers may choose to use a code for "unknown" instead of meaningful information if it is hard to determine an element from the film or record in hand. However, in cataloging preservation masters, catalogers should almost never find themselves forced to use codes for "unknown." As a preservation administrator, you can provide all the data that are needed.

Although all these data elements have some value, the generation element is most important and should always carry meaningful data. Here the cataloger indicates whether the film is a preservation master negative (manufactured, produced, and stored in accordance with preservation standards), some other master (e.g., a printing master), or a service copy. Because this information appears in a "fixed field," networks can use it to locate records for master negatives automatically and to process them either for enhanced screen displays (such as RLIN provides) or to create batches of records for sending in tape form either to another network or the Library of Congress. Some day, perhaps not too far off, this coding may also prove valuable in enabling users of either RLIN or OCLC to search online for microform records in the other database.[14] In addition, generation coding permits librarians and library users to determine whether a master negative exists from which copies can be obtained either through interlibrary loan or purchase.

papers Program. On the LC interpretation, see "Library of Congress Policy for Cataloging Microreproductions," *Cataloging Service Bulletin* 14:56–58 (Fall 1981) and "Library Announces Policy on Cataloging Microreproductions," *Library of Congress Information Bulletin* 40:245–46 (July 31, 1981).

13. For a fuller explanation of the MARC fields described here, see *MARC Formats for Bibliographic Data* (Washington, D.C.: Library of Congress, 1980– [looseleaf]); "Microform Records in RLIN," *RLG Preservation Manual*, pp. 57–79; and *Bibliographic Input Standards*, 3d ed. (Dublin, Ohio: OCLC, 1985).

14. For some years the Library of Congress, OCLC, Research Libraries Group, and West-

Figure 19. MARC 007 Physical Description Fixed Field Codes Applicable to Microforms

Data Element	Code	Meaning
General material designation	h	microform
Specific material designation	a	aperture card
	b	microfilm cartridge
	c	microfilm cassette
	d	microfilm reel
	e	microfiche
	f	microfiche cassette
	g	microopaque
	h	other microform type
Original/reproduction aspect	not used	
Polarity	a	positive
	b	negative
	c	mixed polarity
	d	unknown
Dimensions	a	8 mm microfilm
	b	16 mm microfilm
	f	35 mm microfilm
	g	70 mm microfilm
	h	105 mm microfilm
	l	3 × 5 in. or 8 × 13 cm microfiche or microopaque
	m	4 × 6 in. or 11 × 15 cm (i.e., 105 × 148 mm) microfiche or microopaque
	o	6 × 9 in. or 16 × 23 cm microfiche or microopaque
	p	3¼ × 7⅜ in. or 9 × 19 cm aperture card
	u	unknown
	z	other
Reduction ratio (1st byte)	a	low reduction (less than 16:1)
	b	normal reduction (16:1 to 30:1)
	c	high reduction (31:1 to 60:1)
	d	very high reduction (61:1 to 90:1)
	e	ultra high reduction (over 90:1)
	u	unknown
	v	reduction ratio varies
Reduction ratio (2nd–4th bytes)	000	actual reduction ratio
Color	b	black and white (monochrome)
	c	color
	m	combinations of the two above
	u	unknown
	z	other
Emulsion	a	silver halide (i.e., silver gelatin)
Generation	a	first generation preservation master
	b	printing master (includes non-archival first generation masters)
	c	service copy
	m	mixed generation
	u	unknown
Base	a	safety base
	b	not safety base (e.g., nitrate)
	n	not applicable (item does not have a film base)
	u	unknown

Displays of codes in the MARC 007 field differ from system to system. The following is an example using mnemonic identifiers of each data element as they would appear in a record on the RLIN system.

MMD:d OR: POL:b DM:f RR:a012 COL:b EML:a GEN:a BSE:a

The codes identify a microfilm reel (MMD:d), in negative polarity (POL:b), in 35mm (DM:f), having a low reduction ratio of 12:1 (RR:a012), in black and white (COL:b), on silver gelatin film (EML:a), of safety base (BSE:a). The next-to-last code (GEN:a) identifies the film as a first-generation preservation microform master. The RLIN display does not show the MARC 007 general material designation (which would be "h" for microform). There is no code given in the field labeled "OR:" because this field, called "original versus reproduction aspect," is not currently used in describing microforms.

In RLIN and other systems that use the MARC format, a given record can have more than one MARC 007 field so that, for example, different generations of the same film, having different polarities, can be described in the same record. Three MARC 007 fields in a single record on RLIN might look like the following:

MMD:d OR: POL:b DM:f RR:a012 COL:b EML:a GEN:a BSE:a

MMD:d OR: POL:b DM:f RR:a012 COL:b EML:a GEN:b BSE: a

MMD:d OR: POL:a DM:f RR:a012 COL:b EML:a GEN:c BSE: a

In this example, the first line is the same as the earlier example. The second line describes a second-generation printing master that has the same polarity as the camera master. (It is a "direct dupe" in micrographics jargon.) The only difference between its MARC 007 codes and those of the camera master is in the "GEN:" data element. Here, the code "GEN:b" identifies a printing master. (This code is also used to identify first-generation masters that do not meet archival standards, which include archival storage.) The third line describes a third-generation, positive-polarity, service copy. Its codes therefore differ from the other two in the "POL:" data element as well as "GEN:." The code "POL:a" identifies a positive-polarity film and "GEN:c" a service copy.

Records on other systems might identify MARC 007 data elements by numbers or letters of the alphabet or might simply give the codes untagged. OCLC records show letters of the alphabet. A MARC 007 field on an OCLC record might look like the following example. Note that the symbol "≠" is a conventional notation for the word "subfield." "≠b" thus means "subfield b." In this example, "≠a" is understood following the label "007" and is omitted.

ern Library Network have been planning a Linked Systems Project. Although the initial application of this project is limited to authority records, work is under way on an intersystem search and response application for bibliographic records. See Sally H. McCallum, "Linked Systems Project in the United States," *IFLA Journal* 11:313–24 (1985).

Table 1. Example of MARC 007 Field on OCLC Record

Subfield	Data Element	Code	Meaning
ǂa	General material designation	h	microform
ǂb	Specific material designation	d	microfilm reel
ǂc	not used		
ǂd	Polarity	b	negative
ǂe	Dimensions	f	35 mm
ǂf	Reduction ratio (1st byte)	a	low reduction
ǂf	Reduction ratio (2nd–4th bytes)	012	12:1
ǂg	Color	b	black and white
ǂh	Emulsion	a	silver gelatin
ǂi	Generation	a	1st generation
ǂj	Base	a	safety

007 h ǂb d ǂc ǂd b ǂe f ǂf a012 ǂg b ǂh a ǂi a ǂj a

Written out in tabular form, this example would be interpreted as shown in Table 1.

Librarians who catalog microforms have at hand copies of the guidelines and update bulletins provided by the networks they use. A detailed guide to cataloging on RLIN is also given in the *RLG Preservation Manual*.[15] This not only describes cataloging procedures, but also explains the use and value of RLIN preservation enhancements. These enhancements include the appearance of an asterisk to flag microform records in RLIN clusters (a cluster is a group of records from different institutions, all describing the same title) and RLIN's unique queuing date field. The queuing date field permits a library to show the date on which it decided to film a title or on which it began filming it. This field is removed from the record when the record is later revised to describe the film that was made. It permits the earliest possible recording of an RLG member's intention to film a specific title.

A recent OCLC technical bulletin describes the major preservation enhancement that this utility has implemented: OCLC now permits users to qualify database searches so that they retrieve only records for microforms. This speeds preservation searches by screening out the (sometimes numerous) records for hard-copy versions of a title.[16]

All catalogers, whether using RLIN, OCLC, or any other database, will have access to the following major tools: *Anglo-American Cataloguing Rules*, second edition; *MARC Formats for Bibliographic Data*; and the *Cataloging Service Bulletin*.[17] You should know they exist and might peruse them to get a feel for their contents, but you need not worry about mastering all that they contain.

15. "Microform Records in RLIN," *RLG Preservation Manual*, pp. 57–79.

16. "Microform Reproductions," *OCLC Technical Bulletin 154 Rev. 1* (Sept. 1985): 1–4.

17. Ibid.

Cataloging Options

Catalog records may be full-level, minimal-level, or somewhere in between. Depending on the cataloging level selected, they may have full MARC coding or abbreviated coding, and the codes given may be meaningful or show frequent "unknowns." Record headings (author and title) may be revised as needed to meet the form and content requirements of *AACR2*, they may be used on a "no conflict" basis (whereby headings that conflict with the Library of Congress Name Authority File—LCNAF—are revised and all others are left as they are), or they may always be left as they are on the catalog card that is used as the basis for the new microform record.

Most catalogers and many others favor full-level records with as few MARC "unknown" codes as possible and headings that meet *AACR2* requirements for form and content. In cataloging microforms, however, it is sometimes seen as expedient to produce minimal-level records having extensive "unknown" codes with headings that do not meet *AACR2* requirements. This practice saves money, but the records are less useful. It should be used judiciously, and only after extensive justification—a cataloging impact statement of sorts—has been prepared. If the record for an existing film has an aberrant heading, or if the description it gives is incomplete, a searcher may not be able to determine whether a microform found is exactly the same as the volume being searched. Also, if the MARC coding is inadequate, it may not be possible to determine whether a master exists and if so who holds it—information that is needed if a library is to follow procedures recommended in the chapter on selection.

Coordinating Filming and Cataloging

Preservation administrators should approach cataloging administrators as partners in preservation microfilming programs. To schedule their work, catalogers need, of course, to know what will be filmed: what projects are being implemented, planned, or even just generally discussed. More than that, wherever possible, they should be co-authors of planning documents, budgets, schedules, and proposals. Their expertise will be essential in preparing grant proposals.

Once an item has been filmed, catalogers need to know from you what data to put in the MARC 533 note field and the 007 fixed field, if it is not readily apparent from the film itself. They also may need to see either the hard-copy original or the film that has been made from it. It is the responsibility of the preservation administrator to provide this information if needed and to arrange for catalogers to obtain originals or films that they need to see.[18]

18. *AACR2* defines sources of information that are acceptable for use when cataloging an item and prescribes specific sources for specific cataloging elements. For example, these rules require that the title and statement of responsibility be taken from the title frame of a microfilm, if any. If there is no title frame, then another source may be used (other frames of film, film container, etc.). In practice, catalogers do not always insist on seeing a title frame. In most cases, a catalog card plus information needed for entering data into the MARC 533 and 007 fields should be sufficient. A simple form showing 533 and 007 data and containing a space onto which the catalog card can be photocopied can be used.

Last, bibliographic control is, of course, an element in preservation record keeping. The preservation administrator should arrange to receive reports of all preservation master negatives cataloged and should incorporate this information into statistics for the microfilming program.

Controlling Archives and Manuscripts

Cataloging

Unlike books and serials, archival and manuscript collections are rarely cataloged item by item. Their contents are too numerous and too little amenable to standardized treatment. If these difficulties were not sufficient to inhibit widespread cataloging, another would surely do so: because each manuscript or archival record is unique, archivists are unable to distribute costs via shared cataloging on bibliographic networks, and, because all cataloging would therefore be expensive original cataloging, no institution could afford the cost of doing large amounts of it.

Guides and Indexes

In providing access to the contents of collections, archivists traditionally rely upon guides, inventories, series descriptions, checklists, and personal services—that is, their own knowledge of what the collections contain. When specific collections are filmed, archivists frequently prepare checklists, indexes, sales lists, or brochures that are not unlike materials produced by commercial microform publishers. The National Historical Publications and Records Commission (NHPRC), a funding agency that provides major support for archival microform projects, strongly encourages the preparation of guides and indexes, and its *Microform Guidelines* gives detailed instructions.[19]

As more and more collections are filmed, the guides and indexes that provide access to them also multiply, and it becomes increasingly difficult to determine what items are available on film. This search inefficiency is somewhat more acceptable with respect to archival collections than it is with library materials, however, because films of unique items are also unique. Since there is no danger of costly duplication of effort, an archivist does not do a prefilming search before commencing production. The inefficiency is a real problem all the same. Archives and manuscripts are no less valuable research materials than books and serials. Users of archives and libraries need to know that microfilms exist so that copies may be borrowed or purchased, thus perhaps saving an expensive research trip.

Archivists have long recognized the value of broad, general guides. In the last two decades, some fairly useful ones have been issued. A number of large repositories, like the National Archives and Records Administration

19. *Microform Guidelines* (Washington, D.C.: National Historical Publications and Records Commission, 1986), pp. 9–10.

and the Library of Congress, have produced catalogs of microforms encompassing their entire collections. In addition, the *National Union Catalog of Manuscript Collections* (NUCMC) at the Library of Congress accepts reports for microforms, albeit with some restrictions and only at the collection level.[20]

Automation

Archivists have taken several significant steps to apply automated control to their collections. For example, plans are under way to mount NUCMC on RLIN. More significantly, a new MARC format has recently been created for archives and manuscripts. Replacing the MARC Manuscripts format, which was first published in 1973 but never widely used, the new MARC Format for Archives and Manuscripts Control (AMC) aims at providing automated support not only for access, but also for acquisition, accession, and management of archival materials. Archivists can use it to create records for collections of archives and manuscripts (e.g., the papers of Daniel Webster) as well as for individual items (e.g., a letter from Webster to his lawyer).

The Library of Congress (LC) interpretation of *AACR2* for microform cataloging does not and truly cannot apply to microforms of archives and manuscripts. In contrast to records for microforms of books and serials created under LC's interpretation, the AMC format permits a single record to give control over both full-sized collections and individual items, as well as over any microforms that may have been made of them. Thus when a collection is filmed and the originals are retained, a single record can be used to describe both the collection and the microforms made of it.

A note (in MARC Field 530) explains whether originals have been retained and gives details regarding the microform. Like the note given in the MARC 533 field in LC's interpretation of *AACR2*, this note gives format (microfilm, microfiche, etc.), dimensions (e.g., 35 mm), number of reels or other units, and producer. Like records for books and serials in microform, an AMC record contains a MARC 007 field giving codes for the physical description of the microform. Clearly, the same potential exists within the MARC AMC format for creating and sharing information about microforms of archival collections. But since the format's implementation is so recent, it is too early to say how successful it will be.

What to Do

Unfortunately, deciding what to do with microforms of archives and manuscripts is often difficult. Choices abound. Using the bibliographic net-

20. *National Union Catalog of Manuscript Collections* (Washington, D.C.: Library of Congress, 1959–). It accepts records for collections of original materials. Microform collections are considered to be original in cases such as the following: where the original collection has been destroyed, where the microform collection is made up from diverse original collections, and where the original collection is in private hands, held within the U.S. in another institution, or held abroad. Reports may be submitted for inclusion in NUCMC at the following

works, materials can be cataloged either by collection or item by item. Reports can be submitted to the Library of Congress for inclusion in NUCMC. Guides and indexes may be prepared either to individual collections or to the complete microform holdings of a repository. Or, as sometimes happens, nothing can be done at all—materials can be filmed and in all likelihood the existence of the films soon forgotten. For example, the landmark microfilming projects of the Historical Records Survey (1935–42) are now lost.[21] Circumstances are far from ideal, yet there is little hope for near-term improvement.

Cataloging microforms of archives and manuscripts, either by collection or item by item, should be handled like cataloging books and serials: by a trained cataloging staff. Guides and indexes should be produced in accordance with NHPRC guidelines and ANSI standards (samples of good ones can be obtained by writing to the NHPRC[22]). The best advice on what to do is probably the least welcome: make decisions on a case-by-case basis, considering the potential usefulness of the microfilms in the scholarly community and the cost of providing access to them.

The minimum form of access to microfilmed archives and manuscripts is a standard archival inventory or register. Ordinarily, a collection will have been given a finding aid of this type some time before it is filmed. If so, this existing inventory or register can be adapted to show details about the microfilm, such as the reel and position within reel on which a given item may be found. Generally speaking, few collections that are worthy of the expense of microfilming possess so little value that such finding aids, by themselves, suffice. An example might be a collection having mainly local interest, for example, student service records from the Office of the Dean at a small university.

Collections having progressively wider potential audiences should be given progressively more detailed finding aids. Collections having the largest number of potential users deserve the fullest possible access. Examples might include the papers of J. Robert Oppenheimer, U.S. Census population schedules for a state or region, papers of the Southern Tenant Farmers Union, or the Library of Congress Shaker Collection. These microfilm collections are, in effect, publications and should be treated as such. Some might be given full analytical cataloging (cataloging in which records are

address: *National Union Catalog of Manuscript Collections*, Manuscript Section, Special Materials Cataloging Division, Processing Services Department, Library of Congress, Washington, DC 20540.

21. Clifton Dale Foster, "Microfilming Activities of the Historical Records Survey, 1935–42," *American Archivist* 48:45–55 (Winter 1985).

22. NHPRC guidelines are cited above. Standards include *American National Standard for Library and Information Sciences—Basic Criteria for Indexes* (ANSI Z39.4-1984); *Writing Abstracts* (ANSI Z39.14-1979); *Guidelines for Thesaurus Structure, Construction, and Use* (ANSI Z39.19-1980); and *Patent Documents—Identification of Bibliographic Data* (ANSI Z39.46-1983). See Appendix 4 for address. Note that guides and indexes are increasingly being prepared on personal computers, such as the IBM PC and compatibles, using database programs such as dBase.

provided for component parts as well as the collection as a whole). Others might be cataloged as collections and provided with extensive printed guides and indexes. In all cases, collections of wide interest should be reported to NUCMC and also to the commercially published *Guide to Microforms in Print*.[23]

NHPRC's *Microform Guidelines* give excellent advice on handling these collections. They provide a fourteen-point checklist of items to be included in guides and suggest the types of indexes that are most helpful in providing access to different types of collections (for example, at a minimum, name and place indexes for collections compiled from several sources). With respect to cataloging they state: "If possible, microforms and their printed guides or indexes should be cataloged in an appropriate USMARC format for inclusion in an online bibliographic system, such as OCLC, RLIN, UTLAS, or WLN to provide information to potential users of the microfilm and to facilitate interlibrary loan.... Grantees should also see that microforms are listed in appropriate catalogs at sponsoring institutions. For more information about cataloging procedures grantees should contact their institution's library's cataloging or technical services staff."[24]

Conclusion

The subject of bibliographic control of microforms—"external" bibliographic control to be precise in distinguishing from the "internal" control given by film targets, carton labels, file drawer labels, and the like—is difficult, but also one on which expert help can be obtained, whether from a professional cataloger or from sources such as the NHPRC. Even where duplicated effort is not threatened, ignoring the need for bibliographic control results in unconscionable waste. To make a preservation master negative and keep its existence a secret is to undermine the purpose of the work and misuse the medium. While it is true that *some* bibliographic control, however weak, is better than none, the time, effort, and expense of selecting and preparing items for filming, of filming them, and of storing the microform properly warrant the best bibliographic control that current technology can provide.

For the first time in history, we are now capable of building a logical national bibliographic database. In coming years we should also have the facility to link electronically the individual databases that make up this logical one. The means for providing universal access to microforms are at last becoming available.

At the same time, libraries are moving rapidly toward integrated local automated systems, including online public access catalogs. It may eventually be practical for a library patron to use a terminal to locate microforms of

23. Information on submitting reports to NUCMC is given above. For information on submitting reports to *Guide to Microforms in Print*, contact Meckler Publishing, 11 Ferry Lane West, Westport, CT 06880.

24. *Microform Guidelines*, p. 11.

books and serials held in any of the major research libraries anywhere in the United States. Any number of difficulties could inhibit progress toward universal online public access to microforms, but the momentum of the past few years suggests that many could readily be overcome. The worst that could happen would be to develop the capability of full access and discover the access to be limited by the failure of libraries to catalog microforms.

Although in archives and manuscript collections there is a less pressing need for universal access to microforms, the growth of automated control over these collections and the items they contain is a development whose value—while it is not yet much studied—is potentially great. The creation and increasing use of the MARC Format for Archives and Manuscripts Control offers the intriguing possibility that large numbers of archives and manuscripts microforms will eventually be accessible via local public access catalogs that are electronically linked, through host computers, with other catalogs nationwide.

At the beginning of this chapter was the prediction that sufficient bibliographic control of microforms might not be achieved until the next century. With the help of you and your colleagues to build on the achievements described here, Myrick's "long wait" may nearly be over, well in advance of the year 2000.

List of Suggested Readings

Cole, Robert Grey. "Bibliographic Control." *Illinois Libraries* 58:211–16 (Mar. 1976).

Evans, Max J., and Lisa B. Weber. *MARC for Archives and Manuscripts: A Compendium of Practice*. Madison, Wis.: The State Historical Society of Wisconsin, 1985.

Jebb, Marcia. "Bibliographic Control of Microforms." *Drexel Library Quarterly* 11:32–41 (Oct. 1975).

Joachim, Martin D. "Recent Developments in the Bibliographic Control of Microforms." *Microform Review* 15:74–86 (Spring 1986).

McNellis, Claudia Houk. "Describing Reproductions: Multiple Physical Manifestations in the Bibliographical Universe." *Cataloging and Classification Quarterly* 5:35–48 (Spring 1985).

Reichman, Felix, and Josephine M. Tharpe. *Bibliographic Control of Microforms*. Westport, Conn.: Greenwood Press, 1972.

Sahli, Nancy. *MARC for Archives and Manuscripts: The AMC Format*. Chicago: Society of American Archivists, 1985.

Simonton, Wesley. "Bibliographical Control of Microforms." *Library Resources and Technical Services* 6:29–40 (Winter 1962).

6

Cost Controls

Until recently, only a handful of libraries and repositories in the United States engaged in preservation microfilming, either in-house or through commercial services. However, as libraries and archives have been faced with increasing numbers of deteriorating materials and as the threat of brittle paper has been documented and publicized, more institutions have started to look seriously into the scope of their local problems and explore options for trying to solve them. One of the difficulties in that process has been the dearth of information about how much it costs to develop and operate a preservation microfilming program.

Recent studies conducted at Yale and Stanford Universities, the University of California at Berkeley, and the Library of Congress, as well as those carried out by institutions conducting preservation planning programs, give a much clearer picture of the dimensions of the preservation problem.[1] Consistently, these reports have determined that between 25 to 50 percent of the collections surveyed are already brittle. On a national level, such percentages translate into figures well over the $100 million mark for a cooperative solution to this dilemma. On a local level the numbers are no less daunting. Yale, which has recently completed an ambitious three-year study of its collection, concluded that almost 2 million volumes in the library system contained brittle paper. Even using a conservative estimate of $50 per volume, it would cost $50 million to film just half of Yale's deteriorated volumes. A 1985 re-

1. Gay Walker and others, "The Yale Survey: A Large-Scale Study of Book Deterioration in the Yale University Library," *College and Research Libraries* 46:111–32 (Mar. 1985); Sarah Buchanan and Sandra Coleman, *Deterioration Survey of the Stanford University Libraries Green Library Stack Collection* (Stanford, Calif.: Stanford University Libraries, 1979); Richard B. King, Jr., *Deterioration of Book Paper* (Berkeley, Calif.: University of California Libraries, Office of Library Plans and Policies, November 1981); "Survey of Book Condition at the Library of Congress," *National Preservation News* 1:8–9 (July 1985); and the final reports of preservation planning programs conducted by Dartmouth, University of Virginia, and University of Washington (Washington, D.C.: Association of Research Libraries, Office of Management Studies, 1982). The Preservation Planning Program is a self-study methodology developed by the ARL Office of Management Studies for use by academic and research libraries.

port from the National Archives and Records Administration concluded that the costs of copying the agency's deteriorating documents over a 22-year period would exceed $100 million.[2] It is no wonder that many institutions, afflicted with a brand of "bottomless pit" paralysis, have been reluctant to tackle their preservation problems.

As discouraging as these numbers might be, nonetheless some research libraries and archival repositories are mounting preservation programs that are making great strides toward preserving the intellectual heritage of this country. In making preservation choices, you must keep in mind that although the large numbers of items that might potentially be microfilmed is high, when compared to the cost of restoring the original, microfilming suddenly moves into more favorable light. A conservation laboratory that offers both services provided a telling example. Laboratory staff restored fourteen 18th and 19th century New England town record books and diaries at a cost of $5,305. They also filmed the same books at a cost of $780.[3]

Fortunately for Yale and other research libraries, the majority of brittle materials do not represent unique holdings; furthermore it is quite possible that some of them do not warrant saving in perpetuity. A significant overlap among collections nationwide, coupled with the availability of shared online databases such as RLIN, OCLC, and WLN, makes it possible for institutions to coordinate their large-scale preservation microfilming efforts to share the responsibility and make the best use of available preservation resources. While it might cost $50 to make a preservation master negative of a 300-page book, it could cost only $5 to $10 to produce a service copy for a user or another institution, thereby providing a strong incentive for avoiding unnecessary duplicative filming efforts.

Because archival repositories handle unique materials for the most part, they do not have the same opportunities to rely on other institutions to film materials that they themselves also own. The cost avoidance enjoyed by cooperating libraries cannot be used as an argument to support the microfilming of unique materials. Nevertheless, there are ways of controlling costs, as well as deriving benefits from the increased accessibility and protection of the originals that microfilming accomplishes.

This chapter has a triple purpose: to provide a framework to use in estimating the cost of mounting a preservation microfilming program, to outline a structure of analyzing cost once a program is in place, and to suggest ways in which costs might be reduced or controlled. Inherent in the choices you and your colleagues make, among a wide range of possible procedures and standards, are cost implications that must be weighed in the balance with the goals and resources of the operation. Cost ranges used as examples in this chapter are based on findings of the mid-1980s and can only be con-

2. *20-Year Records Preservation Plan* (Washington, D.C.: National Archives and Records Service, 1984), p. 5.

3. Full restoration of the volumes included cleaning, deacidifying, buffering, mending, and either rebinding or repairing the original binding. Filming included all preparation, filming (and retakes), inspection, and duplicating the film. This information was supplied by the Northeast Document Conservation Center.

sidered indicative. There is no substitute for careful analysis of local variables in the budget planning process.

Cost Variables

Given all of the possible cost variables, as well as the number of people capable of having an impact on costs, it is not surprising that reliable documentation on the cost of preservation microfilming is hard to come by, except in the most general terms. While the variables make it difficult, if not impossible, to come up with a simple and reliable formula for estimating potential costs, there is a growing body of information available to inform planning decisions. This information can be adapted and applied to the particular circumstances of a project or operation, increasing the likelihood of accurate estimates. In addition, institutions can collect data—both from "test runs" in advance and studies during actual operations—to gain further insight into budgetary considerations.

Some very general preservation microfilming cost figures, usually within the neighborhood of $50 per volume for a typical 300-page book, have been bandied about for a number of years. Even though more cost data is now available, those numbers can still serve well for gross estimating purposes. However, if you were to examine closely the specific details of an actual project, or even activities associated with filming a single title, you would find that the costs vary significantly from item to item, project to project, and institution to institution.

Several recent analyses show the variance in microfilming costs among institutions. The Research Libraries Group conducted a cost study in 1984–85 involving seven institutions participating in the Cooperative Preservation Microfilming Program. Total costs for all steps in the process, *including cataloging* and supplies, ranged from $25.81 to $71.80 per title, with a median of $48.20. In an independent study in 1984, the University of Michigan concluded that its average cost for evaluating, filming, *and cataloging* a brittle book in-house was $35.71, comparable to the cost of purchasing a commercial replacement. More recently, Paul B. Kantor of Tantalus, Inc. studied preservation microfilming costs at four institutions with in-house programs and concluded that a representative cost of microfilming a nominal 240-page book, including all steps *except for cataloging, film, and chemicals*, was $24.48. Kantor is quick to point out (as is any researcher exploring microfilming costs) that since books vary in size, shape, and physical condition, each book is singular in the labor and other requirements related to processing it for filming.[4]

4. See Patricia A. McClung, "Costs Associated with Preservation Microfilming: Results of the Research Libraries Group Study," *Library Resources and Technical Services* 30:363–74 (Oct./Dec. 1986); Janet Gertz, "The University of Michigan Brittle Book Microfilming Program: A Cost Study," *Microform Review* 16:32–36 (Winter 1987); Margaret M. Byrnes and Nancy E. Elkington, "Containing Preservation Microfilming Costs at the University of Michigan Library," *Microform Review* 16:37–39 (Winter 1987); and Paul B. Kantor, *Cost of Preservation Microfilming at Research Libraries: A Study of Four Institutions* (Washington, D.C.: Council on Library Resources, 1986), pp. 11, 27.

It will come as no surprise that the number of pages per title to be filmed makes a significant difference in the cost per volume. Some of the other variables may not be as obvious. Characteristics of the materials, such as their age or imprint dates, condition, completeness, organization, format and subject, can contribute significantly to variations in the costs of selection, preparation, filming, and cataloging. Often these are not variables within your control. Additional variables, which may or may not be subject to managerial intervention, include: personnel (e.g., level of staff, skills, turnover, productivity), equipment and supplies, space and physical set-up, filming agent, technical standards, and level of cataloging required. The remaining variables are necessarily subject to managerial control and include the actual procedures for the project or operation, and the way in which the project is administered. Decisions regarding planning, management, and implementation provide the greatest opportunity for controlling costs and achieving maximum results for each dollar expended.

Potentially there are four categories of costs affected by the policies and procedures of a preservation microfilming activity: (1) labor, (2) supplies and equipment, (3) contract services, and (4) management and overhead. None of these exists in a vacuum. Take, for example, labor costs. If cameras are poorly maintained or ill-suited to the task at hand, labor costs may be higher than they would be under ideal circumstances, because of equipment failure, retakes, operational inefficiencies, or administrative time required for troubleshooting. Similarly, labor costs may be affected by the physical arrangement of work spaces as well as the pattern (or lack thereof) of workflow through the "pipeline." Geographical location, the available labor pool, and institutional policies concerning benefits also influence labor costs. It is essential that preservation administrators—who will be most likely to recognize the expenses incurred by such limitations—make clearly articulated and well-documented reports to those in a position to provide additional support or resources.

Labor Costs. Labor costs, the first category, are determined by the levels of staff assigned to various tasks, as well as the amount of time it takes to complete each one. Ideally, the decision regarding level of staff should follow an appraisal of the required skills and expertise; however, in practice the available personnel often takes precedence over a systematic pairing of people and tasks. And even the best-laid plans can be disrupted by any number of events (e.g., illness, pregnancy leave, vacancies, strikes), which can wreak havoc on a budget and schedule.

Equipment and Supplies. Direct expenses for the second category, equipment and supplies, will vary according to how much of the process is performed internally and how much is contracted out to a service bureau. If filming, processing, and duplicating are performed in-house, it follows that substantially more equipment, supplies, and work space will be required. However, even if these services are performed on contract with an outside agency, the costs remain; they show up indirectly in the filmer's bill, rather than as local costs.

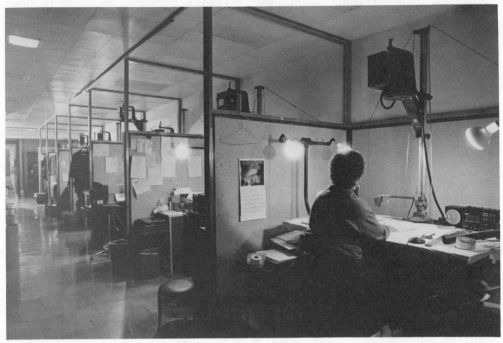

A row of planetary camera stations at the Library of Congress. Source: Library of Congress

Contract Services. Cost of contract services, the third category, can be substantial. Most institutions involved in preservation microfilming will need to contract for some services to be provided outside the library or repository. In general, the smaller the operation, the greater the number of outside services that will be required. Contract services could conceivably be sought for preparation of materials or virtually any part of the technical (filming) process. Typically, they might be for some combination of the following:

1. Camera work (the actual filming)
2. Processing of film
3. Technical inspection
4. Testing for residual chemicals and/or methylene blue testing
5. Production of additional generations and/or copies of the film
6. Storage of the preservation master negatives and/or the printing masters.

Institutions with internal filming capabilities still might choose to supplement that activity by contracting for one or more of the above.

Contract costs can be reduced if the contractor is a commercial micropublisher. A substantial amount of library or archival material has been filmed through cooperation of libraries or archives with micropublishers. In this case, the commercial publisher bears the cost of filming materials for

publication in return for the right to sell copies of the film. An example is the American Antiquarian Society's association with the Readex Corporation for the Early American Imprints Project. However, the publisher customarily approaches the library or archives rather than the other way around. The terms of such agreements will vary with the circumstances, and particularly according to the expected marketability of the product. You should expect to receive at least a service copy in return for making your materials available, and sometimes you can negotiate additional compensation. At a minimum, contracts should require publishers to reimburse the institution for any costs it sustains in cooperating with the publisher. They should also stipulate that the resulting master negatives be stored in accordance with existing archival standards (see Chapter 4) and describe the steps to be taken to assure preservation of the master negatives, should the company go out of business.

Another version of the commercial micropublisher contract is represented by a policy in which institutions sell copies to finance, or subsidize, their filming operations. Using this approach, institutions can become, in a sense, publishers, so that they can accomplish filming projects on a cost-recovery basis.[5] For example, the American Theological Library Association began an ambitious project in 1984 to film approximately 4,000 titles in one year and to finance this operation from the subscription sale of a microfiche product that includes all of the titles, preserved first as preservation master negatives on roll film, with copies produced on microfiche.

Management and Overhead. To these direct costs—the salaries, supplies and equipment, and services purchased from external sources—must be added the fourth category, management and overhead. Although there is no clear distinction between indirect and overhead costs, the definitions themselves are not crucial. The important point is that they are often difficult to calculate in terms of an isolated project or operation, but nevertheless represent real costs that must be taken into account. In a typical preservation microfilming operation, a list of indirect costs might include: hiring expenses, management, training, record keeping/paperwork, computer charges for cataloging, and storage of film. Examples of overhead costs to consider might be: space, utilities, postage and miscellaneous supplies, institutional administrative costs, clerical support, and janitorial services.

Budget Planning

There are different ways to approach the institutional budget for preservation microfilming. It is not unusual to see it included as a line item in either collection development or technical services budgets, although increasingly in large research libraries and repositories, multipurpose preservation units

5. Nancy Gwinn, "The Rise and Fall and Rise of Cooperative Projects," *Library Resources and Technical Services* 29:81 (Jan./Mar. 1985).

are appearing with separate allocations. In addition, more grant funds are available for developing programs and carrying out special projects.

Typical library or archival filming activities fall into four categories:

1. Ongoing preservation microfilming routines
2. "Over-the-counter" orders and mail orders from individuals and other institutions
3. Special projects (grants, projects focusing on branch libraries, subject collections, special or rare materials)
4. Cooperative projects involving other institutions.

Decisions affecting budget planning will be made within the context of the type of activity. It is possible for an institution to have activities in all four categories under way simultaneously. Institutions usually plan preservation budgets by calculating the general level of fiscal support for preservation activity rather than the number of items to be preserved. But calculating unit costs can produce realistic projections of workload and curb unrealistic expectations.

There are a variety of ways to figure the costs of an existing microfilming operation. The most straightforward—and perhaps the most realistic—is to divide the time spent (or salary expenditures) by actual units of productivity, such as number of titles searched or volumes filmed, and then factor in other expenses for supplies, equipment, processing, etc., as appropriate. The New York Public Library uses another method which calculates just the filming costs. Preservation staff calculate an average cost per inch (based on the thickness of a volume) for producing microfilm from printed material; this figure allows them to estimate costs for filming large quantities of materials.[6]

Your institution and type of filming activity will have its own idiosyncrasies—special procedures and internal paperwork—which will affect the cost of your filming operation. To get a handle on such variables for budget planning, divide the workflow into distinguishable steps and then consider level of staff and approximate time required for each step, as well as the equipment and service needs. However, before you can achieve a reasonable degree of accuracy in that exercise, you must make the decisions regarding the procedures, standards, and policies to be followed. The more clearly these are articulated, documented, communicated, and understood, the greater the efficiencies will be on the time side of the cost equation. Ongoing review and analysis that incorporates input from employees who actually perform the tasks will also contribute to increased efficiencies as experience is gained.

Cost Data for Local Use

Until recently most of the data on the cost of microfilming has related either to the specific per-frame charges for just the filming step or else to general

6. The current formula uses $40 per inch, so a volume that was 1″ thick would contain about 400 pages of material (including bindings), which would work out to approximately $.20 per frame.

institutional averages that were not sufficiently detailed to be compared to other situations. To aid you in planning for, or analyzing, your own program, here is a step-by-step discussion of some of the budgetary considerations inherent in a preservation microfilming operation. The five steps are defined as prefilming activities, the filming process, inspection, bibliographic control, and storage. Whenever possible, reference will be made to available time and cost data. A sample worksheet for estimating filming project costs based on these principles appears as Figure 21.

Prefilming Activities

Much of the focus of the costs of preservation microfilming has been on the per-frame cost of the camera work and producing the film. Usually that is a readily identifiable cost, billed back from a commercial service bureau or an in-house filming department. The costs relating to steps that precede filming are more difficult to identify. For the most part, costs for the prefilming steps are for labor. Keep in mind that often a great deal of time is expended on materials that will never be filmed because during the prefilming procedures they are removed from the "pipeline" for any number of reasons.

The RLG study provides the most complete data on prefilming activities in libraries, while the wide range in costs among the seven institutions best illustrates the "variables" theme of this chapter. At the low end of the range it took approximately 10.5 minutes to complete all of the steps, on the average, per title. On the high side it took 1 hour and 23 minutes per title. Factors affecting the spread were the searching hit rate (less than 1 percent compared to more than 50 percent) and the amount of curatorial review required (a cursory amount was needed in a special collection of poetry, while item-by-item decisions were made on a mish-mash of social science materials from the open stacks). Similarly, collation and target preparation took longer for the fragile social science materials with their foldouts, charts, and maps than for the small, relatively intact poetry books.

There is little data available on the prefilming costs of archival and manuscript materials. Even more than with printed materials, the costs vary tremendously depending on the nature of the collections and the extent to which they have been processed, organized, and used by readers in advance of the microfilming preparation. The Ohio State University Archives uses an average preparation figure of eight hours of student labor per cubic foot of materials (usually $8^{1}/_{2}'' \times 11''$ documents requiring minimal attention or targeting).[7]

Further insight into the preparation time question is provided by Table 2. To process four different collections ranging in length from 2.5 to 3.25 linear feet, the Minnesota Historical Society found that it took as little as 20 hours to prepare 3 linear feet of newspaper clippings from the American Crystal Sugar Company and as much as 122 hours to prepare 3.25 linear feet of the Horace P. Hudson Papers. While the American Crystal Sugar Project required a minimum amount of preparation for its newspaper clippings that

7. October 24, 1985, telephone conversation between Patricia A. McClung and Ohio State University Archivist, Raimund Goerler.

Table 2. Preparation Time for Four Archives Collections

Date	Collection	Length	Time
1/84	American Sugar Newspaper Clippings	3 ft.	20 hrs.
7/84	Horace B. Hudson Papers	3.25 ft.	122 hrs.
10/84	Washington & Kandiyohi Co. Naturalization Records	3 ft.	23 hrs.
12/84	E. G. Hall Papers	2.5 ft.	43 hrs.
		11.75 ft.	208 hrs.
Average hours per foot		17.7 hrs. per ft.	

SOURCE: Lydia Lucas, Head of Technical Services, Division of Archives and Manuscripts, Minnesota Historical Society.

were to be discarded after filming, the manuscripts and clippings in the Hudson Papers were not so straightforward. They required unfolding, cleaning, tape repair, organizing by subject and chronology, preparation of technical instructions to the camera operator, some transcription of illegible text, target preparation, the writing of a biographical sketch and detailed content descriptions, as well as the preparation of a folder list. The complexity of most archival and manuscript collections makes it impossible to generalize with any degree of confidence about average times.[8] However, there can be little disagreement on the assertion that this type of material takes much longer to prepare than books.

For purposes of analysis, the prefilming steps are divided as follows: identification of materials, searching, curatorial review, collation and physical preparation, and target preparation.

Identification of Materials. One of the most important factors in a preservation microfilming budget is the universe from which materials will be selected for filming. As previously stated, the subject matter, format, completeness, age, and condition of the materials affect the filming costs significantly. These factors also have an impact on the degree to which searching, curatorial review, and physical preparation are necessary.

What follows are some examples of the ways in which certain types of materials can affect costs:[9]

1. Some subject areas or collections may require review for retention or withdrawal on an item-by-item basis, and sometimes by more than one selection officer or curator.
2. Newspapers usually take more time to film, and proceed at the rate of one page per frame rather than two.
3. Very brittle or fragile materials must be handled more carefully, thereby slowing down the process.

8. Unpublished data supplied from 1985 personal correspondence between Patricia A. McClung and Lydia Lucas, Head of Technical Services, Division of Archives and Manuscripts at the Minnesota Historical Society.

9. This list was originally compiled by Sherry Byrne, Preservation Officer, University of Chicago Libraries.

4. Bound volumes must be filmed in a book cradle, which may take more time than filming pages from which the binding has been removed.

5. Disbinding materials before filming sometimes must be done by hand (when there are floating or irregular margins, narrow inner margins, double-page plates, etc.).

6. Foldouts in a book might have to be filmed at reduction ratios different from the rest of the volume, and often they must be filmed in sections. In addition, they sometimes fall apart when they are unfolded and need to be mended before filming can occur.

7. Oversize materials and items with foldouts must be handled carefully and may not fit in a book cradle. A sheet of glass may need to be placed over each opening of the book, which is very time-consuming.

8. Incomplete materials require that replacement pages be ordered or a duplicate edition be borrowed through interlibrary loan.

9. Archival and manuscript materials are frequently folded, stapled, or clipped, requiring additional preparation time.

10. Scrapbooks can rarely be filmed "as is." It may be necessary to set up each page for filming by removing materials, unfolding items, etc.

11. If there is a wide variation in color or shade within a volume or among archival or manuscript materials, more camera adjustments are necessary, as well as more frequent use of exposure and light meter.

12. For certain materials, it can be difficult to locate appropriate (or adequate) cataloging records for making targets.

13. Unusual organization of an item or series requires more elaborate collation and targets.

14. Some archival and manuscript materials necessitate special organization and/or finding aids.

Although in some instances institutions will have a clear idea about what materials they want to film, more often the identification is among the most time-consuming and costly processes. However, the more clearly the category or specific collection is defined in advance of a project, the fewer the surprises, financial and otherwise, down the road. The cost of selection can be high, if professional staff are required to review every title. As a program is fine-tuned, categorical policy decisions are possible (e.g., all heavily circulated, unique titles will be replaced without further review), which will focus selectors' attention on more difficult decisions and reduce the total amount of labor involved.

In general, the category of materials to be filmed—to the extent that it can be described and analyzed—drives virtually all of the other costs in the process. Time studies can be conducted for searching and processing materials; costs related to volume and/or page numbers can be calculated based on a sample of the materials. If a filming operation is focused on items screened from circulation or other service points in the institution, it still may be possible to sample this population and derive useful figures for making budget predictions.

Searching. Searching of materials, as described in Chapter 2, potentially represents another labor-intensive aspect of the procedures. When a particular subject collection or other identifiable category can be identified in advance, then a sample searching analysis can be designed to collect the following information:

1. What sources might be appropriate to search for availability of other copies, microfilms, editions, reprints, or formats to minimize duplication of effort?
2. What is the projected "hit rate" for each of the sources?

Armed with this information, managers can design a search strategy in which tools with the highest "hit rate" are searched first. Tools with very low hit rates may be eliminated altogether. If the hit rate in all sources is low, then the cost of searching should be measured against the cost of the amount of unnecessary filming that would occur if the searching step were eliminated. Archival and manuscript materials, which by definition are unique, will, of course, not require the searching step.

Keep in mind that the factors that affect searching costs today will be changing rapidly over the next decade. For example, already in place is a project to automate the *National Register of Microform Masters* and load the records in OCLC and RLIN; with those records available online, the labor cost of searching *NRMM* volumes will drop. However, as more and more volumes are filmed, hit rates should rise, thus increasing the relative cost of searching per volume filmed. How this will affect the searching process remains to be seen.

Curatorial Review. Once again the materials to be filmed determine the extent to which curatorial review should be employed. Occasionally there are sufficient funds and/or justifications for filming a particular collection or group of materials "end to end" without the intervention of a curator's evaluation. Other times it is possible at the outset to establish criteria for inclusion or exclusion of materials, which can be applied by less expensive staff. Obviously, the most expensive option is the one in which highly paid professional bibliographers or subject specialists spend time making item-by-item judgments as to whether or not something warrants preservation microfilming.

Collation and Physical Preparation. Collation and physical preparation (as described in Chapter 3) require little in the way of equipment and supplies; most of the cost is in labor. In general, this part of the process might include: collation, brittleness testing, disbinding (when appropriate), preparation of instruction sheets for camera operators, and paperwork to accompany materials to the camera operator (and after filming to accompany materials and film to the cataloging department). In the RLG project, this part of the process took between 5 and 45 minutes per title, with labor costs ranging from $.50 to $7.74 per title. The Northeast Document Conservation Center charges a flat rate of $36 per hour for time spent preparing materials for filming as well as for filming and inspection. (This figure in-

cludes overhead, of course, which is often not calculated in internal institutional studies.) The Center reports that even materials that arrive well prepared require additional checking to ensure that there are no problems that would interfere with the camera operator's work.

Materials that, before disbinding and filming, have been examined and flagged for potential problems, such as folded maps, illustrations that extend across inner margins, and missing text or pages, are less likely to create difficulties further along the line. Preservation microfilming is sufficiently expensive that it is worth spending a few extra dollars to ensure that it is done correctly, particularly given that other institutions may well be inclined to discard their copies of an item based on the availability of microfilm. The extent to which other preparation steps should be undertaken (such as erasing extraneous marks and annotations, mending torn pages, securing missing pages or text) is a policy matter that warrants clear guidelines. You might consider building in a time cutoff point for the staff performing the prefilming tasks, so that they would know when a problem item should be bumped out of the normal work flow for reevaluation before excessive amounts of effort are expended on it.

Target Preparation and Reel Breaks. As seen in earlier chapters, target preparation is closely linked with the collation step and is crucial to ensure that the film can be used successfully. Target preparation can take as little as 5 minutes and as much as 27 minutes per title, depending on the materials. Since targets can be produced by relatively inexpensive staff, costs should range between $1.00 and $4.00 per title.[10] Of course, there may need to be an initial capital expenditure for lettering equipment and target supplies, although the use of an existing microcomputer is also possible.

Before material can be sent to the filmer, you may need to organize it to indicate the order and amount of materials to be included on a particular reel. Another approach is to provide guidelines and instruct the filming agent to determine appropriate reel breaks. When filming newspapers and long serial runs, it is necessary to provide for reel breaks to occur at logical places to facilitate access and bibliographic control. When shorter items are being filmed, it is customary to combine titles on a reel to save space. Established routines and the use of tools designed to aid this process (such as the Library of Congress's *Processing Manual*) can save time at this step.[11]

The Filming Process

Given sufficient funds, space, and technical expertise, virtually any library or repository, regardless of size, *can* set up an internal laboratory for archival microfilming. That does not mean it *should*. The cost of establishing an in-house filming facility will depend on what equipment is already available, whether remodeling is required—to accommodate equipment, to increase

10. McClung, "Costs Associated with Preservation Microfilming," p. 371.

11. Tamara Swora and Bohdan Yasinsky, *Processing Manual* (Washington, D.C.: Library of Congress, Preservation Microfilming Office, 1981).

plumbing capacities, and to control light intensity, direction, and fluctuations—and whether technical and managerial expertise is already available on the staff or will require additional salary funds to acquire. In balancing this against the cost of using an external contractor, institutions must be sure to factor in the cost of transporting materials to and from the filming agent.

Equipment. Table 3 shows the principal pieces of equipment required for producing, processing, and inspecting microfilm. Together they represent an approximate capital outlay in 1987 of between $58,000 and $62,000, which is not an unrealistic budget commitment for the larger institution, unless structural modifications to existing buildings or rental space are required. In that event, costs could escalate.

Depending on the type of material to be filmed, there may be cost savings available by using a rotary, rather than a planetary, camera. (A rotary camera photographs single sheets while they are automatically moved through the camera by some form of transport mechanism, whereas a planetary camera utilizes a stationary, flat bed for sheets or volumes to lie on.) For example, the Ohio State University Archives, using a 16mm Kodak Reliant rotary camera, has been able to film certain kinds of archival material (such as $8^{1}/_{2}'' \times 11''$ documents) for slightly less than $.01 per frame for production of a master negative. It costs an additional $.015 per frame to produce the diazo service copy and file both copies into labeled storage jackets. The low costs are attributed to the increased speed of production and the simplicity of operation inherent in the camera's design. The Archives is able to film four times as much material on the rotary camera in the same period of time (and with inexpensive student labor) as can be filmed on its 16mm planetary camera.

However, using a rotary camera has a number of disadvantages for preservation microfilming, such as irregular spacing of images on the film, uneven resolution, difficulty in employing targets, and frequency of camera malfunction. The risk to brittle pages, onion skin, or exceptionally heavy papers is high, particularly if the papers are not to be discarded after filming. Bound volumes cannot be filmed. Raimund E. Goerler points to these problems in his discussion of the Ohio State project, but also to the success with which thousands of standard-sized ($8^{1}/_{2}'' \times 11''$) documents, primarily office files, have been filmed inexpensively.[12]

In 1986, the Council on Library Resources commissioned Paul B. Kantor of Tantalus, Inc. to test the Ohio State Archives project. He arranged for three libraries to submit very brittle materials to the project for filming; their evaluations of the resulting microfiche noted severe problems with den-

12. A description of this methodology can be found in Raimund E. Goerler and Robert A. Bober, "Preservation Microfilming: At What Cost?" *Conservation Administration News* 26:8,22 (July 1986). The Northeast Document Conservation Center was able to film a large project, the 1883–1897 trial transcripts of the Court of General Sessions in New York, with a 16mm tabletop planetary camera for $.057 per frame, and $9.00 per reel for duplication. The transcripts occupied 1300 reels. Economies of scale with a large project of similar, straightforward documents are always possible.

Table 3. Microfilm Facility Equipment List

Type	Example	Approximate Price
35mm camera	Kodak MRD-2	$15,000 +
Processor	Pro Star or	10,000–12,000
	Allen MM15	15,000 +
Duplicator	Extek 3100	10,000–12,000
Densitometer	Macbeth TC-932	1,350
Microscope	Keyan Industries 2008	160
Ultrasonic Splicer	Metric Splicer	3,500
Book Cradle	Kinex 740 Document Holder	170
Light box		300
Footage meter		286
Rewinds		125
Loupe		60
Microfilm reader	NMI 2020A	1,200
Film storage cabinet		1,000
		$58,151–62,151

sity, resolution, alignment of images, and fragments of paper falling into the image area. Kantor considered all the problems correctable, but this test clearly dramatizes the ongoing controversy surrounding the use of rotary cameras.[13]

Although the reported cost savings are attractive, the use of rotary cameras should nevertheless be approached with caution to ensure that extra quality control steps do not eat up any cost savings achieved. Thorough testing is required to ensure that the resulting films meet national standards and that the original documents can withstand the mechanical handling of the camera. The Ohio State University Archives is the only institution to report on the use of a rotary camera for preservation microfilming in recent years, so there is not a large body of experience from which to draw. The controversy is likely to continue until a rotary camera-based project can pass routine tests such as Kantor's with the same frequency as can those projects using planetary cameras.

Technical Expertise. The price tag for equipment and space is only part of the equation. An equally important consideration is the technical expertise required to produce high-quality film. There are not only the direct labor costs of employing people with the necessary skills and expertise, but also the less tangible management costs inherent in maintaining the equip-

13. Paul B. Kantor, President of Tantalus, concluded: "Rotary camera filming, at 24× reduction, with density correction has the potential to provide preservation microfilm meeting the RLG standards of quality provided: (1) the belt drive mechanism can be tuned to provide more reliable and accurate alignment of pages, and (2) the problem of fragments can be controlled." Paul B. Kantor to Deanna Marcum, Vice President, Council on Library Resources, Inc., November 21, 1986. He suggests that the camera might be suitable for "a substantial fraction" of all materials encountered in practice.

ment and insuring that the technical standards are met consistently. Even in major urban areas, large research libraries and archival repositories often find it difficult to attract and keep competent camera operators, laboratory technicians, and microphotography experts. Except in unusual circumstances, it is likely that only the largest institutions (such as Library of Congress, Columbia University, the New York Public Library, and the National Archives and Records Administration) will be in a position to make the budgetary, staff, space, and managerial commitments to develop and maintain long-term in-house filming and processing capabilities. Even some of these institutions, which microfilm thousands of volumes a year, choose to contract out for at least part of their programs.

There are at least two points of view on this matter. Those who contract for services point out that libraries and repositories should not undertake filming or processing because the technical expertise can be secured for comparable prices elsewhere, and the problems inherent in in-house operations can detract from other missions. Advocates of in-house operations would counter that, except for a few notable exceptions, experienced commercial filmers who can understand and meet the standards necessary to produce archival film at reasonable prices are extremely rare.

Computing the Filming Cost. When it comes time to estimate actual costs, the per-frame charge from a commercial service bureau or internal photo laboratory can be one of the most straightforward pieces of the preservation microfilming budget. Nevertheless, it is imperative that the contract or agreement specify exactly what the per-frame charges include and what standards for camera work, processing, printing, and inspection will be applied. To produce a preservation master negative of a monograph that has been disbound, per-frame charges in 1985 for 35mm film on a planetary camera might vary from $.10 to $.26 per frame. Depending on whether or not the materials can be filmed two pages per frame (most can) or just one, the filming costs can be determined by a simple formula: (number of pages/2) times per-frame charge plus 5 percent to cover extra frames for targets or other extra material. Add to that figure the costs for a printing master and/or a service copy, if the procedure includes producing these at the same time rather than on demand. More often than not these charges are calculated by the foot, rather than the frame, and run anywhere from $14 to $40 per reel for each of the additional generations. Institutions with in-house filming capabilities will also need to calculate the cost of technical inspection, and even those who contract out will need to at least spot check the service bureau's work. Those dealing with commercial service bureaus will find a charge for the filmer's inspection folded into the bill for external services.

In the RLG project, filming costs for producing three generations of film and conducting the technical inspection accounted for between 45 percent and 78 percent of the total costs of the project at each of the seven participating institutions. One institution with an in-house filming operation broke down the specific elements of the filming and technical inspection costs as shown in Table 4. The Northeast Document Conservation Center analyzed its costs for filming four books averaging 250 pages each in Table 5.

Table 4. 1987 Filming Costs for RLG Cooperative Preservation Microfilming Project (Columbia University Libraries)

Costs per:	Master Negative		Duplicate Negative		Service Copy		Subtotals
	Exp.	*Reel*	*Exp.*	*Reel*	*Exp.*	*Reel*	
Filming (labor)	$.051	$37.25					
52 min./title							$ 6.83/title
286 min./reel							37.25/reel
133 exp./title							
724.57 exp./reel							
Processing (labor)	.0105	7.59	$.0105	$7.59	$.0105	$7.59	
22 min./title							4.18/title
119.75 min./reel							22.77/reel
Inspection (labor)	.024	17.28					
20 min./title							3.20/title
108 min./reel							17.28/reel
Total labor		$62.12		$7.59		$7.59	$14.03
							$77.30/reel
Supplies							
Film		$ 9.75		$5.00		$4.00	$ 3.44/title
							18.75/reel
Chemicals		.54		.54		.54	.30/title
							1.63/reel
Boxes		.14		.14		.76	.19/title
							1.04/reel
Reels		.17		.17		.94	.24/title
							1.29/reel
Methylene Blue		1.20					.22/title
							1.20/reel
Total Supplies		$11.80		$5.85		$6.24	$ 4.39/title
							24.91/reel
							.033/exp.
Totals:							
Labor/title		$14.21					
Supplies/title		4.39					
Total per title		$18.60		$.1395			
Total per reel							$101.21

NOTE: On the average $19.00 was spent on labor and supplies per title filmed. The cost of equipment, space, management time, and other overhead was not included. For the most part, the materials filmed consisted of American literature monographs averaging 266 pages in length; they all were published between 1876 and 1900 and contained brittle paper. It took an average of 1 hour and 34 minutes per title to complete the process.

SOURCE: Prepared by Eileen Usovicz, Carolyn Harris, and Sherry Byrne, Columbia University Library Preservation Office, 1985; updated 1987.

In-house vs. Contract Costs of Filming. It is difficult to calculate the cost of doing in-house microfilming as compared to using an external service bureau. Most studies by universities and other nonprofit repositories do not include overhead costs, while service bureaus must take all overhead costs into account when bidding a job. In addition, except for nonprofit operations like the Northeast Document Conservation Center, commercial service bureaus also need to build in a profit margin. Even so, it may be possible to make informed judgments about the advisability of starting or continuing an in-house operation based on such "apple and orange" com-

Table 5. 1987 Filming Costs for Four Typical Titles in RLG Cooperative Preservation Microfilming Project (Northeast Document Conservation Center)

	Master Negative		Duplicate Negative		Service Copy		Cost per Title
	Exposure	Reel	Exposure	Reel	Exposure	Reel	
4 titles/500 exposures							
Filming/labor	$.20	$100.00					$25.00
Processing/labor	.012	5.00	.013	$5.00	.013	$6.50	4.50
Inspection/labor	.025	12.50					3.13
Total labor		$117.50		$5.00		$6.50	$32.63
Supplies							
Film		$ 13.60	.011	$5.65	.01	$4.80	$ 6.01
Chemicals		.15		.15		.15	.11
Boxes		.15		.15		.15	.11
Reels		.88		.88		.29	.51
String ties		.09		.09		.09	.07
Methylene Blue test		.14					.04
Total supplies		$ 15.01		$6.92		$5.48	$ 6.85
Totals:							
Labor/title		$ 29.38		$1.63		$1.63	$32.63
Supplies/title		3.75		1.73		1.37	6.85
Total per title		$33.13		$3.36		$3.00	$39.48

Total cost per exposure for master negative only = $.27
Total cost per reel for master negative, duplicate negative, service copy = $157.96
Total cost per exposure for master negative, duplicate negative, service copy = $.32

NOTE: RLG Projects at NEDCC have a labor cost for inspection that is lower than NEDCC shop rate of $.03 per exposure and $15.00 per reel. This chart does not include packing and labor for shipping.
SOURCE: Prepared by Veronica Cunningham, Northeast Document Conservation Center, 1985; updated, 1987.

parisons. Since the RLG project involved both in-house and external filming agents, the cost study provides some useful figures.

Out of seven institutions in the RLG study, five conducted their filming internally. Per-frame costs for those operations (again, to produce three generations of film and conduct the technical inspection) ranged from $.17 to $.26 per frame. Furthermore, the institution on the low end at $.17 was able to calculate its costs another way so as to include such overhead costs as utilities and equipment amortization (the cost of the space was still not included). That revised figure rose to $.28 per frame.

By comparison, the two commercial operations (one for-profit and the other nonprofit) charged $.33 and $.34 per frame for the same products, or 25 percent to 50 percent more. But their figures do, of course, include all of the costs—direct, indirect, and overhead—associated with operating a filming facility. Under the circumstances, the difference in costs, at least between the $.26 internal cost and the $.34 external charge, may not be that far apart.

It is at the filming step that the costs for libraries and archives are most analogous. At least when 35mm planetary cameras are used, the per-frame charges will be in approximately the same ballpark whether the materials consist of a stack of letters, a pile of printed documents, newspapers, or pages from a published monograph. However, some adjustments in price

may be necessary for the degree of difficulty involved in handling a particular format and depending on whether or not bound materials can be cut before filming.[14]

Microfiche Production Costs. This chapter has focused on the cost of preservation microfilming using 35mm roll film, the most widely used and accepted method. But there is increasing interest in microfiche, which can also be produced and stored according to archival standards. Despite user preference for microfiche and the convenience afforded by that format, most libraries and archives discover that it is much more costly to produce. Why is this so?

There are several ways of producing microfiche. One is to film an item using roll film, then cut the film into segments to either "load" into microfilm jackets or "strip up" by mounting them into other kinds of transparent carriers. The eye-legible "headers," or titles that identify the contents of the microfiche, must be prepared separately. These jackets or carriers, containing the original film segments, then become the masters for producing film copies that emulate microfiche. The additional labor involved in these steps, as opposed to just producing the roll film, is an obvious additional cost component. For most libraries or archives that have in-house laboratories, however, this has been the only method of producing microfiche. Unless the laboratory is geared totally to microfiche production, added to the complexity is the time required to shift staff between roll film production and fiche production.

To avoid this labor cost, a laboratory may use a step-and-repeat microfilm camera, which produces a single sheet of 105mm film with the images placed precisely in rows and columns in strict adherence to national standards. These cameras can be considerably more expensive than ordinary planetary cameras; depending on the level of sophistication, they can run anywhere from $20,000 to $100,000. A separate 105mm microfilm processor is also required. In most preservation microfilming programs, only a few copies of filmed titles are likely to be made, which makes it hard to justify this level of initial expenditure. If you believe the material you wish to film will have a high demand, it might be wise to think either about negotiating with a commercial micropublisher, which might bear the total costs of the filming so your institution could concentrate its resources on other items, or about a subscription-based project where a number of institutions could contribute and spread out the initial costs of production.

Figure 20 graphically shows the cost elements using different kinds of microfiche compared with 35mm roll microfilm (16mm film is only marginally less costly).[15] The figures are based on a filming project involving 2,000 im-

14. For special materials that are very difficult to handle during filming, costs per frame at the Northeast Document Conservation Center have ranged as high as $.62 (personal correspondence with Veronica Cunningham, October, 1985).

15. Cost estimates are based on 1986 dollars and are supplied by Peter Ashby, Executive Vice President, Microforms International Marketing Corporation of Elmsford, N.Y., a member of the Pergamon/BPCC Group. The estimates do not factor in such commercial considerations as recovering the original investment except for actual costs, nor funds for marketing, production of printed guides, etc.

Figure 20. Comparative Costs of Roll Film and Microfiche

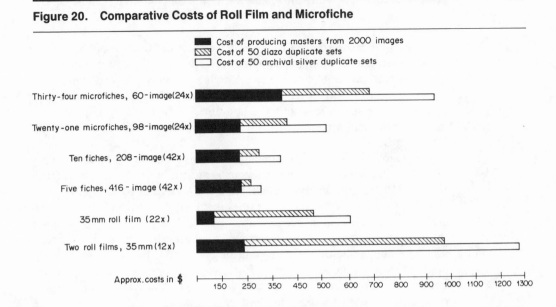

■ Cost of producing masters from 2000 images
▨ Cost of 50 diazo duplicate sets
☐ Cost of 50 archival silver duplicate sets

Thirty-four microfiches, 60-image(24x)

Twenty-one microfiches, 98-image(24x)

Ten fiches, 208-image (42x)

Five fiches, 416-image (42x)

35mm roll film (22x)

Two roll films, 35mm (12x)

Approx. costs in $

150 250 350 450 500 600 700 800 900 1000 1100 1200 1300

SOURCE: Peter Ashby, Executive Vice-President, Microforms International Marketing Corp., Elmsford, N.Y.

ages of standard documents or bound volumes that do not require special handling. Production of a master negative and fifty copies in each case are compared. One advantage of microfiche is the lower cost of producing duplicate copies. Using higher reduction microforms (42× or higher) lowers the per-copy costs even more, but these are usually unacceptable for libraries or archives, because the quality may be lower and the reading equipment may not be widely available. Perhaps there are cameras available that can overcome some of these difficulties, but few institutions report experience with them.

These comparative costs are based on filming generally undertaken in a commercial environment. Unfortunately, there is little, if any, published data available that compares the relative costs of the two formats within normal library or archival preservation microfilming environments. Two special projects mentioned earlier in this book—American Theological Library Association and the American Philological Association—use microfiche but have not as yet published cost data.

Inspection

Depending on the procedures, there are usually two stages of inspection— one completed by the filmer (technical inspection) and another performed by the library or archives (to review the filmer's work and check for bibliographic problems). A thorough and well-documented inspection process requires that staff knowledgeable about technical specifications pay careful attention to whether the films meet technical standards for legibility and permanence, are bibliographically correct, and are unblemished.

Institutions with in-house facilities vary in how they divide the inspection tasks between the camera operator and the preservation office; however, most would agree that whether filming is done in-house or on contract with a commercial vendor, the camera operator's work must be checked carefully once the film is returned.

This kind of attention to detail, time-consuming though it may be, is meant to ensure that quality standards are achieved. Inspection times in the RLG study hovered between 12 and 15 minutes for a frame-by-frame inspection of an average 300-page volume or approximately 45 minutes to an hour per reel. Data on frame-by-frame inspection at the Northeast Document Conservation Center illustrates the way in which formats and the condition of the materials influence inspection times. Newspapers and straightforward monographs can be inspected at the rate of 30 minutes per reel, while manuscripts, scrapbooks, special materials (clippings, photo albums, etc.) require 1 hour to 1 hour and 17 minutes per reel.[16] Other institutions may experience greater variance since local circumstances differ.

In the development and implementation of standards and procedures, common sense and good judgment must also be part of the formula. Microfilming is not always an exact science, and the successful use of standards for a quality product requires that they be interpreted and applied by knowledgeable people. For example, there may be instances in which a frame falls within the density "requirements," but nevertheless should have been shot at a different exposure to promote legibility. And sometimes a camera operator will shoot the same chart or illustration at three different exposures to be sure to get a legible frame. If two of those three images do not pass the density test, that would not provide sufficient cause to splice them out or refilm the reel.

Cataloging and Bibliographic Control

The most significant factors in the cost of cataloging are:

1. The level and quality of existing cataloging for the original materials. Clearly the better the existing cataloging the less time it will take to derive and adapt the microfilm cataloging from it.
2. The desired level of cataloging for the microfilm. Depending on the materials and institutional policies, it may be possible to realize savings by using an abbreviated cataloging standard, such as the "recon (or retrospective conversion) level" described in Chapter 5. In all cases, however, records for books and serials *must* be machine-readable in USMARC format and meet the minimum standards for loading on the major bibliographic databases.
3. The decision (or policy) regarding retention of the original materials. Some institutions have found that it is significantly more expensive to discard materials than to retain them because of the cataloging procedures necessitated by a withdrawal from the collection. Other institutions have found that the long-term costs of continually housing and

16. Personal correspondence between Patricia A. McClung and Veronica Cunningham, Northeast Document Conservation Center, Andover, Mass., October, 1985.

servicing brittle materials far outweigh the costs of withdrawal. That is not to say the costs should influence the decision, but rather that it does have an impact on the total bill, making generalizations about cataloging costs more difficult.

Additional cost considerations relate specifically to the particular format, to whether or not an online cataloging system is used, and, if so, which one. All formats, including monographs, pamphlets, broadsides, letters, personal papers, serials, and newspapers, have inherent bibliographic issues that affect the fiscal "bottom line." For example, if indexes or other types of finding aids are developed in conjunction with a filming project, that might well be the most time-consuming part of the process. While this is sometimes necessary for published materials such as complicated serial runs, it is often essential for materials found in archival and manuscript repositories.

Cataloging costs can be expected to account for 8 to 12 percent of the total costs, when minimal level (or RLG recon level) standards are applied, and up to 30 percent of the total costs if full *AACR2* standards are used (and records have not already been converted to *AACR2*). The level of cataloging staff required accounts for another significant variable in the actual cost per title. The average time per title cataloged in the RLG study ranged from approximately 10 minutes to 1 hour, with costs between $2 and $20.

A strong economic case exists for the importance of making information about preservation masters available in a national database such as RLIN, OCLC, and eventually an online version of the *National Register of Microfilm Masters*. If properly produced, stored, and made available for copies, there is no need for more than one preservation master negative of an item. Consequently, organizations such as the Council on Library Resources, the Association of Research Libraries, and the Research Libraries Group have advocated the necessity for access both to bibliographic information about the existence of master negatives and, whenever possible (that is, if there are no copyright restrictions), to copies from the master negatives.

Either for a grant proposal or for internal budget planning, it is often necessary to prepare a projected budget in advance of embarking on a preservation microfilming project. Figure 21 is a 12-step model worksheet that you can use to calculate your own institution's microfilming costs. The worksheet provides a framework that can be adapted depending upon the particular circumstances. Prepared for use in the Research Libraries Group cost study, the model is meant to be suggestive, rather than prescriptive. It does not include costs of storage. Many of the steps apply only to typical library materials, and will not apply to archival or manuscript materials.

Storage

Chapter 4 outlines the requirements for proper storage of preservation master negatives and underscores the importance of that financial commitment. Appropriate storage for the service copy, as well as for the duplicate negative, if one exists, should also be taken into account when planning the budget. The exact bill for storage will vary depending on each institution's facilities, and whether or not it is necessary to acquire or lease space in a vault for master negative storage. In that case, the location and size of the vault represent additional variables that influence the costs. Storage facili-

Figure 21. Worksheet for Estimating Project Costs

A. Define and figure the size of the entire target population before the searching and curatorial review steps occur.

 1. Total number of volumes in the proposed collection = _____ (1)

 2. Total number of titles in the proposed collection = _____ (2)

B. Estimate the percentage of materials expected to be eliminated by curatorial review (this step may require a sample study).

 3. Estimate % expected to be eliminated by review process = _____ (3)

C. Anticipated searching "hit rate" (that is, the percentage of titles expected to be available on film, fiche, or other format; it will probably be necessary to conduct a pilot search project to document this percentage. In the RLG project alone the hit rate ranged as low as 1% and as high as 64% depending on the target and search strategy.).

 4. Estimated searching hit rate % = _____ (4)

 (Depending on the project, it may be advisable to switch the order of curatorial review and searching. Some curators will prefer to review materials after they have been searched, while others will be able to screen materials before the searching step.)

D. Reduce the numbers in (1) and (2) first by the percentage in (3), and then by the percentage in (4).

 5. Number of volumes to be filmed = _____ (5)

 6. Number of titles to be filmed = _____ (6)

 6a. Calculate average number of volumes per title = _____ (6a)
 [Divide number of volumes by number of titles]

E. Estimate the local costs per title for prefilming activities (identification, searching, preparation, and curatorial review). Estimate times for each step, and then costs based on the level of staff performing each step.

 7. Estimate prefilming costs per title = _____ (7)

 * 7a. Convert prefilming costs per title to per volume = _____ (7a)

F. Estimate the amount of time it will take to catalog each title. (Consider whether or not the item already has been cataloged, whether or not the record is already online (where applicable), whether or not the original needs to be withdrawn from collection, the standard of cataloging to be applied, level of staff to be assigned to the task, etc.)

 8. Cataloging cost per title = _____ (8)

 * 8a. Cataloging cost per volume = _____ (8a)

continued

Figure 21 (cont.). Worksheet for Estimating Project Costs

G. Calculate the average number of pages per volume among those in the to-be-filmed category (short of a sample study, a well-educated guess may be necessary).

 9. Average number pages per volume = _____ (9)

H. Get estimate from filmer (whether internal or external) for the per-frame cost of producing master negative and service copy (and duplicate negative, if applicable). This should include all charges from filmer (e.g., inspection, supplies, etc.).

 10. Per-frame filming charge = _____ (10)

I. Allowing two pages per frame (unless filming newspapers or other oversize materials), calculated per-volume costs for filming and producing all required generations.

 * 11. (9) divided by 2 times (10) = per volume
 filming costs = _____ (11)

J. Calculate local inspection costs (filmer's inspection costs should be included under H). [Based on RLG project, local inspection may take between 5 and 15 minutes per title depending on number of frames and thoroughness of filmer's inspection.]

 * 12. Local inspection costs per volume = _____ (12)

Add * items to arrive at an approximate cost per volume.

ties will provide detailed price lists upon request. Note that prices will vary depending on whether film can be stored in a common vault area or whether an institution decides to lease its own vault within the storage facility. You could expect to pay an annual rental fee of $30 per drawer (minimum 20 drawers; each drawer holds approximately 42 reels) in common storage. A 600-cubic-foot vault (minimum size at the National Underground Storage facility in Boyers, Pa.) rents for $3300 per year.[17] There may be additional charges to equip private vaults with special equipment, such as a hygrothermograph to monitor the environment; in addition, drawers will have to be purchased for the vault at approximately $25 each. The labor, supplies (labels, packing materials, etc.), and postage required for shipping materials to the storage facility also contribute to the total costs.

17. January 1, 1986, price list from National Underground Storage, Boyers, Pa.

Conclusion

To summarize the topic of controlling the costs of preservation microfilming, as with any problem that at first seems insurmountable, it is best to proceed by breaking it down into manageable chunks. As more and more institutions begin to chip away at the corpus of deteriorating materials, and while efforts continue to encourage publishers and others to use alkaline paper in the future, gradual progress is evident. It is imperative that unnecessary duplicative undertakings be avoided so that scarce resources are not wasted. In this context, sharing of bibliographic information about preservation masters, and even intentions to create them, becomes the single most important factor in the economics of preservation microfilming. Through increased cooperation on this front, as well as open communication on technical and procedural developments that affect efficiency and cost, the "bottomless pit" begins to look more like myth than reality.

List of Suggested Readings

Bauer, Charles J. "Microfilm—Doing It Yourself: The Make-or-Buy Decision." *Journal of Micrographics* 16:17–20 (Jan. 1983).

Costigan, Daniel M. "Economics of a Micrographics System." *Journal of Micrographics* 14:15–30 (Mar. 1981).

Donahoe, Stephen. "Cost-Benefit Analysis." *MicroNotes* 9:14–15 (May 1981).

The Economics of Microfilming and Document Reproduction: Papers Given at Seminars Held by the Microfilm Association of Great Britain, Cambridge, 27th September 1968, and Edinburgh, 8th November 1968. Cambridge: Microfilm Association of Great Britain, 1969.

Gertz, Janet. "The University of Michigan Brittle Book Microfilming Program: A Cost Study." *Microform Review* 16:32–36 (Winter 1987).

Goerler, Raimund E., and Robert A. Bober. "Preservation Microfilming: At What Cost?" *Conservation Administration News*, 26:8, 22 (July 1986).

Hayes, Robert M. "Analysis of the Magnitude, Costs, and Benefits of the Preservation of Research Library Books: A Working Paper Prepared for the Council on Library Resources." January 21, 1985 (unpublished).

Kantor, Paul B. *Costs of Preservation Microfilming at Research Libraries: A Study of Four Institutions*. Washington, D.C.: Council on Library Resources, 1986.

McClung, Patricia A. "Costs Associated with Preservation Microfilming: Results of the Research Libraries Group Study." *Library Resources and Technical Services* 30:363–74 (Oct./Dec. 1986).

Niles, Ann. "Conversion of Serials from Paper to Microform." *Microform Review* 9:90–95 (Spring 1980).

Schofer, Ralph E. *Cost Comparison of Selected Alternatives for Preserving Historic Pension Files*, NBSIR 86-3335. Gaithersburg, Md.: U.S. Department of Commerce, National Bureau of Standards, 1986.

An Afterword

Although the use of microforms as a preservation tool has grown considerably in the last decade, many librarians and archivists remain hostage to some basic misconceptions about this subject. For example, the notion that microreproduction is quick, simple, and inexpensive is still widespread and the source of unrealistic expectations. At the same time, errors are widely believed to be an inevitable by-product of microfilming. Undue attention is often focused on the actual filming at the expense of other stages of production such as selection, preparation, and inspection, which are of equal importance. Some researchers find microforms inconvenient and aseptic, despite great improvements in the design of reading rooms and equipment. Whatever the basis for these problems in the past, this manual has shown that they are all eminently manageable and should not deter us from the use of microfilming in preservation programs.

At the most basic level, preservation microfilming involves a series of specialized tasks—some of them quite technical, others more common sense in nature—that must be performed correctly, and in the right order. To compromise one inevitably affects the others and, ultimately, the entire rationale for microfilming in the first place. For example, materials inadequately prepared for filming are apt to be of little or no use to the researcher, regardless of how well they are filmed. Film that is properly manufactured and processed, but is not stored under optimum environmental conditions, may deteriorate much sooner than desired. Failure to produce adequate finding aids or bibliographic records restricts access to collections and, in the case of printed library materials, increases the chance that they will be unnecessarily filmed more than once. To provide high-quality, cost-effective preservation and access to their collections, librarians and archivists must be knowledgeable about, and involved in, all aspects of preservation microfilming.

This interdependence of each stage in the production of microforms is one important reason why they are so susceptible to error. The detailed and repetitive nature of many of these tasks also increases the probability of error. Filming manuscripts or books on a planetary camera, or using a micro-

film reader to check thousands of images against the corresponding originals, requires an extraordinary amount of sustained attention to detail, and the training, motivation, and temperament of many technicians may not be equal to the task. The production process is also heavily dependent on the smooth operation of cameras, processors, densitometers, readers, duplicators, and other equipment. A single breakdown can easily involve the loss of valuable time or the destruction of reels of film. Only sound management practices—regular maintenance of equipment, strict observance of quality control procedures, detailed recordkeeping—can prevent these problems from undermining the production of high-quality microforms.

Although microforms have been used for preservation purposes for more than fifty years, there is no cause for complacency. Despite evidence that the volume of filming continues to increase, production capacity must be increased even more in a planned and systematic way, either through the creation of new filming centers or the expansion of existing ones. Institutions need constantly to review their production, quality control, and storage practices to incorporate new standards and ensure that their own operations, and those of their vendors, meet established standards for archival quality. And further improvements in the bibliographic control of microforms will be required to provide increased access to collections and to avoid unnecessary duplication in filming.

There are other needs as well, as more and more institutions consider preservation microfilming as an option. Although standards and specifications cover many areas, it is still difficult to sort those that relate primarily to business uses from those generally more stringent requirements that apply to libraries and archives. Preservation microfilming must be given the same management attention as other critical library or archival functions—cataloging or binding, for example—and not dealt with as an undesirable step-child. There is also a great need for cost data relating to all aspects of the process. This manual carries some of the earliest data to be recorded in a systematic way, but more data and careful analysis will be required to determine where costs can be safely reduced. The librarians have forged well ahead of the archivists in this regard. Yet in archives are to be found much more in the way of untapped resources waiting for the accessibility that microforms could provide.

Both organizations and individual institutions can do much to further the cause of preservation microfilming. If there is one idea that has surfaced time and time again in this manual, it is that duplicate filming is wasteful in time and money. Yet there is at this moment no absolutely sure way to avoid it, although the recent granting of funds to convert the *National Register of Microform Masters* to machine-readable form gives hope. In the library world there has been great objection to any kind of national program planning that might seem to hinder an individual institution's prerogatives. Better ways must be found to share information nationally, if not actually to coordinate filming efforts, if we are to ensure that the information and knowledge seekers of the future have the most comprehensive selection of thoughts from the past.

These needs are not so much obstacles as opportunities. Microfilming

does offer us at reasonable cost a proven technology that can be used effectively and immediately to preserve library and archival materials of enduring value. But microforms are not the perfect media. They have not, and are not likely to, become the primary format in libraries, as was predicted as early as the 1940s. Even so, they will continue to find their place in a full range of media, from vellum manuscripts to the laser-written optical disk. New electronic technologies and mass deacidification techniques will influence our preservation choices, as they should, and we must be ready to test, experiment, and apply these new methods. But for the foreseeable future, librarians and archivists will continue to rely on microforms as a primary means of preserving their most valuable collections for future use.

Appendix 1

Preservation Microfilming: Standards, Specifications, and Guidelines

This list contains standards of the American National Standards Institute (ANSI), along with specifications and guidelines of other organizations and institutions in the United States. Copies can be obtained from those organizations, the addresses of which are included in Appendix 4. The citation contains both the date of the first edition of the document and the latest edition at the time this manual was prepared.

Standards

ANSI PH1, PH2, PH4, PH5 and ANSI/ISO Standards

American National Standard for Photography (Film)—Safety Photographic Film, ANSI/ASC PH1.25-19— (first edition, as Z38.3.1: 1943; current edition: 1984).

American National Standard for Photography (Film)—Archival Records, Silver-Gelatin Type, on Cellulose Ester Base, ANSI/ASC PH1.28-19— (first edition, as Z38.3.2: 1945; current edition: 1984).

American National Standard for Photography (Film)—Archival Records, Silver-Gelatin Type, on Polyester Base, ANSI/ASC PH1.41-19— (first edition: 1976; current edition: 1984).

American National Standard Photography (Film)—Storage of Processed Safety Film, ANSI/ASC PH1.43-19— (first edition, as PH5.4: c. 1957; current edition: 1983).

American National Standard for Photographic (Film)—Micrographic Sheet and Roll Films—Dimensions, ANSI/ASC PH1.51-19— (first edition: 1979; current edition: 1983).

"Draft Proposed American National Standard for Photography (Film)—Source Document Microfilms—Determination of ASA Speed and Average Gradient," BSR PH2.51-1986 (new, proposed standard).

American National Standard for Photography (Processing)—Processed Films, Plates, and Papers—Filing Enclosures and Containers for Storage, ANSI/ASC PH.1.53-19— (first edition, as PH4.20: 1958; current edition: 1984).

American National Standard for Photography (Film)—Ammonia-processed Diazo Films—Specifications for Stability, ANSI/ASC PH1.60-19— (first edition: 1985).

American National Standard for Photography (Film)—Processed Vesicular Film—Specifications for Stability, ANSI/ASC PH1.67-19— (first edition: 1985).

American National Standard for Photography (Chemicals)—Residual Thiosulfate and Other Chemicals in Films, Plates, and Papers—Determination and Measurement, ANSI/ASC PH4.8-19— (first edition, as PH4.12: ca. 1954; current edition: 1985).

American National Standard Dimensions for 100-Foot Reels for Processed 16-mm and 35-mm Microfilm, ANSI/ASC PH5.6-1968 (R1974). This standard is to be replaced by "Dimensions for 100-Foot Reels for Conventionally Threaded Processed 16- and 35-mm Microfilm" and assigned a number of MS34 (now under review).

American National Standard for Microcopying—ISO Test Chart No.2—Description and Use in Photographic Documentary Reproduction, ANSI/ISO 3334-1979 (now under ISO review). The test chart described in this standard is based on the U.S. National Bureau of Standards Microcopy Resolution Test Chart.

ANSI/AIIM Standards (formerly ANSI/NMA Standards)

American National Standard for Micrographics—Microfiche, ANSI/AIIM MS5-19— (first edition: 1975; current edition: 1985).

American National Standard for Information and Image Management—Roll Microfilm, ANSI/AIIM MS14-19— (first edition: 1947; current edition: 1987).

American National Recommended Practice for Information and Image Management—Identification of Microforms, ANSI/AIIM MS19-19— (first edition: 1978; current edition: 1987).

American National Practice for Operational Procedures/Inspection and Quality Control of First-Generation, Silver-Gelatin Microfilm of Documents, ANSI/AIIM MS23-19— (first edition, as an industry standard: 1979; current edition: 1983).

American National Standard for Micrographics—35-mm Planetary Cameras (top-light)—Test Target and Procedures for Determining Illumination Uniformity, ANSI/AIIM MS26-19— (first edition: 1984; current edition: 1987).

American National Recommended Practice for Information and Image Management—Microfilming Printed Newspapers on 35-mm Roll Microfilm, ANSI/AIIM MS111-19— (first edition: 1977; current edition: 1987).

ANSI Z39 Standard

American National Standard for Information on Microfiche Headings, ANSI Z39.32-19— (first edition: 1980; latest edition: 1981).

AIIM Standards

Standard for Information and Image Management—Microfilm Jackets, AIIM MS-11 (first edition: 1987).

Standard for Micrographics—Splices for Imaged Film—Dimensions and Operational Constraints, AIIM MS18-1984.

Guidelines for Microfilming Public Records on Silver-Halide Film, AIIM TR6-1985.

Technical Report for Information and Image Management—Microfilm Jacket Formatting and Loading Techniques, AIIM TR11-1987.

Specifications and Guidelines

These specifications and guidelines, as distinct from ANSI standards, do not meet the following requirements:

a. They have not been created under procedures that assure open participation of all interested parties and balanced representation of affected groups during their preparation.
b. They are not put to vote of all interested and/or affected parties and groups.
c. Thus, resolution of negative ballots to achieve a consensus of interested/affected parties and groups is not required.
d. There are no procedures assuring due process (a means of sorting out problems experienced by interested/affected parties and groups).
e. There are no provisions for automatic review and revision, ensuring that the standards/guidelines are kept up to date.

Nonetheless, they contain guidance in areas not covered in current standards and they expand the preservation provisions of these standards in highly desirable ways. For these reasons, although their observance is not required of institutions that wish to produce preservation microform masters, they are quite useful. Libraries and historical societies that do preservation microfilming, or have it done for them under contract, should, as applicable, adhere closely to their advice and recommendations.

Library of Congress Specifications

Specifications for Microfilming Manuscripts in the Library of Congress (first and only edition: 1980).
Specifications for the Microfilming of Books and Pamphlets in the Library of Congress (first and only edition: 1973).
Specifications for the Microfilming of Newspapers in the Library of Congress (first and only edition: 1972).
 The three publications above replaced the following work: *Specifications for Library of Congress Microfilming* (first and only edition: 1964). All may be ordered from the Association for Information and Image Management.
Swora, Tamara, and Bohdan Yasinsky. *Processing Manual* (current edition: 1981).
 Although this publication specifically details the procedures used by the Preservation Microfilming Office, there is much information of use to any institution planning to microfilm monographs and serials. Copies are available from the office (see Appendix 4).

Other Specifications

"Micrographics." 36 CFR Part 1230 (now under review).
 This section of the *Code of Federal Regulations* provides standards for using micrographic technology in the creation, use, storage, retrieval, preservation, and disposition of federal records. The author is the National Archives and Records Administration. A revision is expected to be issued in 1987.
National Historical Publications and Records Commission. *Microform Guidelines* (current edition: 1986).
Research Libraries Group. *RLG Preservation Manual* (second edition: 1986).
 Includes guidelines used in RLG's Cooperative Preservation Microfilming Project.
Sung, Carolyn Hoover. *Archives and Manuscripts: Reprography* (first edition: 1982).
 One of a series of manuals produced by the Society of American Archivists.

Appendix 2

Sample Preservation Microfilming Contract

This sample contract was developed for the institution that plans to use the services of a filming agent outside the supervisory control of the preservation administrator. A contract may not be needed if the filming agent is an internal photoduplication laboratory located elsewhere in the institution, but the elements included here can be adapted as written technical specifications to ensure complete understanding of all requirements. The services covered in this contract include the production of 35mm microform preservation master negatives, printing masters, and service copies. They do not include storage or duplication-on-demand, since the need for these services varies significantly and is usually the subject of separate contracts.

The contract is divided into three sections: General Information, Technical Specifications, and an Appendix of local instructions, procedures, and sample forms. Examples of some of the latter appear as illustrations elsewhere in this manual. Information in the contract is based on American National Standards Institute standards, Library of Congress specifications, Research Libraries Group guidelines, and binding contracts in wide use by libraries.

To be used effectively, this contract should be modified or adapted to accommodate local and institutional policies, procedures, and specific requirements. Specific suggestions for local consideration appear in parentheses. This model is oriented toward printed materials, but most elements would apply to manuscript materials as well.

SAMPLE MICROFILMING CONTRACT

GENERAL TERMS AND CONDITIONS

I. General Information

 A. *Scope*

 1. This contract applies to library and archives materials produced in microform for _____ (herein referred to as the Institution) and to the services listed in the attached proposal schedule for the period of twelve (12) months.

 2. The Institution, by mutual agreement with the contractors (herein referred to as the Filming Agent), may extend this contract, under the same terms and conditions.

B. *Prices*
1. Prices quoted shall be net. Pickup, transportation, and delivery charges shall be separately itemized, unless otherwise specified.
2. *Escalation Clause*

 All prices shall remain firm for the first twelve (12) months of the contract. After the initial twelve months, prices may be subject to re-negotiation on an annual basis during the period of the contract and must be based on increases in general industry prices or the overall cost of living. Adjustments shall be made under the following conditions:
 a. Notification of any increase in costs is to be submitted in writing for consideration by the Institution at least thirty (30) days prior to the effective date for price increases. Any payment issued by the Institution prior to the effective date of the price increase shall be honored by the Filming Agent at the price effective at the time of the issuance of the payment.
 b. No more than one price increase shall be allowed during each renewal year of the contract.
 c. Prices for special materials or small projects (less than 12 months duration) may be negotiated on an individual basis.
 d. In the event that a price increase cannot be mutually agreed upon, the contract is subject to cancellation by either party.
3. *Taxes*

 Materials and services furnished to the Institution are not subject to Federal Excise Tax, Federal Transportation Tax, or State Sales Tax, and such taxes shall not be included in prices. The Institution's Federal Tax Identification Number is _____.

C. *Compliance with Specifications*
1. All work is to be done for the Institution according to the attached specifications, guidelines, and standards from the American National Standards Institute and the Library of Congress. These specifications, guidelines, and standards apply to the microfilming of library and archival materials, and the processing, duplicating, and inspections of the film. The Filming Agent must adhere to these directives unless instructions from the Institution specify otherwise.
2. The Institution reserves the right to specify in the contract additional filming methods and instructions for any and all items should this be necessary. The filming methods and instructions (i.e., reduction ratio, image placement, arrangement of volumes on a reel) specified for each item or category of materials by the Institution shall not be changed by the Filming Agent without prior consent of the Institution. If an item cannot be filmed in the manner specified, it shall be returned by the Filming Agent with justification for its rejection.
3. The Filming Agent shall establish the qualifications of the Filming Facility by submitting the following evidence:
 a. Samples of completed preservation master negative microfilm for examination by the Institution's Preservation Officer (or Representative). Samples shall include a variety of materials such as a

 monograph, multivolume set, or volumes from a serial; volumes with paper of varying color, yellowed paper, and very fragile paper; and volumes with special features, oversized items, folded maps, and illustrations.

 b. One sample of each type of storage material to be provided: reels, boxes (including a completed label), and wrap-arounds.

 c. A list of at least three (3) active accounts, and persons to contact for service verification.

 d. A financial statement for the last two (2) full years of operation.

 e. Statistics regarding staff size, and describing all filming, processing, duplicating, splicing, and inspection equipment including manufacturer and model.

4. Prior to the contract award and at any time during the contract period, the Filming Agent shall permit representatives from the Institution to inspect the Filming Facility during its normal working hours.

5. Failure of the Filming Agent to meet the requirements of the contract shall constitute default. The Institution shall notify the Filming Agent in writing of unsatisfactory service, poor workmanship, or poor delivery. Failure of the Filming Agent to correct the conditions of default at its own expense or to come to an amicable solution with the Institution within thirty (30) days shall constitute default. Recurrences of unsatisfactory service will constitute default.

6. Either the Institution or the Filming Agent shall have the option to cancel the contract upon thirty (30) days' written notice to the other party for performance that is not in compliance with all instructions and specifications stated herein.

D. *Subcontracting*

All services (microfilming, processing, duplicating, and quality control) with the exception of storage shall be done on the premises of the Filming Agent unless written permission to do otherwise is granted by the Institution. No subcontracting shall be permitted without the express written approval of the Institution.

E. *Insurance and Security*

1. The Filming Agent shall insure, at no extra charge to the Institution, all materials against loss or damage from any cause, from the time they leave the Institution until they are returned. Each filming shipment is to be insured while in transit, and while in the Filming Facility. The limit of liability for an item lost or destroyed shall be a sum which will cover the cost to the Institution of reordering and processing an acceptable replacement item. An insurance coverage quote shall be submitted.

2. In the event that an irreplaceable item is damaged or destroyed, the Institution reserves the right to secure, at the Filming Agent's expense, an independent appraisal of the damage or loss sustained. The Filming Agent shall reimburse the Institution in full for damage to, or fair market value of, the item.

F. *Communication*

A representative from the Filming Agent shall visit the Institution annually and be available on request. The representative shall be thoroughly familiar with the terms of this contract and shall have an in-depth knowledge of the technical and bibliographic aspects of library and archives preservation microfilming and the operations of the Filming Agent he/she represents.

G. *Preparation and Targeting*

1. The Institution shall provide camera-ready materials for the Filming Agent unless otherwise specified. Materials shall be sorted by type of material (e.g., monographs, serials, manuscripts, bound, disbound). Bound volumes shall be flagged and must be filmed intact in a book cradle that will not cause damage to the original.

2. Each title (bibliographic unit) or archives collection shall be accompanied by a target or set of targets prepared by the Institution unless otherwise specified. (Some shall be completed by the Institution, others will be completed by the Filming Agent and inserted at the time of filming.) A complete set of targets to be filmed before and after every title and at the beginning and end of each reel shall be provided and instructions for their use specified.

3. Special instructions and flags shall be provided for unusual materials.

4. Each shipment shall include the Institution's packing slip designating the number of volumes or items, category of materials, and the Institution's item control numbers.

H. *Packing, Pickup, and Delivery*

1. The Filming Agent must acknowledge receipt of each item in the shipment using an annotated copy of the Institution's packing slip.

2. All materials shall be microfilmed and returned with the completed microfilm to the Institution on a schedule that is mutually agreeable to the Institution and the Filming Agent. Additional schedules may be agreed upon for the return of specific items or shipments.

3. All items and targets that were packed by the Institution in one shipment shall be returned together with the completed film in a single delivery shipment. Each return shipment shall contain a packing slip designating the number of volumes, category of contents, and the Institution's item control numbers.

4. All pickups and deliveries shall be made indoors at locations specified by the Institution, unless the Institution agrees to an alternate arrangement. (One possibility would be to insist on waterproof liners—perhaps as simple as large plastic trash bags—inside the cartons to make certain the contents stay dry.)

5. All pickups and deliveries shall be made in a vehicle owned by the Filming Agent and driven by a representative of the company, unless the Institution agrees to an alternate arrangement.

6. Packing cartons and uniform preprinted address labels shall be supplied by the Filming Agent, if required.

I. *Errors and Delays*

1. Any errors made by the Filming Agent, which are identified by the Institution's inspection process, shall be corrected or the item re-filmed without additional charge to the Institution and returned within thirty (30) days of the Filming Agent's having received the items for correction. Any extra transportation or mailing costs resulting from such errors shall be paid for by the Filming Agent. Errors that cannot be corrected shall be subject to Section I, Item E-2 (*Insurance and Security*) of the contract.

2. Any errors made by the Institution, which are identified in the filming process, shall be returned to the Institution for correction. Corrections or refilming of an item shall be at the Institution's expense.

3. Whenever items are withheld from a return shipment for any reason, the return consignment must have documentation with it listing the items that have been withheld and the explanation for such action.

J. *Invoices*

The Filming Agent shall provide detailed invoices for each completed shipment within seven (7) days of delivery of the shipment to the Institution. Invoices shall reflect the price structure delineated in the budget proposal. They shall reference the Institution's item control numbers and shall include the number of exposures filmed and the charge per exposure, the number of reels produced, the number of reels duplicated and the charge per reel, the total charge for the shipment, and any other itemized charges.

K. *Special Microfilming*

Methods of microfilming other than those specified in this contract may occasionally be requested by the Institution. Specifications for services not described in this contract and rates charged for these services shall be included by the Filming Agent in the bid proposal or provided on request by the Filming Agent. Any special treatments requiring extra charges shall not be carried out by the Filming Agent without the express permission of the Institution.

L. *Improvements and Innovations in Methods and Materials*

Any improvements in specified filming methods and/or materials used by the Filming Agent shall be acceptable to the Institution within the terms of this contract: methods and/or materials must undergo extensive, documented testing which measures their durability, permanence, and functional qualities. Adoption of any technical innovation shall be approved in writing by the Institution.

M. *Arbitration*

All disputes arising under this contract shall be settled in accordance with the rules of the American Arbitration Association in effect on the signing of this contract.

II. *Specifications for the Filming and Quality Control of Preservation Micro-film*

The Filming Agent is to provide the Institution with microfilms, consisting of a preservation master negative (first generation), printing master (second-generation negative) and service copy (third-generation positive) for each title in accordance with the following specifications, guidelines, and standards of the American National Standards Institute, the Library of Congress, and the Research Libraries Group.

A. *Specifications for Microfilming*
 1. All film shall be 35mm, nonperforated, silver-gelatin type, on poly-ester base, as described in ANSI/ASC PH 1.41-1984. Film should be at least 0.13mm (4 mil) thick. First-generation film shall be Kodak AHU 1460 or equivalent; second-generation direct duplicating film shall be Kodak 2470, or equivalent. Kodak 2470 is preferred for materials with fine lines, light printing, or illustrations. Third-generation film shall be positive polarity.
 2. Processed film shall be delivered wound with the START target at the outer end, in accordance with ANSI/AIIM MS23-1983, on storage reels which shall be chemically inert, sturdy, and of dimensions conforming to ANSI PH 5.6 (R1974). Spools used for unexposed film shall not be substituted for storage reels.
 3. To confine service copy films on their reels, only paper bands held together by button and tie shall be used. The paper shall be in accordance with the materials requirements of ANSI/ASC PH 1.53-1983. Rubber bands shall not be used.
 4. Processed negative and positive film shall be stored on reels in boxes made of acid- and lignin-free paper or board that meets the material requirements of ANSI/ASC PH 1.53-1983. They shall be no larger than $4'' \times 1^5/8'' \times 3^{15}/16''$.

B. *Specifications for Quality Control of Microfilm*
 The following quality control requirements are to be followed by the Filming Agent without exception.
 1. Inspection and quality control data shall always be recorded. The attached report form or its equivalent shall be used, and a copy delivered to the Institution for each roll of first-generation film (preservation master negative) produced.
 2. On each day that first-generation film (preservation master negative) is processed, a sample of film shall be tested for residual hypo using the methylene blue test as described in ANSI/ASC PH 4.8-1985. The test shall be carried out and certified by an independent testing laboratory. Test results shall meet requirements of ANSI/ASC PH 1.41-1984 (*class 1 films*).

3. Each roll of first-generation film (preservation master negative) shall be inspected frame by frame for visible defects and missing pages. (See ANSI/AIIM MS23-1983: "Description of Defects.") Film shall be inspected on a film reader as well as on a light inspection box. Reading equipment used for inspection must not scratch or otherwise damage the film. Second-generation film (printing master) must be inspected on a light box to ensure legibility and freedom from defects. The inspector must wear clean, white, lint-free gloves when handling film.

4. Every roll of first- and second-generation film (preservation master negative and printing master) shall have density readings taken, either roll by roll or title by title, whichever is more strict. There shall be no less than 10 readings per roll nor less than 3 per volume unless the volume is under 50 pages, in which case there shall be at least 2 per volume. Results shall be averaged, the maximum deviation from the average not to exceed 0.15. The average density for all film produced should be within a range of 0.9–1.4. For most items, the density range should be between 1.0 and 1.2. If a specific item requires an exception, it must be noted on the written report form and an explanation made to the Institution.

5. The reduction ratio employed shall be such as to approximately fill the image area across the width of the film as seen on the camera's projected image area, but shall not be lower than 8:1. All edges of the document shall be visible in the image. If the smallest lower case "e" in the text measures 1mm or less, the reduction ratio shall not exceed 14×. Materials that would require a reduction ratio of 18× or above, shall be filmed in position IIB. (See ANSI/AIIM MS23-1983: "Reduction," and MS111-198__: "Maximum Dimensions for Material to Be Filmed.") Reduction ratio changes within the same title should be avoided if possible, but when they must be made, they shall be identified by a target.

6. Folded maps, charts, and illustrations that are larger than the size of text pages shall be filmed in correct order as they appear within the text unless otherwise specified. The reduction ratio shall be changed for each oversize image to fit into a single frame. After the image is filmed, the camera shall be returned immediately to the original reduction ratio to complete the volume. This process shall be repeated each time an oversize image occurs. When images are too large to fit into a single frame and still be legible, they shall be filmed first as a whole, at a higher reduction ratio so as to fit within one frame, then at the original reduction ratio in sections from left to right and from top to bottom. An overlap of one inch shall be provided between adjacent sections.

7. Every roll of first-generation and second-generation film (preservation master negative and printing master) shall be evaluated for resolution using the Quality Index Method either roll by roll or title by title, whichever is more strict. A Quality Index rating of not less than 8.0 for three generations of prints using the line count threshold is required. (See ANSI/AIIM MS 23-1983: "Quality Index.")

8. There shall be no more than six splices (three retakes) per roll of first-generation film (preservation master negative). All retakes should be spliced in proper sequence. All splices shall be made with an ultrasonic splicer. There shall be no splices in second- or third-generation film (printing master or service copy). Retakes shall include at least the two pages preceding and succeeding the pages being refilmed. There shall be no splices between the technical target and the text. If the technical target must be refilmed, a minimum of the following 10 frames of text shall also be refilmed.

9. Framing shall be consistent and regular. The image shall not be skewed more than 10 percent (9 degrees) from parallel with the longitudinal axis of the film. Skew is measured from the two corners of the document image parallel to the longitudinal edge of the projected image frame.

10. Spacing between frames shall be consistent, variations not to exceed 50 percent of the average frame-to-frame distance. Separation between titles shall not be less than six inches. First- and second-generation film (preservation master negative and printing master) leaders and trailers shall be the length dictated by the equipment being used. Third-generation film (service copy) leaders and trailers shall be no less than eighteen inches long.

11. Titles less than one roll in length shall not be split between reels. Other decisions regarding reel breaks shall conform with Institutional policy or be made at the discretion of the Institution.

12. Image placement of IIA shall be used whenever possible. If the dimensions of the original and the type size do not allow it, the image placement IIB is the proper second choice (see no. II above).

III. *Appendix*

(This section includes information, not covered in the contract, that will need to be provided by the Institution for use by the Filming Agent. It is primarily local information that should be developed by each Institution according to individual policies and procedures. All information below should be adapted and expanded as appropriate. A description of what is needed appears after the appropriate heading.)

A. *Target Set*
 (Attach actual targets or facsimiles such as the following.)
 1. Set of "constant" targets and "as-needed" targets.
 Constant targets:
 START
 ID TARGET
 MASTER NEGATIVE #
 COPYRIGHT
 NMA TECHNICAL TARGET (provided by Filming Agent)
 END OF TITLE
 END OF REEL, REWIND

As-needed targets:
BEST COPY AVAILABLE
FILMED AS BOUND
PAGINATION INCORRECT
PAGE(S) MISSING
VOLUME(S) MISSING
CONTINUED ON NEXT REEL

2. Targets accompanying each title.
PRIMARY BIBLIOGRAPHIC TARGET
CATALOG RECORD TARGET
REEL CONTENTS (for serials, newspapers, composite reels)
TITLE GUIDE (for serials, newspapers)
REEL # (titles extending more than one reel)
VOLUME #

B. *Instructions for the Placement of Targets*

(Attach diagrams as needed outlining placement of targets for monographs; multivolume sets, or serials that fit on one reel or less; multivolume sets, serials, and newspapers that take more than one reel; and subsequent reels for titles that need more than one reel.)

C. *Assigning Master Negative Numbers*

(Develop a master negative numbering system. The Master Negative Numbers can be assigned either by the Institution during preparation or at the time of filming by the Filming Agent. Instructions for assigning numbers should be provided to the Filming Agent when appropriate.)

D. *Forms and Reports*

(Attach copies of appropriate forms, and instructions for their use, to be filled out or completed by the Filming Agent. Include other required reports that must also be prepared or provided by the Filming Agent.)

1. *CATALOG RECORD TARGET*—The bottom portion contains technical information that must be filled out at the time of filming by the Filming Agent (see Chapter 3).
2. *QUALITY CONTROL SHEET*—To be filled out by the Filming Agent and returned to the Institution with each return shipment (see Chapter 4).
3. *CERTIFICATION OF RESIDUAL THIOSULFATE LEVEL*—To be provided by the Filming Agent on a schedule as specified.

E. *Instructions for Handling Errors*

(Prepare procedures instructing the Filming Agent how to handle the many different kinds of bibliographic and technical problems that may occur during the filming process. Problems and types of errors can be divided into categories such as: minor requiring no action, serious requiring refilming or corrective action, and others which may have to be reviewed by the Institution to determine appropriate action to be taken. In all cases, problems and errors should be recorded on the Quality Control Sheet in addition to notification to the Institution as specified. Instructions are also required if missing volumes are expected to be filmed at a later time.)

F. *Special Filming Instructions*

(Include any instructions for materials not covered in the basic contract. Additional instructions may be required for more complicated materials, unusual formats, and problem materials. These materials should always be discussed and reviewed by the Filming Agent.)

(Include guidelines for arrangement of materials on reels with information about space between items, reel breaks, and splitting volumes between reels.)

G. *Labeling*

(Include examples illustrating any labeling to be performed by the Filming Agent on film boxes, packing slips, or delivery cartons.)

H. *List of Published Specifications*

(Include here a complete list of relevant American National Standards Institute standards and Library of Congress specifications. See Appendix 1.)

Appendix 3

Glossary

Most of the terms in this glossary have been extracted and adapted from two sources, the *Glossary of Micrographics* (AIIM TR-1980), prepared by the Association for Information and Image Management, and the *ALA Glossary of Library and Information Science* (Chicago: American Library Association, 1983). Some definitions have been updated or revised. This glossary is not intended to substitute for these much more extensive sources or other related dictionaries. Rather it should provide a reference point for the technical terms, or those closely related to them, actually used in the manual.

AACR2—*Anglo-American Cataloguing Rules*, second edition.
accelerated aging—a laboratory method of speeding up the deterioration of a product to estimate its long-time storage and use characteristics.
acetate film (acetate base)—safety film with a base composed principally of cellulose acetate or triacetate.
aging—changes in characteristics of photographic materials related to time.
AIIM—Association for Information and Image Management.
ALA—American Library Association.
ambient light—(1) surrounding light; (2) the general room illumination or light level.
AMC—Archives and Manuscript Control.
ANSI—American National Standards Institute.
archival film—a photographic film that is suitable for the preservation of records having permanent value when the film is properly processed and stored under archival storage conditions, provided the original images are of suitable quality. See also *archival quality*, *archival storage conditions*, *long-term film*, *medium-term film*, *short-term film*, and *preservation master negative*.
archival permanence—see *archival quality*.
archival quality—the ability of a processed print or film to permanently retain its original characteristics. The ability to resist deterioration.
archival standards—the standards that must be met by a given type of recording material or process for this material to retain specified characteristics. See also *archival quality*.
archival storage conditions—conditions suitable for the preservation of a photographic print or film having permanent value.
archives—the organized body of noncurrent records made or received in connection with the transaction of its affairs by a government or a government agency, an in-

stitution, organization, or other corporate body, and the personal papers of a family or individual, which are preserved because of their continuing value. Also used to refer to the agency responsible for selecting, preserving, and making available such material, as well as the repository itself.

ARL—Association of Research Libraries.

automatic exposure—exposure control by photoelectric means for maintaining substantially constant exposure in the focal plane for a range of field luminance.

automatic exposure control—a camera component that senses the brightness of an object and adjusts exposure.

background—the portion of a document, drawing, microfilm, or print that does not include the line work, lettering, or other information.

background density—see *density, background*.

base—a transparent plastic material, usually of cellulose triacetate or polyester, upon which a photographic emulsion or other material may be coated.

bibliographic target—see *target*.

blemish—a film defect, caused by aging and other factors, that appears as microscopic spots, usually reddish or yellowish in color. Redox (oxidation-reduction) blemishes were common, even in archival film, until it was discovered that they were due to the deterioration of film containers. See also *redox blemish*.

book cradle—a device that supports bound volumes for microfilming in a position so pages are open flat and parallel to the focal plane of the camera.

brittleness—that property of a material that causes it to break or crack when deformed by bending.

butt splice—see *splice*.

butt weld—see *splice*.

camera bed—the camera base or bottom support of some planetary cameras to which the column and light arms, or other camera support, are attached. Documents are generally placed on the bed or in a copyholder mounted on the bed for filming.

camera negative—the film used in the camera for exposure, or first-generation film. See also *preservation master negative*.

cellulose ester—a film base composed mainly of cellulose esters of acetic, propionic or butyric acids or mixtures thereof.

chain lines—a pattern appearing in paper handmade on a frame mold of fine wires laid close together and held in place by heavier wires crossing them at right angles. The pattern, or laid lines, made by these wires is visible when the paper is held up to the light. The heavier lines, which run across the short dimension of the mold, are called chain lines, while the finer, more closely spaced lines at right angles are called wire lines.

CLR—Council on Library Resources, Inc.

collate—to ascertain, usually by examination of signatures, leaves, and illustrations, whether or not a copy of a book is complete and perfect.

COM—see *computer-output microfilm*.

computer-output microfilm—any microfilm on which human-readable data are recorded directly from digital data by a computer without a printout as the intermediary.

conservation—the use of chemical and physical procedures in treatment or storage to ensure the preservation of books, manuscripts, records, and other documents. Compare with *preservation*.

container—a generic term for boxes, cans, cartridges, magazines, and cassettes or other structures for enclosing microforms.

contrast—an expression of the relationship between the high and low brightness of a subject or between the high and low density of a photographic image.

copyboard—the surface, frame, platform, or other device for holding material to be photographed.

deacidification—the process by which the acidity of paper (a major factor in its deterioration) is neutralized with, in some cases, the addition of an alkaline buffer to neutralize future acidity. The most common method of deacidification involves aqueous solutions of mildly alkaline compounds; nonaqueous methods are at present being developed for mass application and for items that are sensitive to water.

dense—relatively opaque, generally applied to film images or areas that are darker than normal.

densitometer—a device used to measure the optical density of an image or base by measuring the amount of incident radiant energy (light) reflected or transmitted.

densitometric method (silver)—a testing procedure that produces a yellow stain for density measurement; used for indicating the presence of thiosulfate or other potentially harmful residual chemicals in processed films.

density—the light-absorbing or light-reflecting characteristics of a photographic image, filter, etc. Density is the logarithm to the base 10 of the ratio of the light falling on a sample and the light transmitted or reflected. Density is expressed as $D = \log IT$ where I is the light that falls on the sample and T is the light that is transmitted. In practice, there are many types of density depending on the optical system used (geometric) and on the spectral quality (color) of the light.

density, background—the opacity of the noninformation area of microform. See also *density*.

diazo—materials (coated films or papers) containing sensitized layers composed of diazonium salts that react with couplers to form azo dye images. The color of the image is determined by the composition of the diazonium compound and the couplers used in the process.

diazo material—a slow print film or paper, sensitized by a coating of diazonium salts, which, subsequent to exposure to light (strong in the blue to ultraviolet spectrum) and development, forms an image. Diazo material generally produces nonreversed images; i.e., a positive image will produce a positive image and a negative image will produce a negative image.

distribution copy—see *service copy*.

dry-silver film—a nongelatin silver film which is developed by the application of heat. The film is used in some types of computer-output-microfilm recorders.

duplicate—(1) a copy of a microform made by contact printing or by optical means; (2) to make multiple copies of a document or microfilm, usually with the aid of a master or intermediate.

electrophotographic film—a film base coated with a light-sensitive photoconductor, which retains its sensitivity through repeated exposures and which, through electrostatic processing, permits the updating of microfilm and microfiche by the addition of new microimages and the overprinting of superseded images.

emulsion—a single or multilayered coating consisting of light-sensitive materials in a medium carried as a thin layer on a film base.

emulsion layer—the layer that contains the image-forming light-sensitive substances or photoconductors in a photographic material.

encapsulation—the process whereby a flat document of paper or other fibrous writing material (such as papyrus) is held between two sheets of transparent polyester film by sealing around the edges, providing physical support against handling and storage hazards. It is a quick, simple, and completely reversible process.

expose in sections—to make more than one photograph to cover the whole document if original documents are larger than the maximum area of coverage of a camera.

exposure—(1) the act of exposing a sensitive material to radiant energy; (2) the time during which a sensitized material is subjected to the action of radiation; (3) the product of radiation intensity and the time during which it acts on the photosensitive material.

exposure counter—a mechanical device on some cameras, film holders, etc., that indicates the number of frames or sheets of film or other sensitized material that have been exposed or that remain to be exposed.

exposure setting—the time (camera shutter speed, or light level) used to control the quantity of light or radiant energy received by photosensitive material.

fading—loss in density of photographic images.

fiche—see *microfiche.*

field—(1) the area covered or "seen" by the optical system of a camera; (2) a unit of data within a bibliographic record.

file—(1) a collection of records; an organized collection of information directed toward some purpose; (2) data stored for later processing by a computer or computer-output microfilmer.

film—any sheet or strip of transparent plastic base coated with a light-sensitive emulsion. See also diazo, dry-silver, and vesicular film.

film base—see *base.*

film size—film width, generally expressed in millimeters, e.g., 35mm.

fixing—the removal of undeveloped silver gelatin from the film or photographic paper. Through the use of a fixer solution, light-sensitive crystals are dissolved in water and washed away. This permanently fixes the image on the film negative or print and prevents further reaction with light.

flats—two pieces of matched optical glass for holding film flat during projection or viewing, as in a microfilm reader.

fog—nonimage photographic density. A defect in film that can be caused by (1) the action of stray light during exposure, (2) improperly compounded processing solutions, or (3) wrongly stored or outdated photographic materials.

frame—the part of microfilm exposed to light in a camera during an exposure, consisting of the image area, frame margin, and frame line.

frilling—a puckering and peeling of a photographic emulsion layer from its base. Frilling can be caused by (1) excessive temperature or improper compounding of the baths, (2) poor adhesion qualities of the material, (3) improper hardening of the gelatin, or (4) the use of very soft wash water.

gelatin—a colloidal protein used as a medium to hold silver halide crystals in suspension in photographic emulsions, as a protective layer over emulsions, as a carrier for dyes in filters, etc.

generation—one of the successive stages of photographic reproduction of an original or a master. The first generation is the camera film. Copies made from this first generation are second generation, etc.

gutter—the combined marginal space formed by adjacent margins of any two pages of an open volume.

halide—any compound of chlorine, iodine, bromine, or fluorine and another element. The compounds are called halogens. The silver salts of these halogens are the light-sensitive materials used in silver-halide emulsions.

hard copy—any volume, document, or other material printed on paper.

heading—inscription placed at the top of the microform (microfiche, jacket) to identify its contents. It is readable without magnification.

high contrast—a relationship of image tones in which the light and dark areas are represented by extreme differences in density.

hinge—see *joint.*

image—a representation of information produced by radiation. Images are real

when they are formed in a plane, as on film in a camera. They are virtual when viewed as in a telescope.

image area—(1) the part of a recording area reserved for the images; (2) the area of a jacket containing film channels for the storage of microfilm images.

intermediate—duplicate microform specifically prepared for producing further copies. See also *negative, intermediate*, and *printing master*.

intrinsic value—in archives, the inherent value and, in appraisal, the worth in monetary terms of documents, dependent upon some factor such as age, the circumstances regarding creation, signature, or the handwriting of a distinguished person, an attached seal, etc.

ISBN—International Standard Book Number. A four-part, ten-character code given a book (a nonserial literary publication) before publication as a means of identifying it concisely, uniquely, and unambiguously. The four parts of the ISBN are: group identifier (e.g., national, geographic, language, or other convenient group), publisher identifier, title identifier, and check digit.

ISSN—International Standard Serial Number. The international numerical code that identifies concisely, uniquely, and unambiguously a serial publication.

jacket—a flat, transparent, plastic carrier with single or multiple film channels made to hold single or multiple microfilm images.

joint—either of the two portions of the covering material that bends at the groove and along the ridge when the covers of a volume are opened or closed. Synonymous with *hinge*.

latent image—the invisible image produced by action of radiant energy on a photosensitive material. It may be made visible by the process of development.

latent image fade—the change in the effects of radiant energy on a photosensitive surface which occurs during the time between exposure and development. The amount and rate of change depends on time, temperature, humidity, storage conditions, and type of emulsion.

LCNAF—Library of Congress Name Authority File.

letter book—used in archives to describe three types of material. (1) a book in which correspondence was copied by writing the original letter with copying ink, placing it against a dampened sheet of thin paper (leaves of which made up the book) and applying pressure; (2) a book of blank or lined pages on which are written letters, either drafts written by the author or fair copies made by the author or by a clerk; (3) a book comprising copies of loose letters which have been bound together, or one into which such copies are pasted onto guards or pages.

light box—a device for inspecting film that employs a back-illuminated translucent surface.

light struck—film that has been fogged either accidentally or deliberately.

long-term film—film suitable for the preservation of records for a minimum of 100 years when stored under proper conditions, providing the original film was processed correctly. See also *archival film, medium-term film*, and *short-term film*.

low contrast—a relationship of image tones in which the light and dark areas are represented by small differences in density.

macroscopic—large enough to be read without magnification, e.g., heading or title information on microfiche.

MARC—Machine-Readable Cataloging. A communication format developed by the Library of Congress for producing and distributing machine-readable bibliographic records on magnetic tape.

mass deacidification—see *deacidification*.

master—a document or microform from which duplicates or intermediates can be obtained.

master negative—any film, but generally the camera microfilm, used to produce further reproductions, such as intermediates, distribution copies, or service copies. See also *preservation master negative.*

medium contrast—a relationship of image tones in which the light and dark areas are represented by average or normal differences in density.

medium-term film—a photographic film that is suitable for the preservation of records for a minimum of 10 years when stored under proper conditions, providing the original film was processed correctly. See also *archival film, long-term film,* and *short-term film.*

methylene blue—a chemical dye formed during the testing of archival permanence of processed microimages using the methylene-blue method.

microfiche—a transparent sheet of film, usually 105mm, with microimages arranged in a grid pattern. A heading or number large enough to be read without magnification normally appears at the top of the microfiche in a space reserved for this purpose.

micrographics—the science and technology of creating microimages; designing indexing, storage, and retrieval systems for them; or using them in a micrographic system. Micrographics is generally considered a subfield of reprography.

microscopic blemish—see *blemish.*

NBS—National Bureau of Standards.

negative, intermediate—a negative that has been produced expressly for the purpose of making additional copies. Also called a *printing master.*

NEH—National Endowment for the Humanities.

nitrate film—photographic film with a film base composed principally of cellulose nitrate. Because nitrate film is highly flammable, it has largely been replaced by acetate film.

NMA—National Micrographics Association, former name of the Association for Information and Image Management.

NRMM—National Register of Microform Masters.

NUCMC—National Union Catalog of Manuscript Collections.

OCLC—Online Computer Library Center, Inc.

optical—(1) containing lenses, mirrors, etc., as in optical viewfinder and optical printer; (2) in general, having to do with light and its behavior and control, as in optical properties, optical rotation; (3) pertaining to the science of light and vision.

original—a document that may be reproduced.

oversewing—in binding, a method of side sewing by hand or machine in which sections are sewn to one another near the back edge. Is extensively used in library binding.

planetary camera—a type of microfilm camera in which the pages being photographed and the film remain in a stationary position during the exposure. The page(s) or documents are on a plane surface at the time of filming. Also known as flatbed camera. See also *rotary camera* and *step-and-repeat camera.*

polarity—the change or retention of the dark to light relationship of an image, i.e., a first-generation negative to a second-generation positive indicates a polarity change, while a first-generation negative to a second-generation negative indicates the polarity is retained.

polyester—a transparent plastic made from polyesters and used as a film base because of its dimensional stability, strength, resistance to tearing, and relative non-flammability.

preservation—the activities associated with maintaining library and archival materials for use, either in their original physical form or in some other usable way.

Compare with *conservation*, frequently used as a synonym, though distinctions between the two terms seem to be emerging. Conservation tends to refer to the techniques and procedures relating to the treatment of books and other documents to maintain as much as possible or feasible the original physical integrity of the physical object or artifact. Preservation tends to include conservation, but also comprehends techniques of partial preservation of the physical object (e.g., a new binding), as well as procedures for the substitution of the original artifact by materials conversion, whereby the intellectual content of the original is at least partially preserved.

preservation master negative—a first-generation or camera microfilm produced according to archival standards and stored under archival conditions. It is generally used only to produce printing masters.

printing master—see *intermediate* and *master negative*.

processed film—film that has been exposed to suitable radiation and has been treated to produce a fixed or stabilized visible image.

processing—a series of steps involved in the treatment of exposed photographic material to make the latent image visible and ultimately usable, e.g., development, fixing, washing, drying.

processor—any machine that performs the various operations necessary to process photographic material, e.g., development, fixing, washing, etc.

programming—a prefilming task performed after collation to determine maximum page capacity per reel for multireel titles. Programming is a combination of calculating the maximum number of exposures per reel based on both the reduction ratio and the frame position and, using this figure, deciding where an appropriate bibliographic or chronological break can be made to end the reel.

QI—see *quality index*.

quality index—the subjective relationship between legibility of printed text and the resolution pattern resolved in a microimage. Used to predetermine legibility in the resulting images.

raw stock—unexposed, unprocessed photographic film, paper, or other recording material.

record series—in archives, a group of records maintained as a unit because they relate to a particular subject or function, result from the same activity, have a particular form, or because of some other relationship arising out of their creation, receipt, or use, and intended to be kept together in a definite arrangement.

redox blemish—a microspot formation on silver-gelatin type films caused by air pollution, improper packaging, or storage conditions. See also *blemish*.

reduction ratio—the relationship (ratio) between the dimensions of the original or master and the corresponding dimensions of the microimage; e.g., reduction ratio is expressed as 1:24.

reprography—the science, technology, and practice of document reproduction. It encompasses virtually all processes for copying or reproduction using light, heat, or electrical radiation, including microreproduction. Reprography is often characterized by its economy of scale, generally excluding large-scale, professional printing operations.

residual hypo—see *residual thiosulfate ion*.

residual thiosulfate ion—ammonium or sodium thiosulfate (hypo) remaining in film or paper after washing. Synonymous with residual hypo.

resolution—the ability of a photographic system to record fine detail.

resolution test chart—a chart containing a number of increasingly smaller resolution test patterns. The pattern is a set of horizontal and vertical lines of specific size

and spacing. The NBS Microcopy Resolution Test Chart 1010A is generally used in micrographics.

retake—refilming of documents.

retrospective conversion—the process of converting to a machine-readable form the records in a manual or non-machine-readable file that are not converted through day-to-day processing. Sometimes abbreviated "recon."

RLG—Research Libraries Group, Inc.

RLIN—Research Libraries Information Network, the computerized bibliographic database owned and operated by the Research Libraries Group.

roll microfilm—microfilm that is or can be put on a reel, spool, or core.

rotary camera—a type of microfilm camera that photographs documents while they are being moved by some form of transport mechanism. The document transport mechanism is connected to a film-transport mechanism, and the film also moves during exposure so there is no difference in the rate of relative movement between the film and the image of the document. See also *planetary camera* and *step-and-repeat camera*.

safety film—a comparatively nonflammable film support (base) that meets ANSI requirements for safety film.

second-generation microfilm—a microfilm copy made from the camera film.

service bureau—an organization that is equipped to provide micrographic and related services.

service copy—a microform copy, which is distributed for end use. Synonymous with *distribution copy*.

sharpness—(1) the visual sensation (subjective) of the slope of the boundary between a light and a dark area; (2) the degree of (line/edge) clarity.

silver densitometric method—a method of measuring residual thiosulfate in film.

silver film—a film which is sensitized with silver halide. The term includes nongelatin dry-silver film as well as silver-gelatin film, which is coated with silver halide suspended in gelatin and is developed by a wet process. Silver film is considered by many to be the only film suitable for archival permanence.

silver-gelatin film—see *silver film* and *gelatin*.

silver halide—a compound of silver and one of the following elements known as halogens: chlorine, bromine, iodine, and fluorine.

silver-halide film—see *silver film* and *silver halide*.

splice—in preservation microfilming, a joint made by ultrasonic or heat welding two pieces of film together so they will function as a single piece when passing through a camera, processing machine, viewer, or other apparatus. Most welds are called butt splices, since the two pieces are butted together without any overlap.

splicer—a device for joining strips of photographic film or paper.

stability—the degree to which negatives or prints resist change by the action of light, heat, or atmospheric gases.

static marks—black spots, streaks, or treelike marks produced on sensitive materials by discharges of static electricity during handling or winding and made visible by developing.

step-and-repeat camera—a type of microfilm camera that can expose a series of separate images on an area of film according to a predetermined format, usually in orderly rows and columns, e.g., microfiche. See also *planetary camera* and *rotary camera*.

strip-up—a technique used for the production of microfiche in which short lengths of roll film are attached in rows to a transparent support, which is then used as a master.

target—(1) any document or chart containing identification information, coding, or test charts; (2) an aid to technical or bibliographic control that is photographed on the film preceding or following the document.

technical target—an aid to technical control that indicates the reduction and resolution of the film. See also *target*.

USMARC—see *MARC*.

vesicular film—a film in which the light-sensitive component is suspended in a plastic layer. On exposure, the component creates optical vesicles (bubbles) in the layer. These imperfections form the latent image. The latent image becomes visible and permanent by heating the plastic layer and then allowing it to cool.

watermark—a design in paper appearing as an increased translucence and sometimes including letters and numerals. Variations in design over time and place allow it to be used in dating and localizing paper production.

work copy—see *service copy*.

Appendix 4

Organizations and Institutions Involved in Preservation Microfilming

Below is a list of nonprofit organizations and institutions from which readers may obtain information and advice on virtually any aspect of preservation microfilming. Each entry represents some combination of experience, programs, publications, and services that can help to meet a wide variety of informational needs, whether it be to answer a single question or to develop an entirely new program. To be sure, many inquiries directed to these sources will have to be referred on to other individuals or agencies before they can be completely satisfied. However, this fact will not deter more persistent seekers of information for whom this list can provide a wealth of practical assistance.

The filming centers listed below consist mainly of in-house programs whose services, unless otherwise indicated, are primarily available to those within the institutions where they are located and, hence, they should be regarded as sources of advice and information only. The information provided for each entry here is limited to the name, address, and telephone number of the organization; the type of information or advice most likely to be obtained from that source; and the specific office or position, if any, to contact for assistance.

For a comprehensive list of micrographics services in libraries, consult Joseph Nitecki, *Directory of Library Reprographic Services*, 8th ed. (Westport, Conn.: Meckler Publishers, 1982). *The International Micrographics Sourcebook* (New Rochelle, N.Y.: Microfilm Publishing, 1984–85) is published biennially and contains an extensive list of commercial microfilm service bureaus and the services they offer, as well as current information on equipment and other pertinent subjects.

Filming Centers

University of California
General Library
Berkeley, CA 94720
The library's in-house program focuses primarily on brittle books but also does a significant amount of manuscript microfilming. As the schedule permits, it will contract to microfilm for institutions outside the University. For more information, contact the Conservation Department (415/642-4946).

Canadian Institute for Historical Microreproduction
P.O. Box 2428, Station D
Ottawa, Ontario
Canada K1P 5W5
The Institute films Canadiana within the National Library and elsewhere in Canada. It is essentially a bibliographic program with filming services provided on a contractual basis by a commercial agency. For more information, contact the Office of the Executive Director (613/235-2628).

University of Chicago
Regenstein Library
1100 East 57th Street
Chicago, IL 60637
The library's long-established in-house facility provides preservation microfilming services to the University's libraries and occasionally to other repositories as well. For more information, contact the Preservation Office (312/962-9313).

Columbia University Libraries
New York, NY 10027
Columbia University has experience with filming monographs and serials (especially Oriental materials) and developing technical specifications for contractual services. They have had involvement with cooperative projects. For more information, contact the Preservation Office (212/280-2223).

Genealogical Society of Utah
50 East North Temple Street
Salt Lake City, UT 84150
The Mormon Church operates a worldwide program to film records of genealogical value on site. Direct technical inquiries to Micrographics Services, Acquisitions Division (801/531-2298).

Kentucky Department for Archives and Libraries
P.O. Box 537
Frankfort, KY 40602
In addition to filming state and local records, the Department of Archives certifies commercial vendors and other agencies. Direct technical inquiries to the Micrographics Laboratory, Public Records Division (502/875-7000), all others to the Deputy State Archivist and Records Administrator (502/875-7000, ext. 153).

Library of Congress
Washington, DC 20540
The Library of Congress (LC) maintains one of the oldest and largest preservation microfilming programs in the country and has extensive experience in filming a wide range of archival and library materials. The National Preservation Program Office has also developed a clearinghouse for preservation microfilming projects. Direct technical inquiries to the Photoduplication Service (202/287-5640); all other inquiries to the National Preservation Program Office (202/287-1840). Direct requests for information regarding LC's plans for microfilming individual titles or for photocopies of individual pages to the Preservation Microfilming Office (202/287-5918). The office also provides advice on preparation procedures.

Massachusetts Institute of Technology
Cambridge, MA 02139
The Microreproduction Laboratory (Building 14-0551) provides services and technical guidance to some area institutions having in-house filming programs. For more information, contact the Laboratory (617/253-5667).

University of Michigan
Harland Hatcher Graduate Library
Ann Arbor, MI 48109
The library films primarily brittle books. The main expertise lies, however, in the programmatic aspects of filming. For more information, contact the Preservation Office (313/763-9316).

Mid-Atlantic Preservation Service (MAPS)
Lehigh University
111 Research Drive, Room C-38
Bethlehem, PA 18015
Established in 1986, MAPS is a nonprofit microfilming service, which plans to specialize in preservation microfilming of brittle materials. MAPS publishes newsletters and seeks active communication with institutions and persons interested in the subject. Direct inquiries to the Director (215/694-1293).

Minnesota Historical Society
1500 Mississippi Street
St. Paul, MN 55101
The Society has extensive experience filming Minnesota newspapers and producing micropublications of major collections. Direct technical inquiries to the Director of Microfilm Laboratories (612/296-2145) and all inquiries regarding preparation and bibliographic issues to the Microfilm Editor (612/296-6980).

National Archives and Records Administration (NARA)
National Archives Building
Washington, DC 20408
Some preservation microfilming is done by the field offices located around the country. For more information, contact the Division of Field Archives (202/523-3032). Direct technical inquiries to the Preservation Policies and Services Division (202/523-3237 or 523-3248).

New York Public Library (NYPL)
5th Avenue at 42nd Street
New York, NY 10018
NYPL operates one of the largest in-house filming programs in the U.S., which includes a full range of library and archival materials. For more information, contact the Conservation Division (212/930-0631).

Northeast Document Conservation Center (NEDCC)
24 School Street
Andover, MA 01810
Microfilm operations at NEDCC are dedicated exclusively to preservation projects. NEDCC is experienced in filming a full range of library and archival materials. For more information, contact the Director, Microfilming Services (617/470-1010).

Ohio Historical Society
I-71 & 17th Street
Columbus, OH 43211

The Society films mostly newspapers, but may contract with any agency to film materials relating to Ohio history. For more information, contact the Microfilm Department (614/466-1500).

Pennsylvania Historical and Museum Commission
Division of Archives and Manuscripts
Box 1026
Harrisburg, PA 17120

The Commission films primarily the public records of archival value generated by the state's political subdivisions. It establishes and monitors quality control standards. For more information, contact the Micrographics Technical Supervisor (717/783-9873) or the Archives and Local Records Supervisor (717/787-3913).

South Carolina Department of Archives and History
P.O. Box 11669, Capitol Station
Columbia, SC 29211

The Department of Archives films public documents as well as state and local records of archival value. It also establishes and monitors standards and practices. For more information, contact the Deputy Director (803/758-5816).

State Historical Society of Wisconsin
Division of Archives and Manuscripts
816 State Street
Madison, WI 53706

The Society films a wide range of archival and library materials. For more information, contact the Micrographics Laboratory (608/262-9580), the Newspapers and Serials Librarian (608/262-9580), or the Deputy State Archivist (608/262-9600).

Organizations

American Library Association
Resources and Technical Services Division (RTSD)
50 East Huron Street
Chicago, IL 60611

RTSD includes the Reproduction of Library Materials and Preservation of Library Materials Sections and the Preservation Microfilming Committee, which meet twice a year and sponsor both regional and preconference programs. Publications by RTSD include the quarterly journal, *Library Resources & Technical Services*, and the bimonthly newsletter, *RTSD Newsletter.* (312/944-6780).

American National Standards Institute (ANSI)
1430 Broadway
New York, NY 10018

The American National Standards Institute is a membership organization that develops and promulgates voluntary standards for the United States and represents U.S. interests in international standards organizations. ANSI has promulgated a number of standards relating to microforms and microfilming techniques. These are listed in Appendix 1. (212/354-3300).

American Philological Association (APA)
617 Hamilton Hall
Columbia University
New York, NY 10027
APA is currently involved in a program to microfilm all important works in classical studies published between 1850 and 1918. The project, which began in 1984, utilizes scholar-specialists to select the works. Filming is handled by the Columbia University Libraries. The project has been funded by the National Endowment for the Humanities. For more information, contact Secretary-Treasurer (212/280-4051).

American Theological Library Association (ATLA)
Preservation Board
1118 E. 54th Place
Chicago, IL 60615
ATLA's Preservation Board is currently managing a project to film all worthwhile religious monographs published between 1860 and 1905. Microfiche of the volumes are available through a subscription service. For information on this program, contact the Project Director (312/643-7470).

Association for Image and Information Management (AIIM)
1100 Wayne Avenue
Silver Spring, MD 20910
AIIM (formerly known as the National Micrographics Association) is a trade organization which produces guidebooks, technical standards, and workshops. The "Resource Center" answers technical inquiries submitted by mail or telephone (301/587-8202).

Association of Research Libraries (ARL)
1527 New Hampshire Avenue, N.W.
Washington, DC 20036
ARL sponsors special projects, surveys, and studies relating to preservation microfilming, especially in relationship to the bibliographic control of master negatives. Contact Program Officer (Preservation) (202/232-2466).

Council on Library Resources, Inc. (CLR)
1785 Massachusetts Avenue, N.W.
Washington, DC 20036
CLR sponsors planning, research, and assessment projects on various aspects of preservation, including microforms. CLR has also formed a Commission on Preservation and Access, the objectives of which are to: (1) establish the general conditions, policies, and procedures governing preservation work for the guidance of libraries, publishers, and other agencies interested in participating in brittle books programs; and (2) develop and promote a funding plan to give continuity and cohesion to the effort. The annual reports and newsletter, *CLR Recent Developments*, provide further information about funded projects. For information, write or telephone the Vice President (202/483-7474).

National Center for State Courts
Research and Information Services
300 Newport Avenue
Williamsburg, VA 23185
The Center's publications, project reports, and consultants services include the use of microforms as a means of preservation and access to court records. It also maintains several regional offices around the United States. (804/253-2000).

National Endowment for the Humanities (NEH)
Office of Preservation
Old Post Office Building
1100 Pennsylvania Avenue, N.W.
Washington, DC 20506
NEH funds numerous preservation microfilming projects and programs, most notably including the U.S. Newspaper Project. (202/786-0570).

National Historical Publications and Records Commission (NHPRC)
National Archives Building
Washington, DC 20408
NHPRC is a funding agency within the National Archives that supports preservation microfilming and micropublication of archival and manuscripts collections. Project reports and microform guidelines are available. (202/523-5386).

Research Libraries Group, Inc. (RLG)
Jordan Quadrangle
Stanford, CA 94305
RLG has strong experience in planning and implementation of major cooperative microfilming projects involving large research libraries through the RLG Preservation Program. (415/328-0920).

Society of American Archivists (SAA)
600 S. Federal, Suite 504
Chicago, IL 60605
SAA offers publications and programs pertaining to preservation microfilming. The Conservation Section of SAA meets at the annual meeting. (312/922-0140).

U.S. Department of Education (USDOE)
Higher Education Act/Title II-C Program
1200 19th Street, N.W.
Washington, DC 20208
The DOE funds microform projects in research libraries for both preservation and bibliographic control. Project proposals and abstracts are available. (202/254-5090).

Index

Nancy E. Gwinn is Assistant Director, Collections Management, for the Smithsonian Institution Libraries, where she supervises a preservation services unit and a book conservation laboratory. In the early 1980s, she was instrumental in developing the model cooperative preservation microfilming project of the Research Libraries Group in Stanford, California, and has also worked at the Council on Library Resources in Washington, D.C., and the Library of Congress. Gwinn is the author of numerous articles on preservation, collection development, reference and public services, and foundations and library funding.